O9-BRY-990

FANTASY CHARACTERS

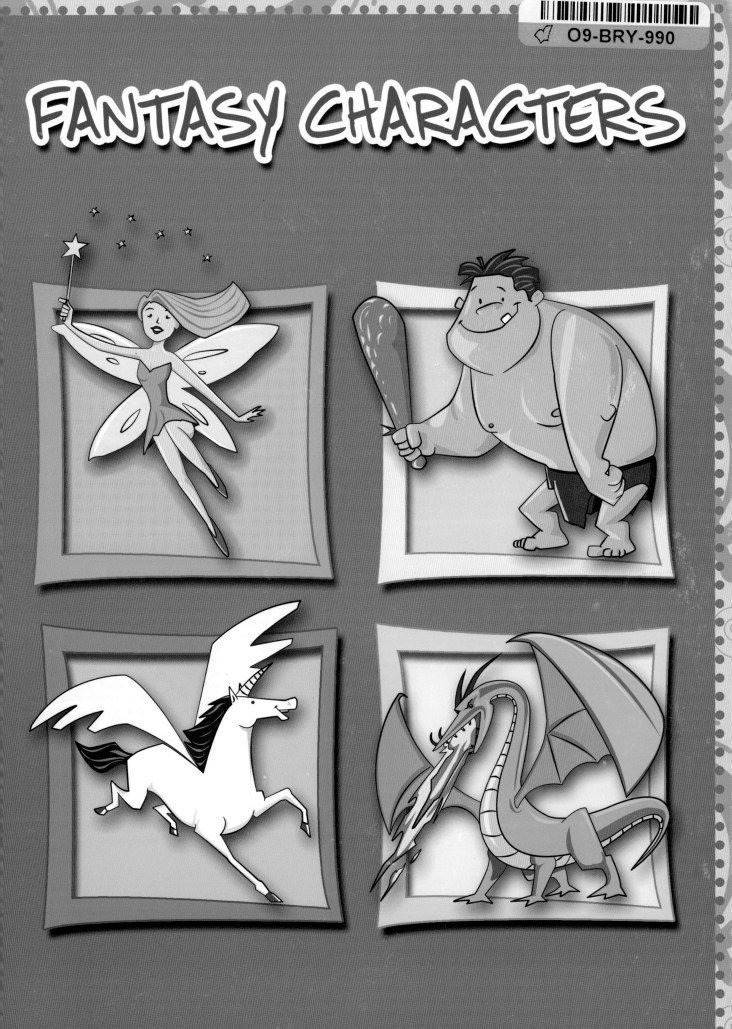

Werewolf

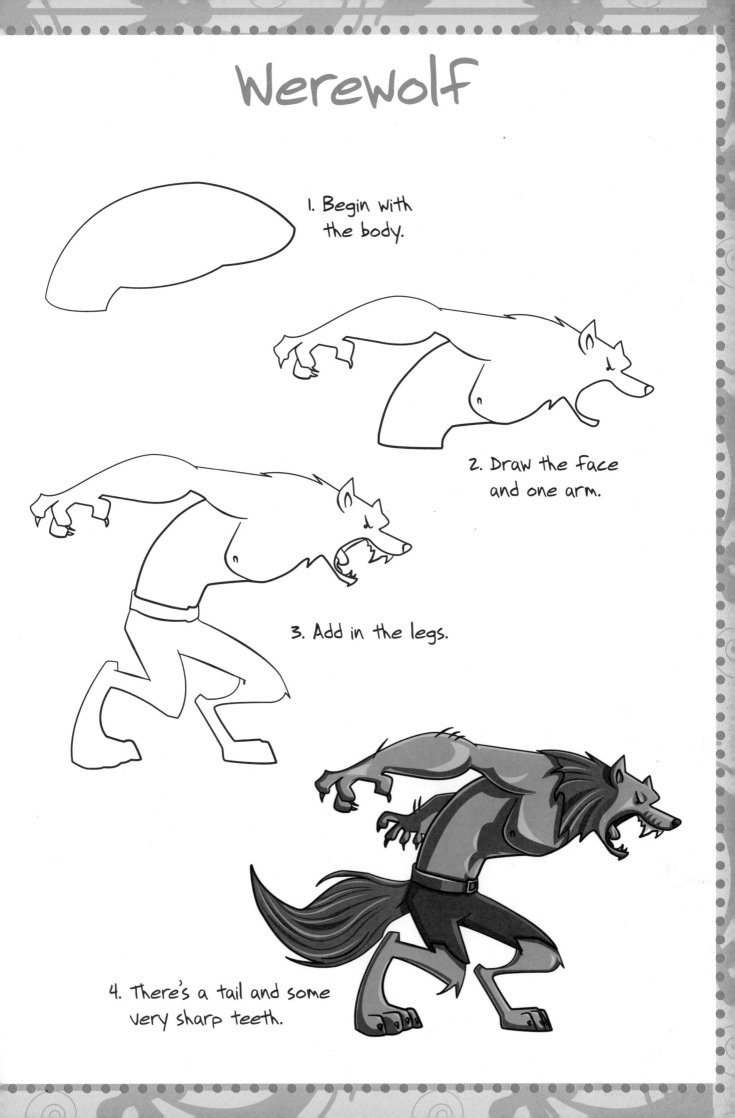

1. Begin with the body.

2. Draw the face and one arm.

3. Add in the legs.

4. There's a tail and some very sharp teeth.

Giant

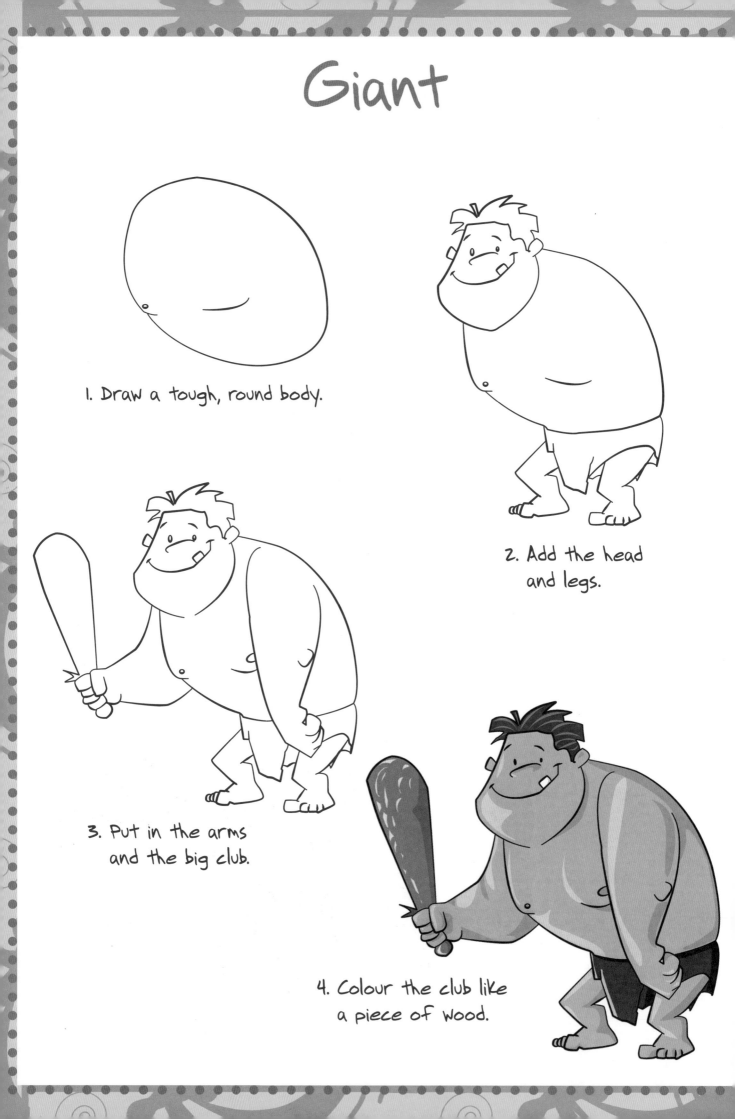

1. Draw a tough, round body.

2. Add the head and legs.

3. Put in the arms and the big club.

4. Colour the club like a piece of wood.

Fairy

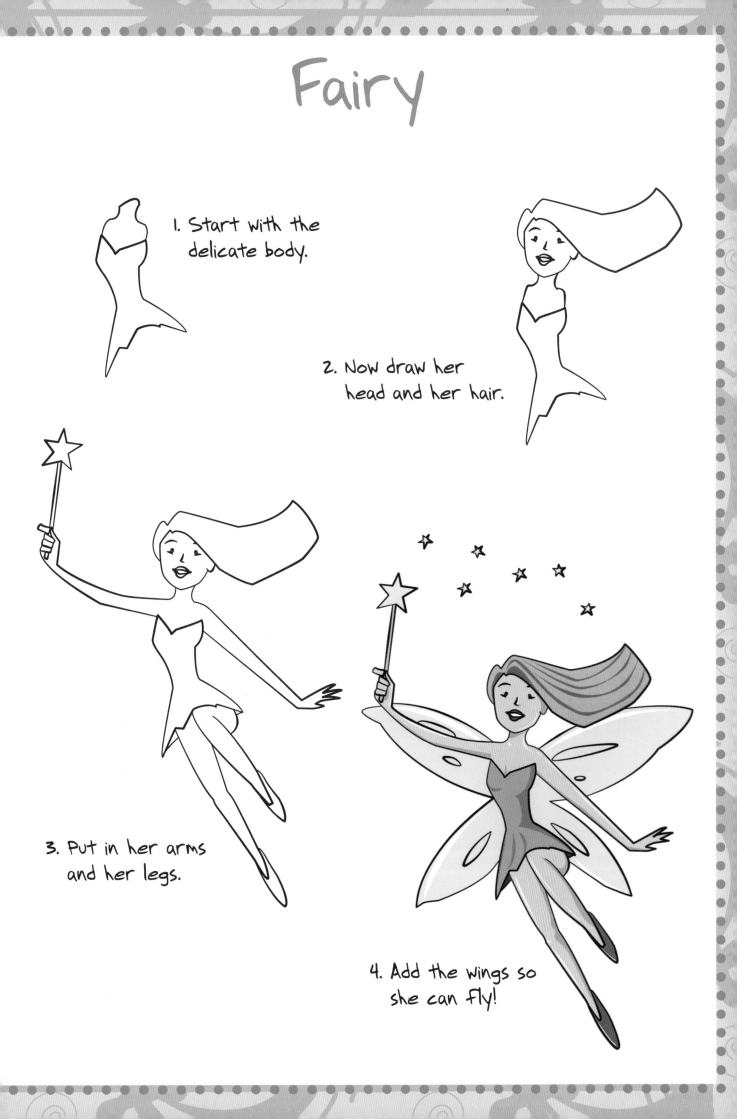

1. Start with the delicate body.

2. Now draw her head and her hair.

3. Put in her arms and her legs.

4. Add the wings so she can fly!

Wizard

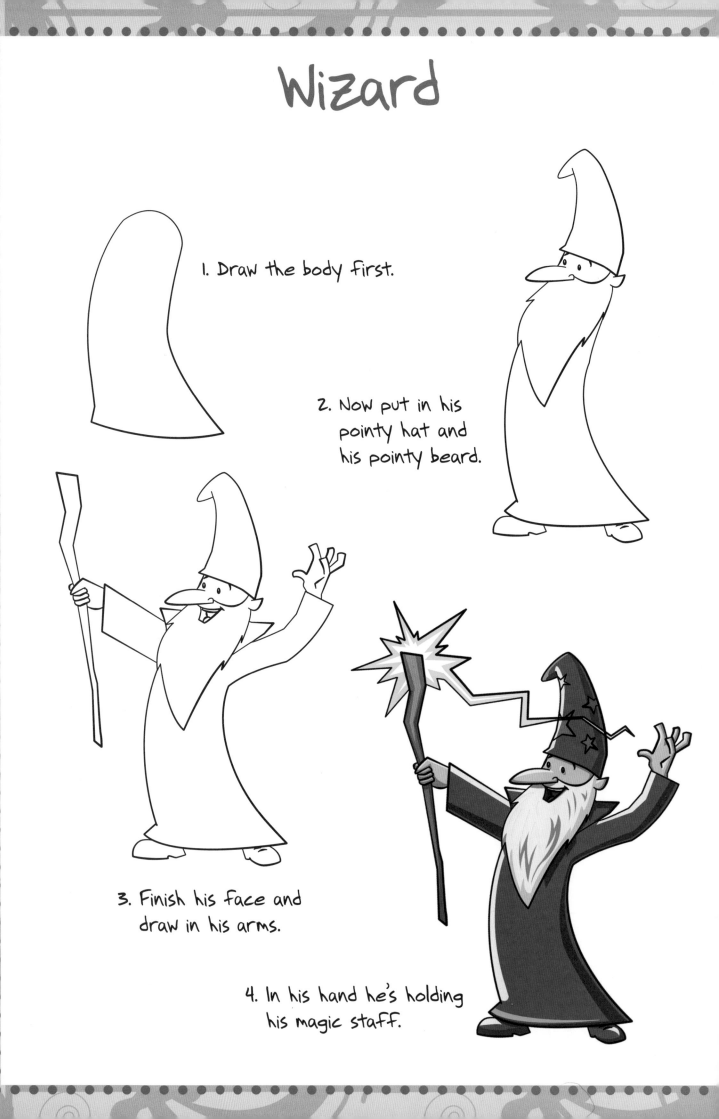

1. Draw the body first.

2. Now put in his pointy hat and his pointy beard.

3. Finish his face and draw in his arms.

4. In his hand he's holding his magic staff.

Elf

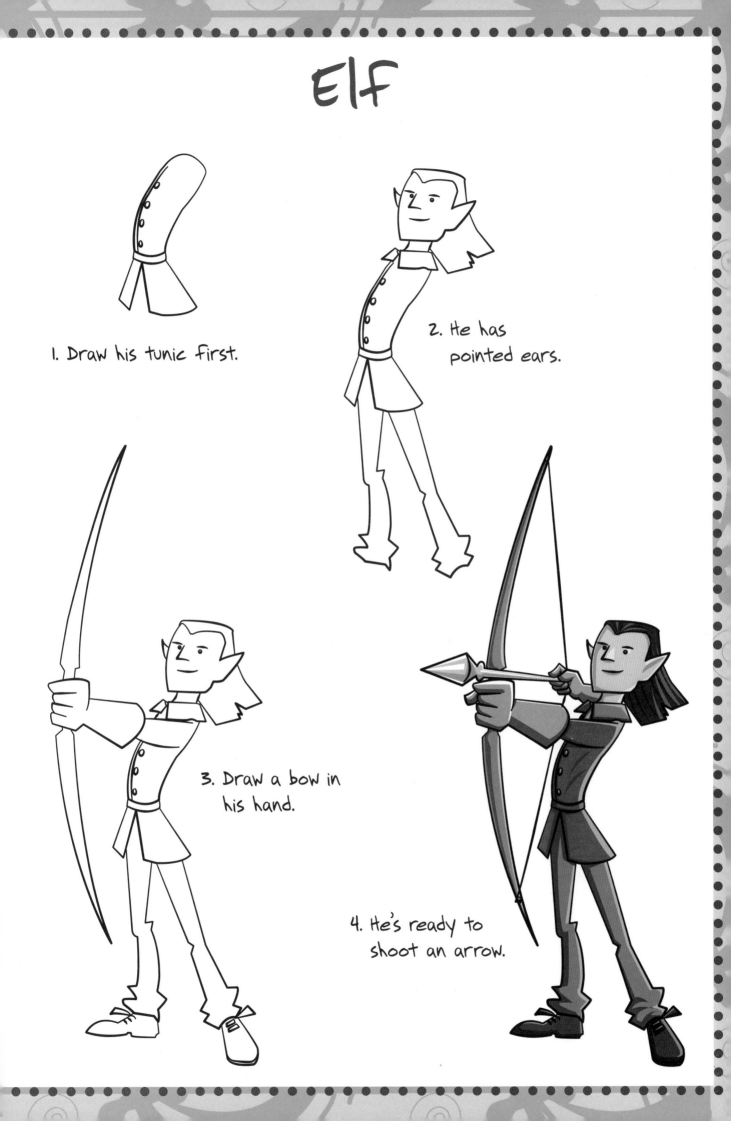

1. Draw his tunic first.

2. He has pointed ears.

3. Draw a bow in his hand.

4. He's ready to shoot an arrow.

Dwarf

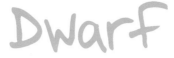

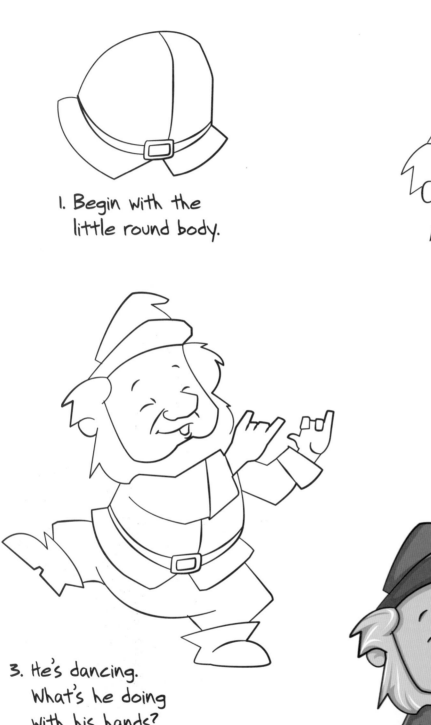

1. Begin with the little round body.

2. Now put in his bearded face.

3. He's dancing. What's he doing with his hands?

4. He's playing a flute!

Dragon

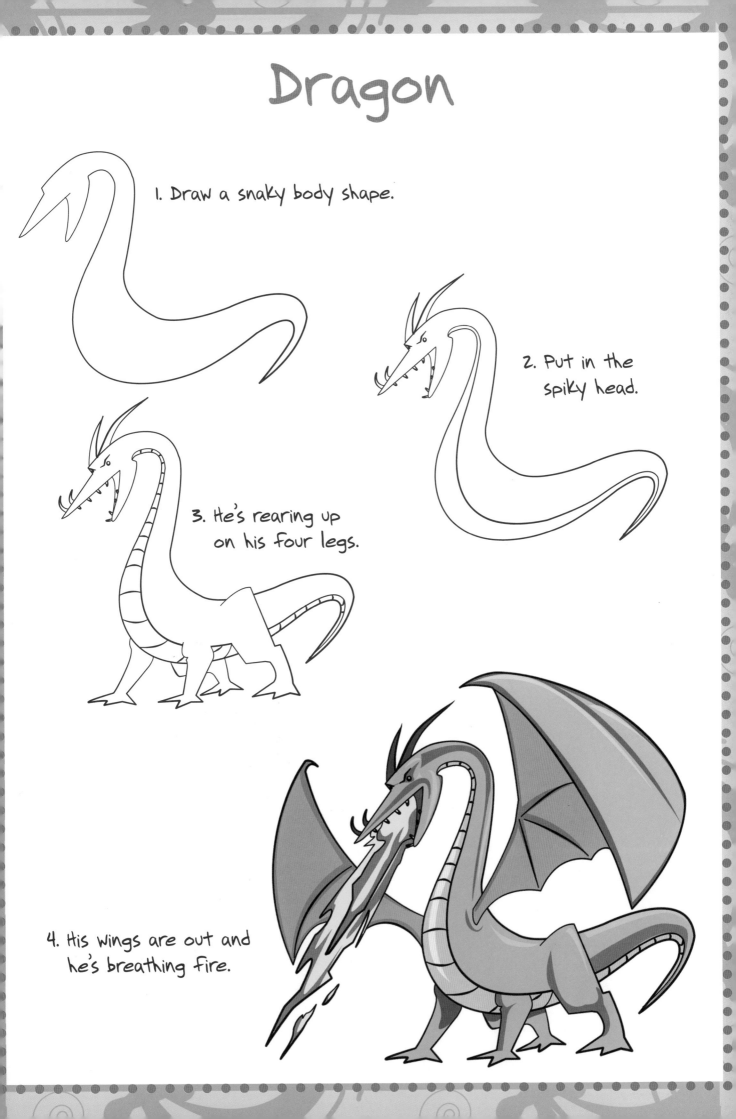

1. Draw a snaky body shape.

2. Put in the spiky head.

3. He's rearing up on his four legs.

4. His wings are out and he's breathing fire.

Mermaid

1. Here's her body.

2. Draw her long hair and her fishy tail.

3. Add her face and arms.

4. Put in some bubbles so we can see she's in the water.

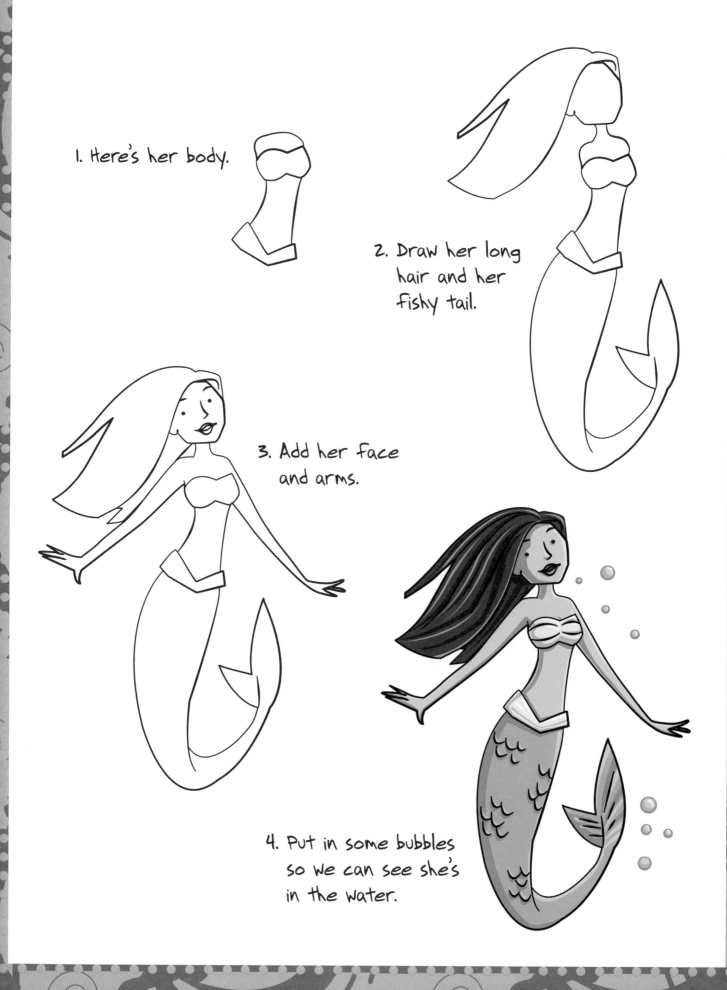

Gnome

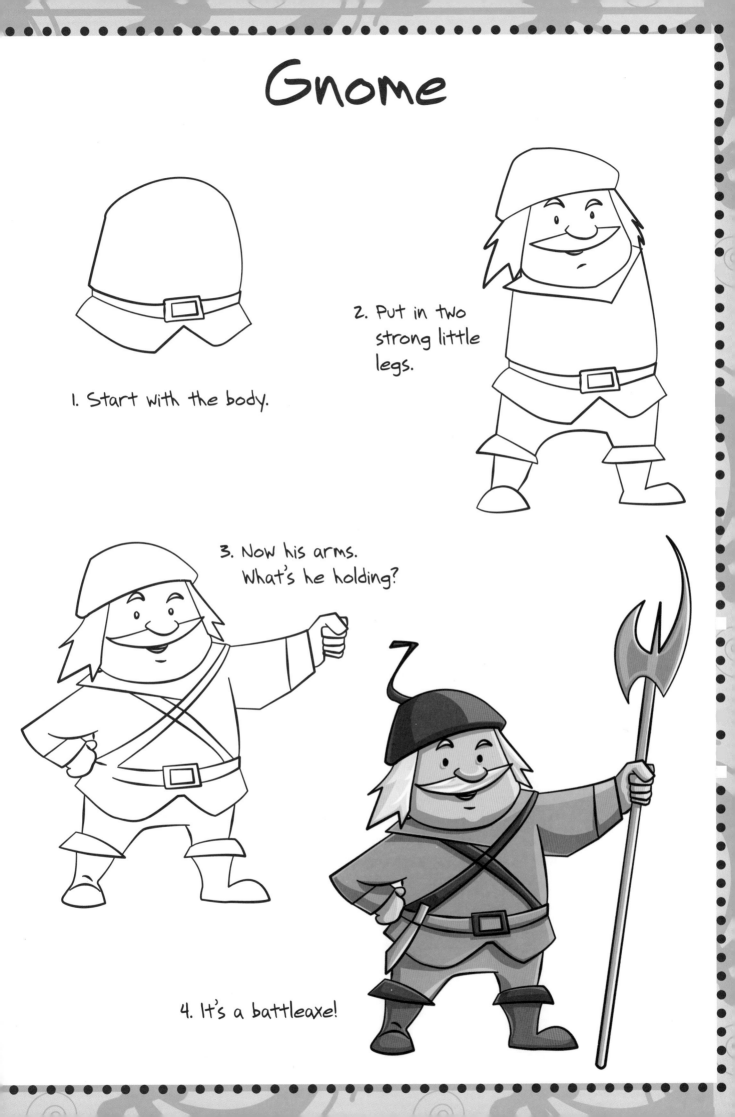

1. Start with the body.

2. Put in two strong little legs.

3. Now his arms. What's he holding?

4. It's a battleaxe!

Centaur

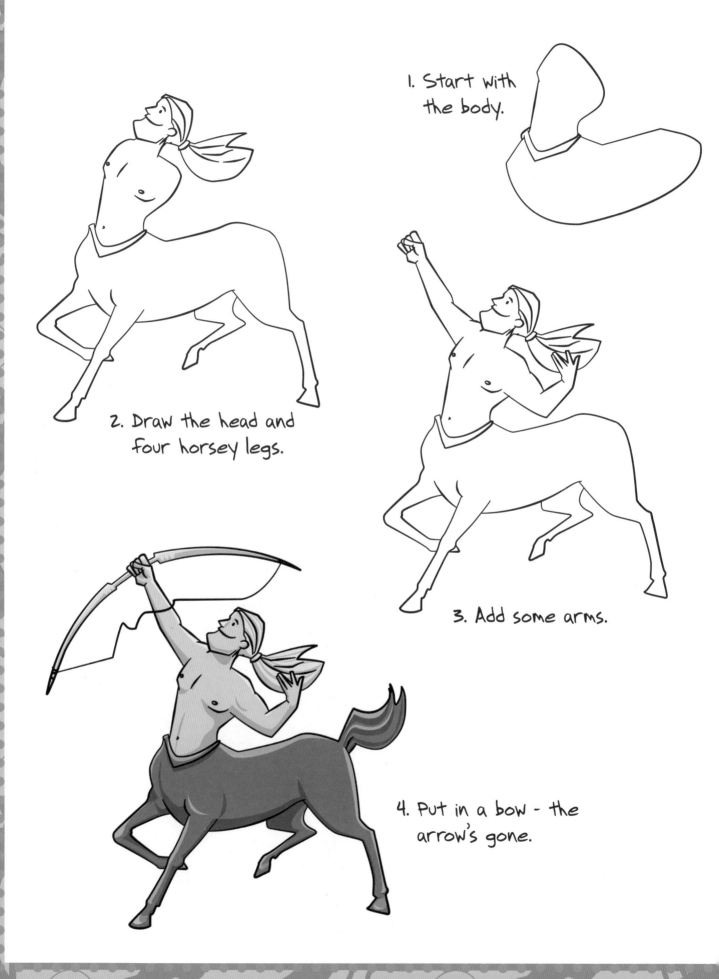

1. Start with the body.

2. Draw the head and four horsey legs.

3. Add some arms.

4. Put in a bow - the arrow's gone.

Witch

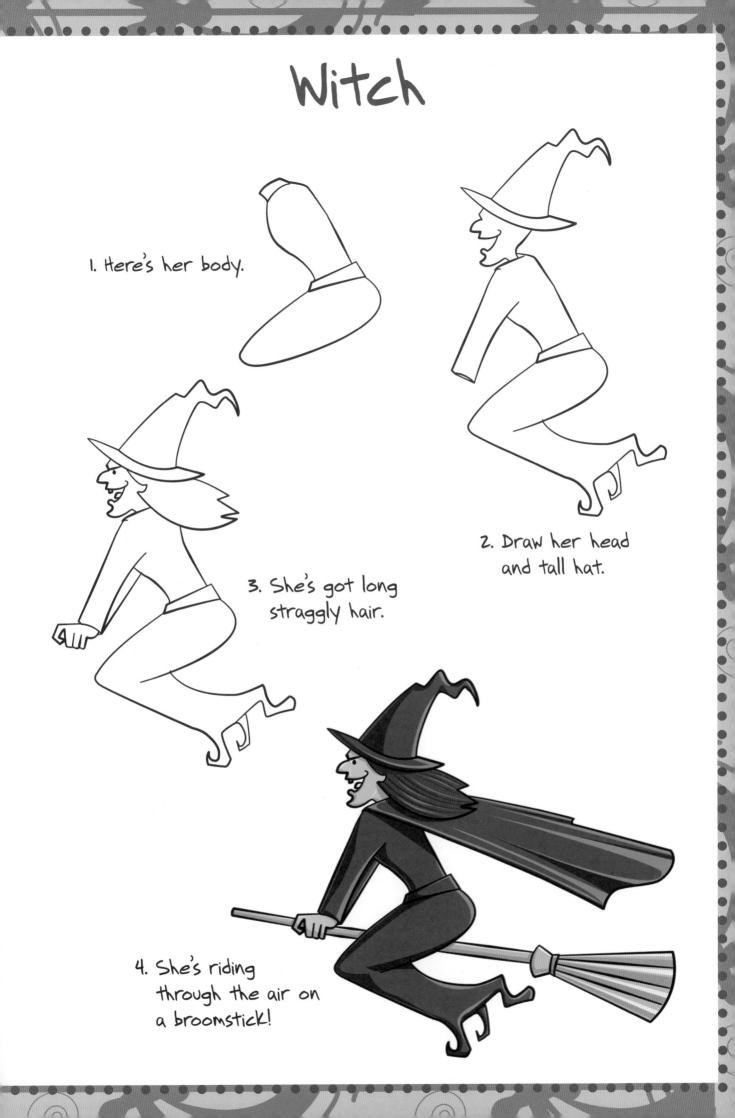

1. Here's her body.

2. Draw her head and tall hat.

3. She's got long straggly hair.

4. She's riding through the air on a broomstick!

Superhero

1. Draw his body.

2. Add his strong arms.

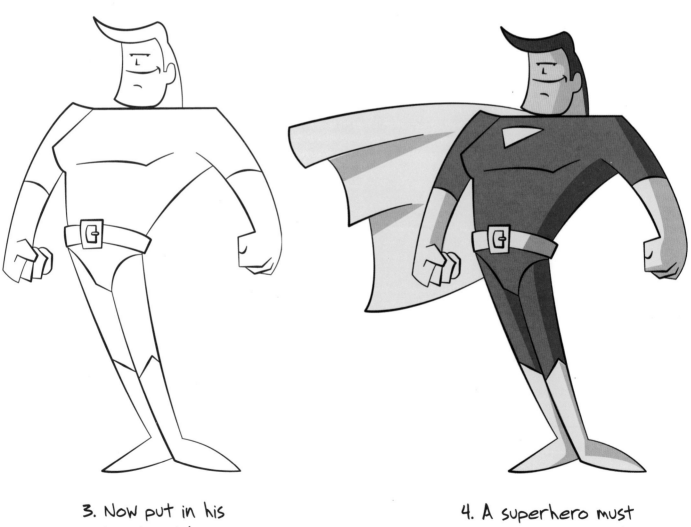

3. Now put in his head and legs.

4. A superhero must have a big cape!

Griffin

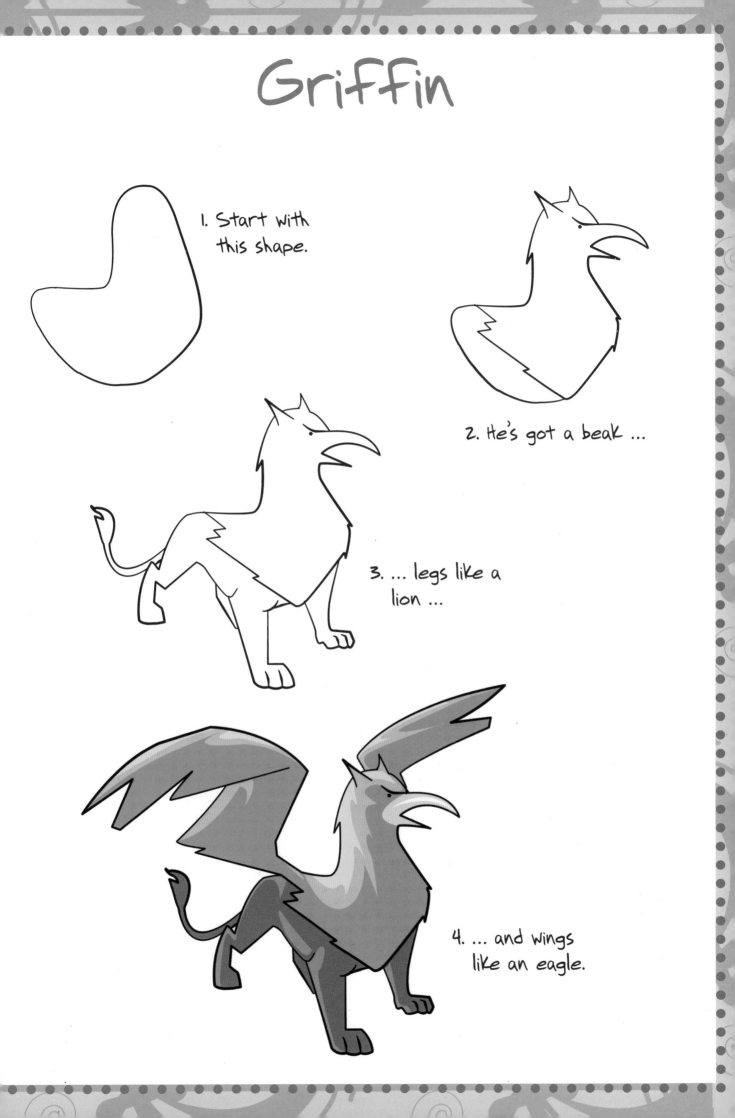

1. Start with this shape.

2. He's got a beak ...

3. ... legs like a lion ...

4. ... and wings like an eagle.

Medusa

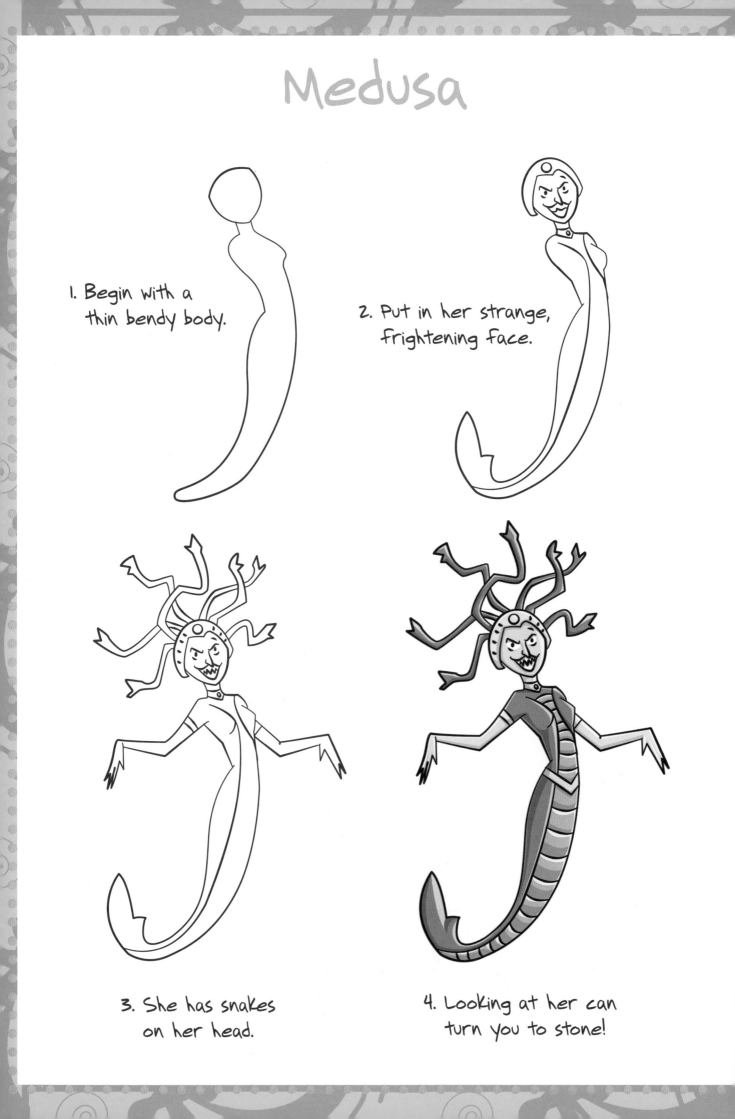

1. Begin with a thin bendy body.

2. Put in her strange, frightening face.

3. She has snakes on her head.

4. Looking at her can turn you to stone!

Unicorn

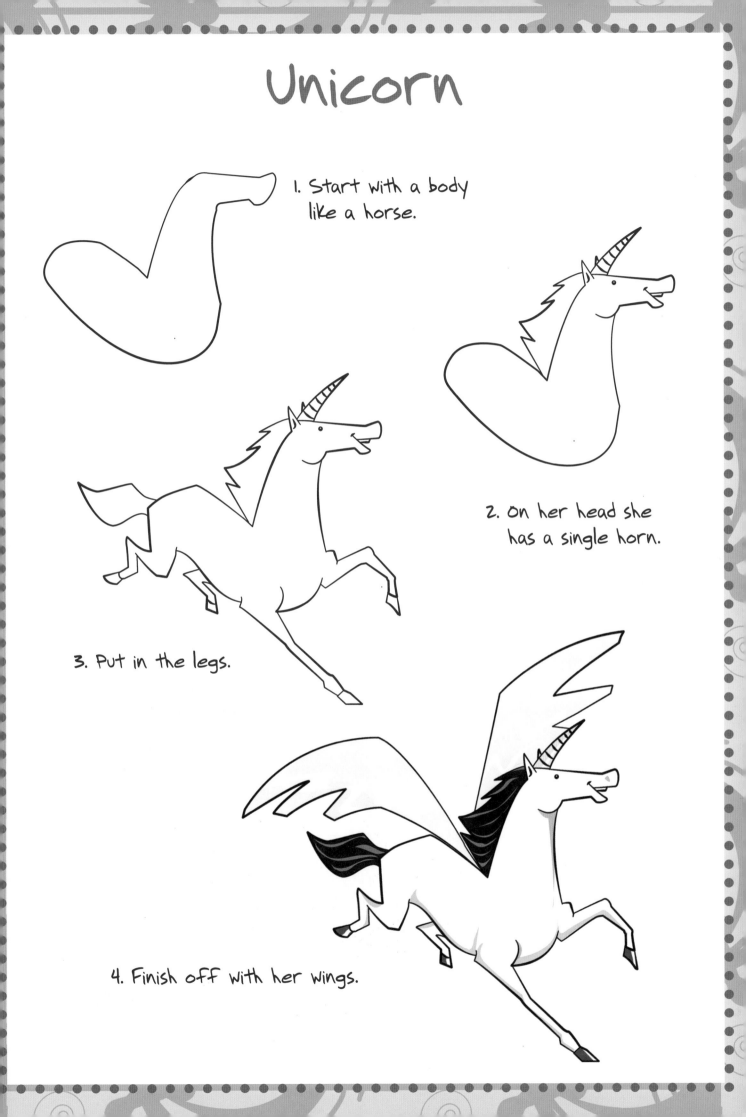

1. Start with a body like a horse.

2. On her head she has a single horn.

3. Put in the legs.

4. Finish off with her wings.

Sphinx

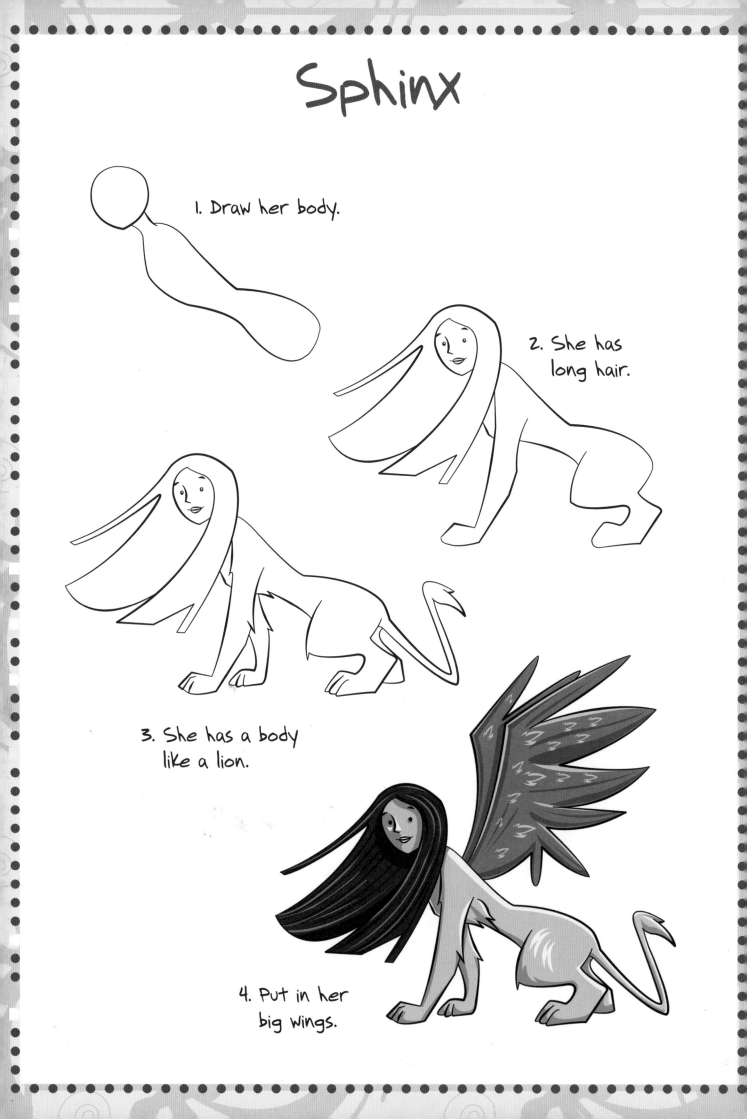

1. Draw her body.

2. She has long hair.

3. She has a body like a lion.

4. Put in her big wings.

WILD ANIMALS

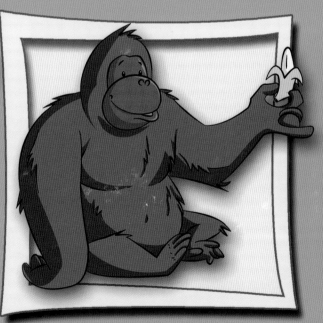

Hyena

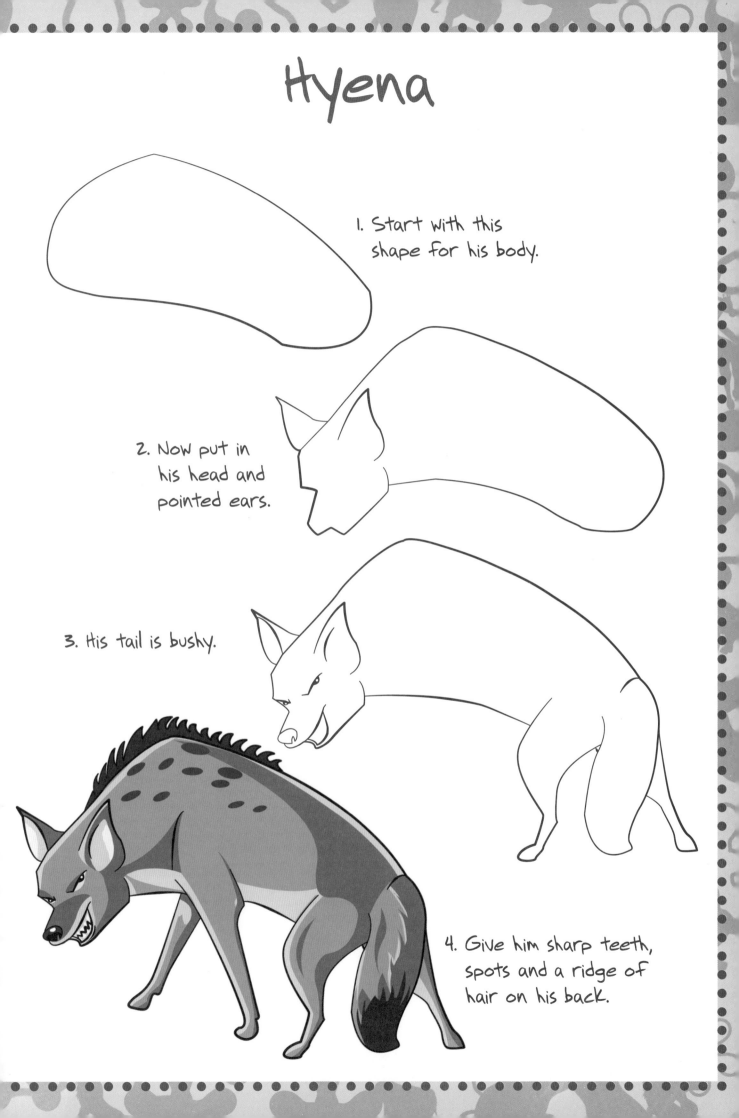

1. Start with this shape for his body.

2. Now put in his head and pointed ears.

3. His tail is bushy.

4. Give him sharp teeth, spots and a ridge of hair on his back.

Dolphin

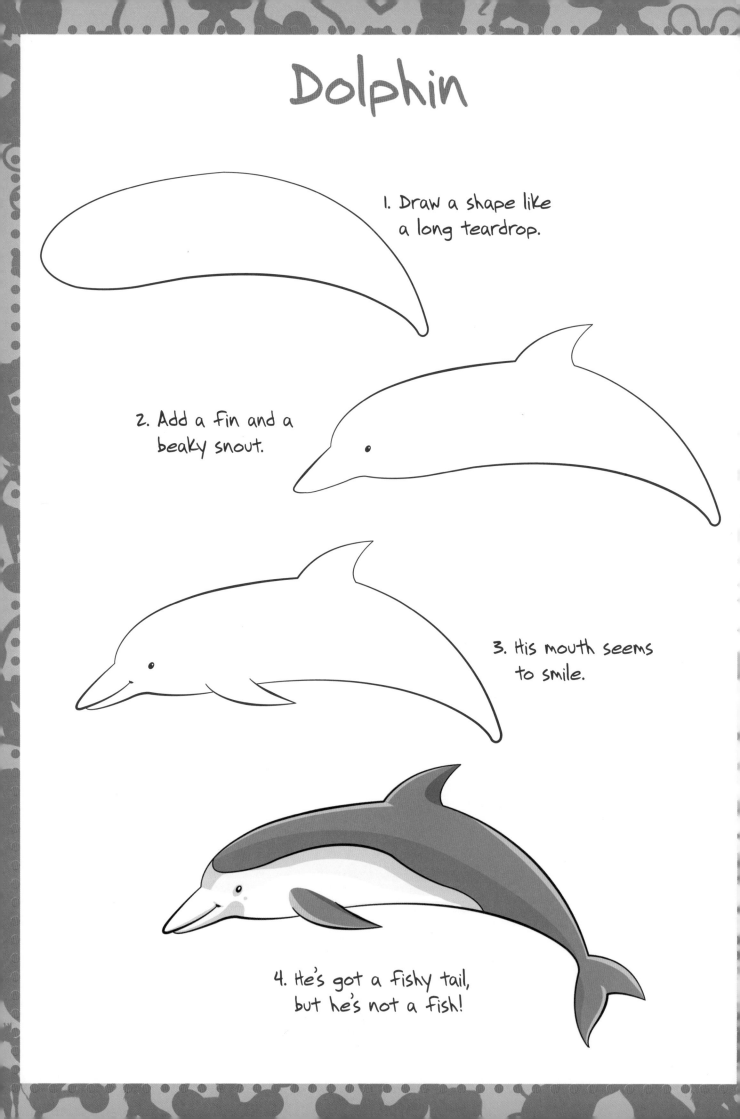

1. Draw a shape like a long teardrop.

2. Add a fin and a beaky snout.

3. His mouth seems to smile.

4. He's got a fishy tail, but he's not a fish!

Lion

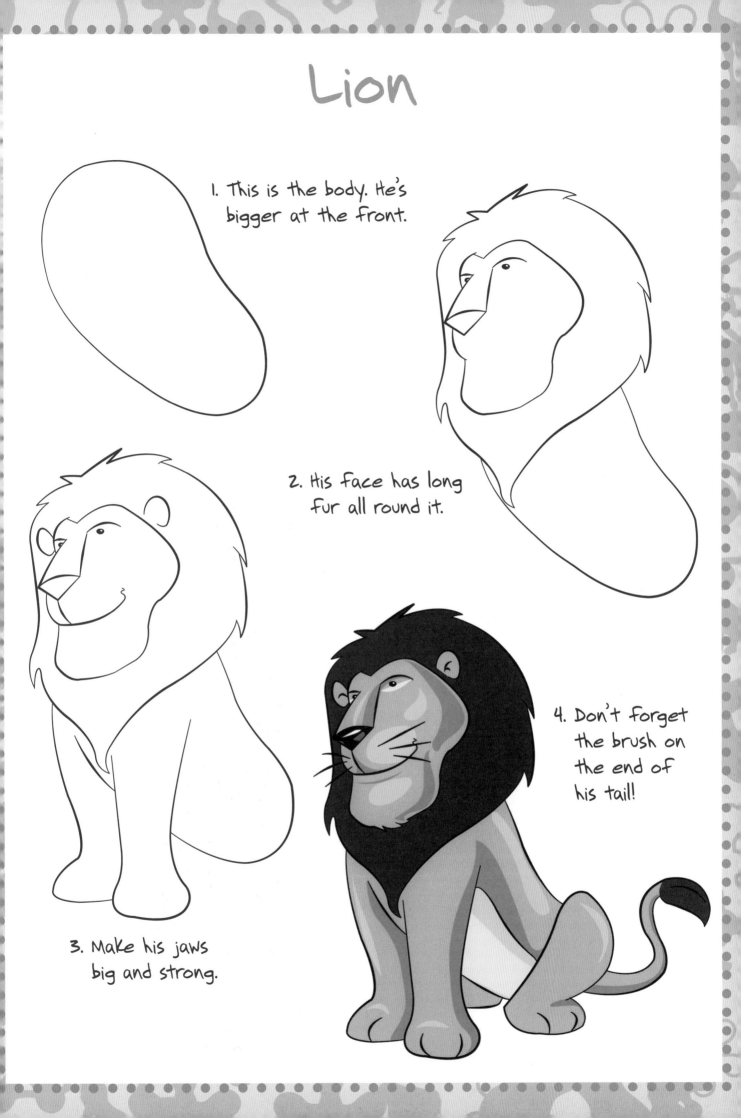

1. This is the body. He's bigger at the front.

2. His face has long fur all round it.

3. Make his jaws big and strong.

4. Don't forget the brush on the end of his tail!

Giraffe

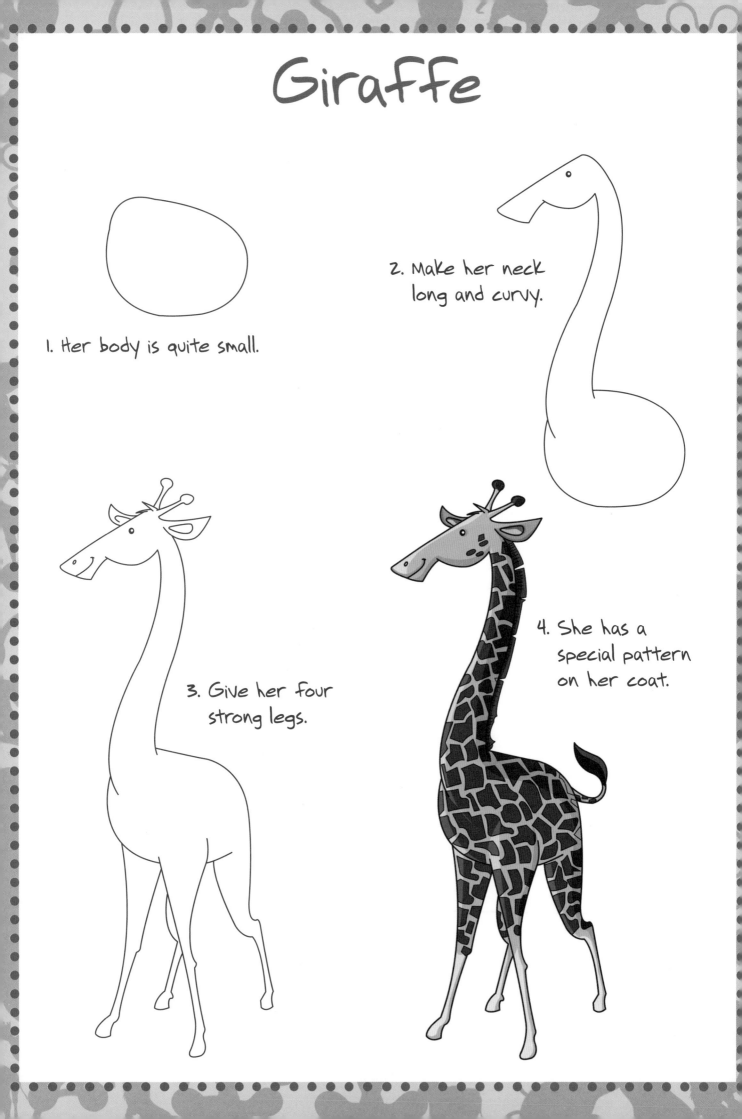

1. Her body is quite small.

2. Make her neck long and curvy.

3. Give her four strong legs.

4. She has a special pattern on her coat.

Rhinoceros

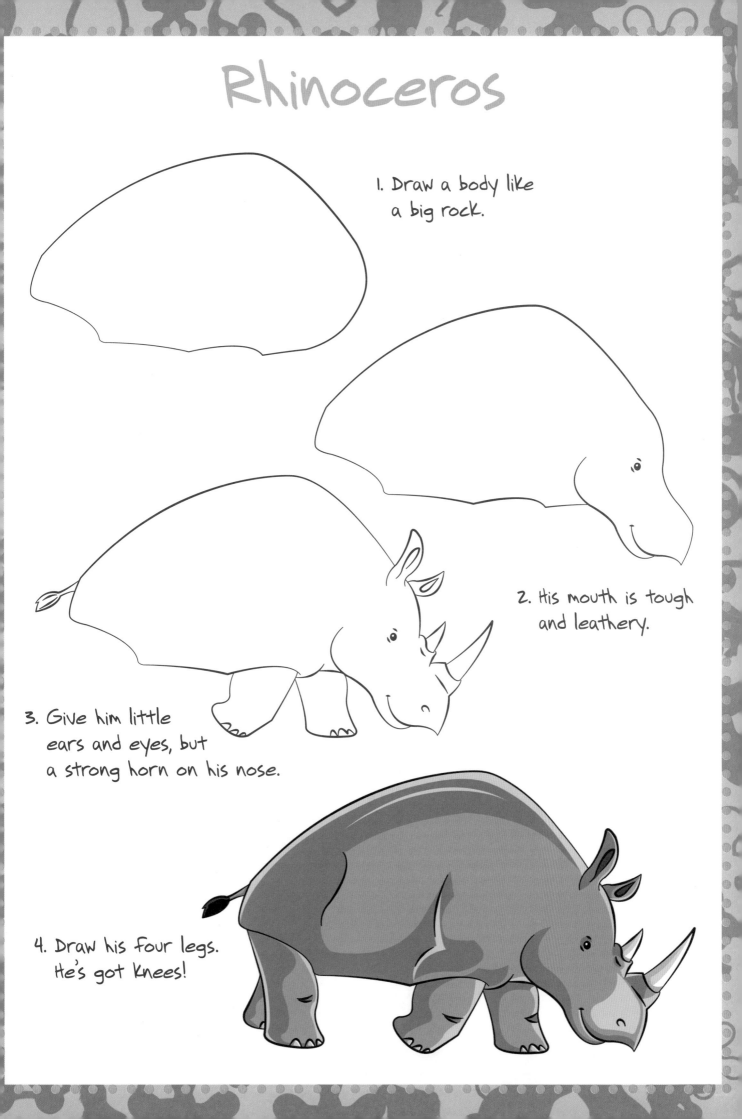

1. Draw a body like a big rock.

2. His mouth is tough and leathery.

3. Give him little ears and eyes, but a strong horn on his nose.

4. Draw his four legs. He's got knees!

Gorilla

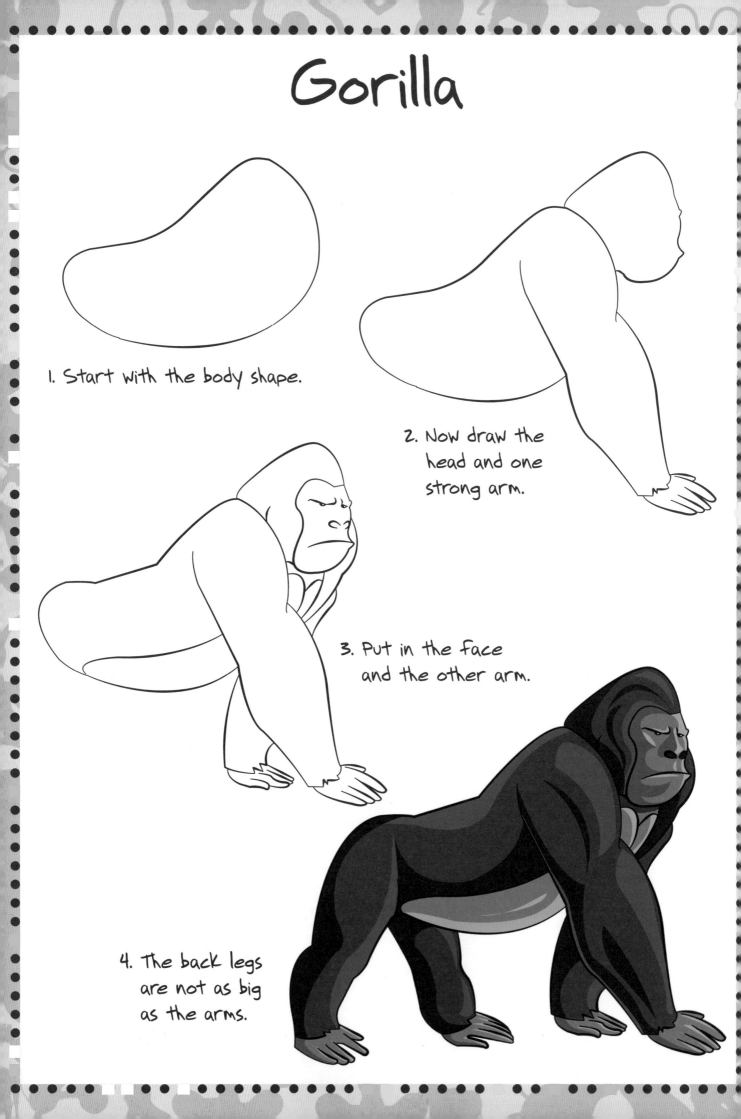

1. Start with the body shape.

2. Now draw the head and one strong arm.

3. Put in the face and the other arm.

4. The back legs are not as big as the arms.

Whale

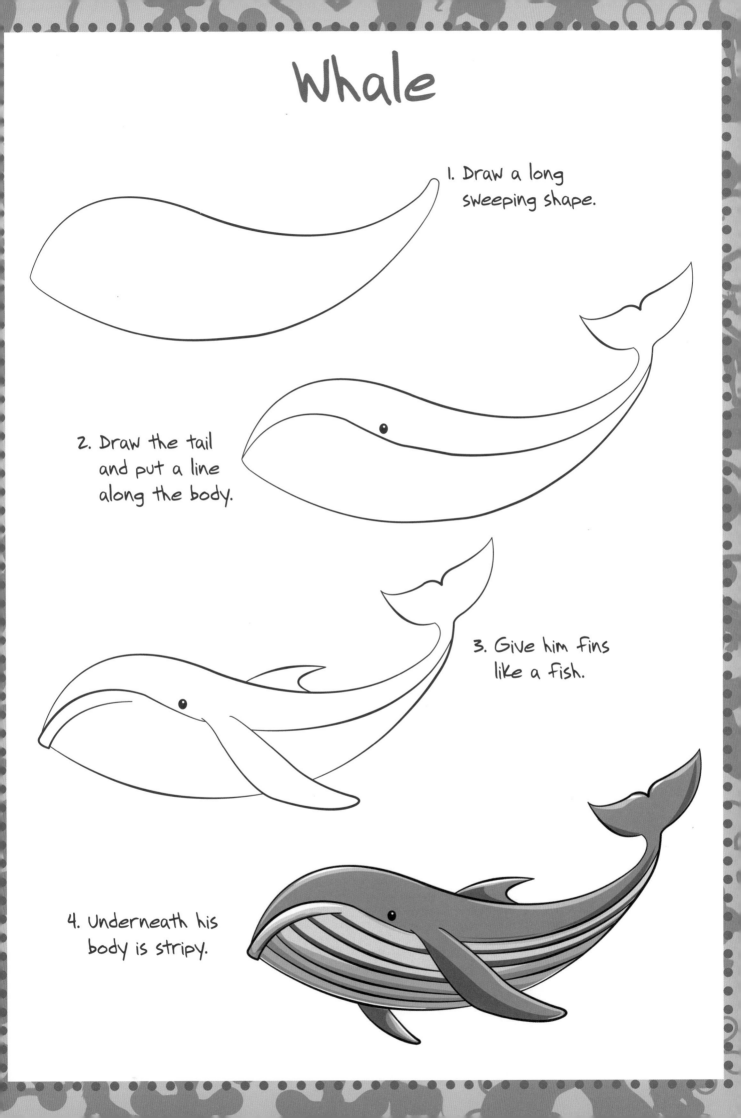

1. Draw a long sweeping shape.

2. Draw the tail and put a line along the body.

3. Give him fins like a fish.

4. Underneath his body is stripy.

Shark

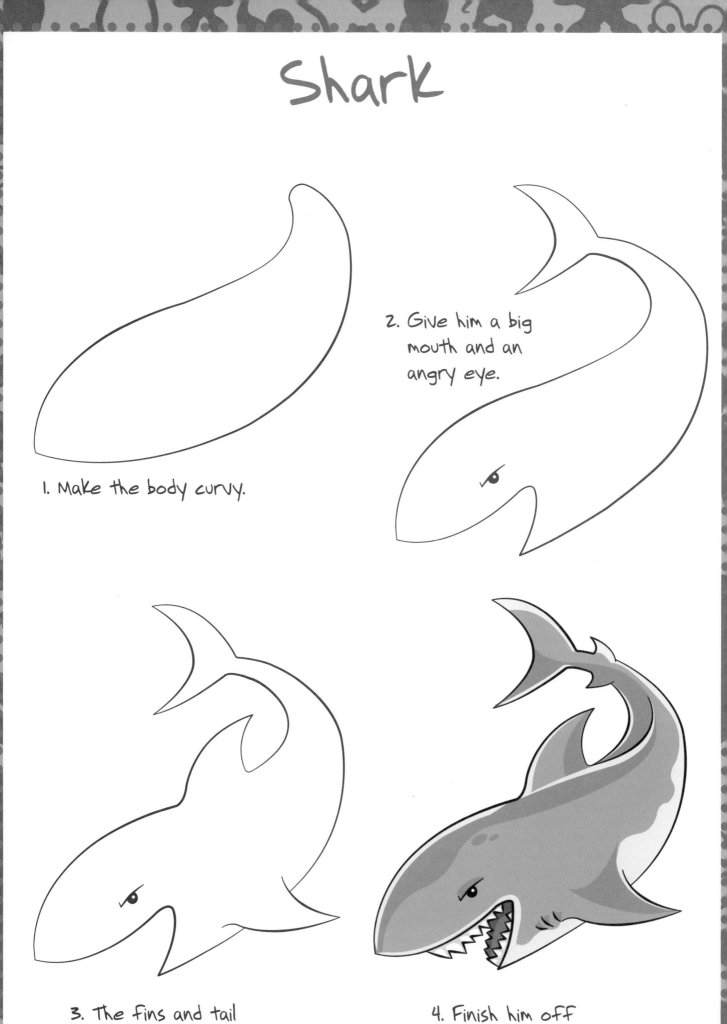

1. Make the body curvy.

2. Give him a big mouth and an angry eye.

3. The fins and tail are pointed.

4. Finish him off with sharp teeth.

Tiger

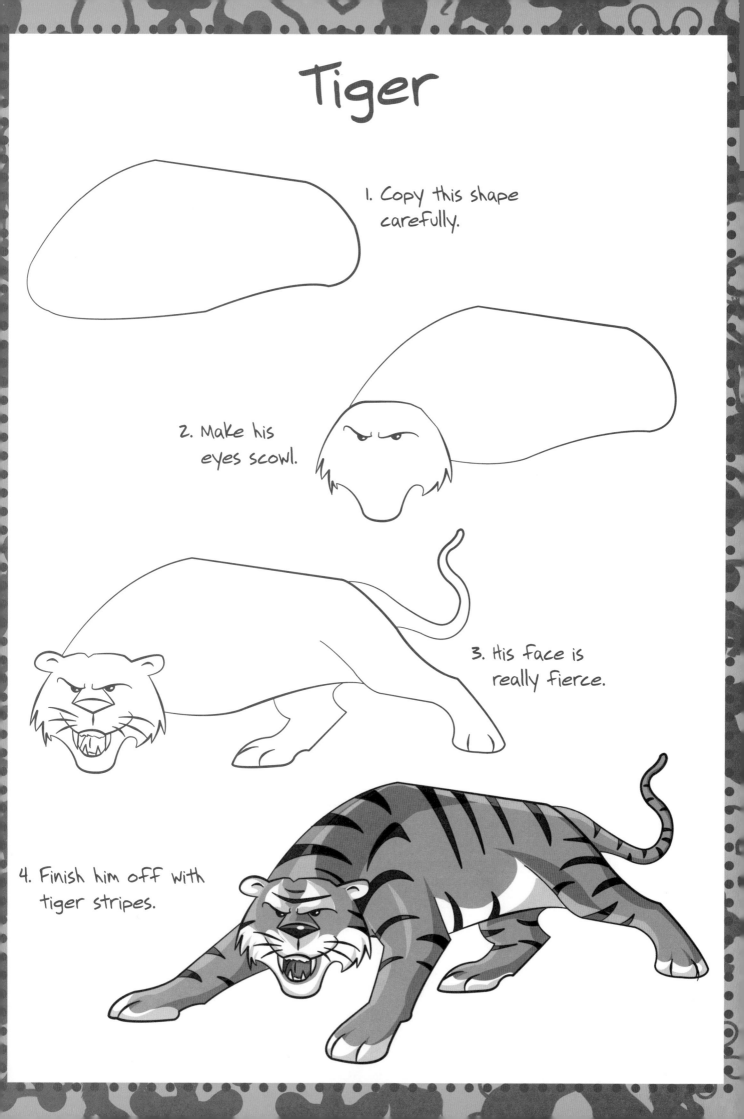

1. Copy this shape carefully.

2. Make his eyes scowl.

3. His face is really fierce.

4. Finish him off with tiger stripes.

Polar Bear

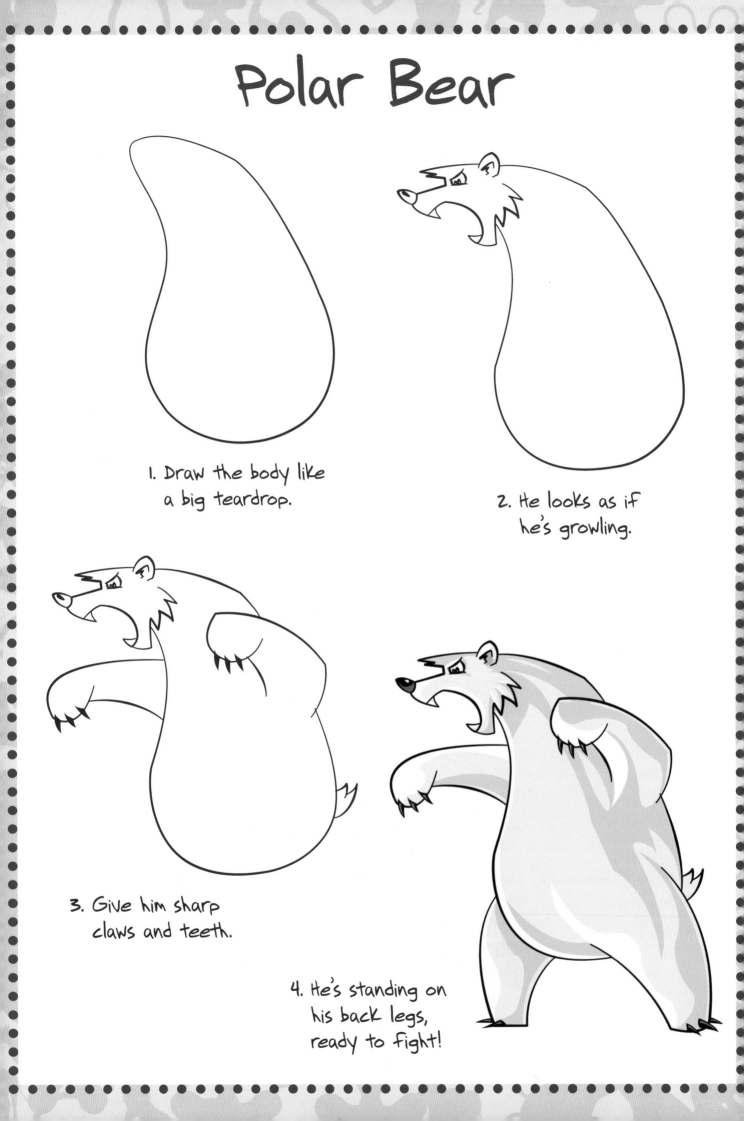

1. Draw the body like a big teardrop.

2. He looks as if he's growling.

3. Give him sharp claws and teeth.

4. He's standing on his back legs, ready to fight!

Elephant

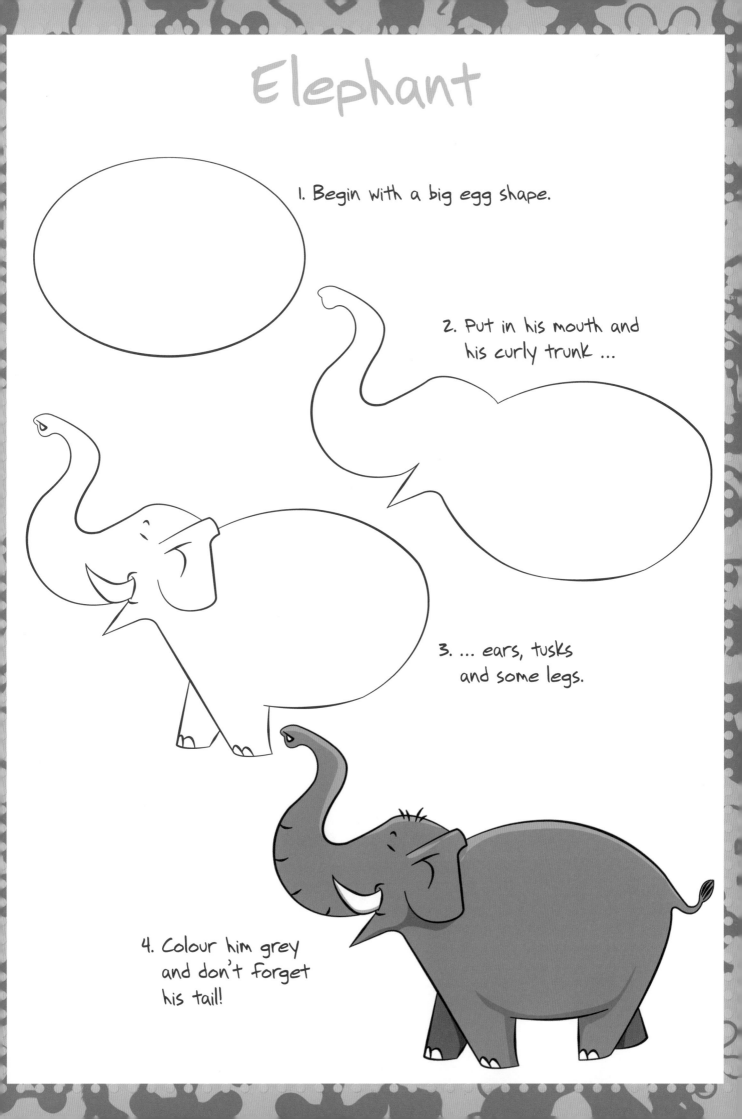

1. Begin with a big egg shape.

2. Put in his mouth and his curly trunk ...

3. ... ears, tusks and some legs.

4. Colour him grey and don't forget his tail!

Hippopotamus

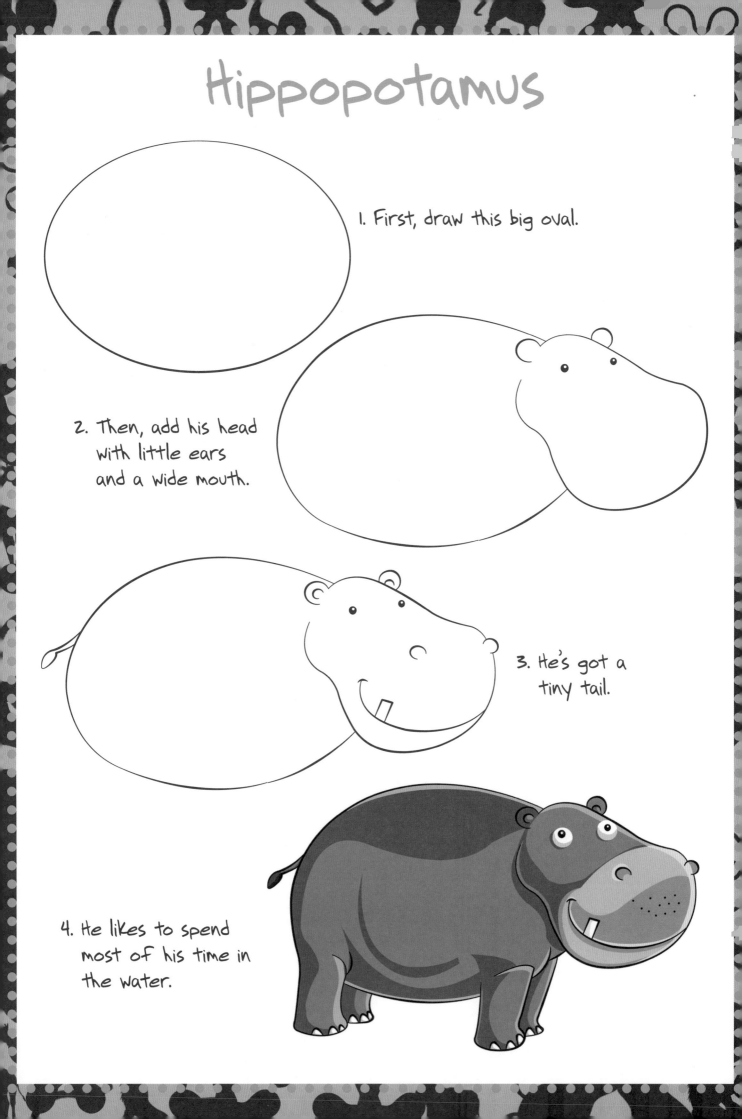

1. First, draw this big oval.

2. Then, add his head with little ears and a wide mouth.

3. He's got a tiny tail.

4. He likes to spend most of his time in the water.

Coyote

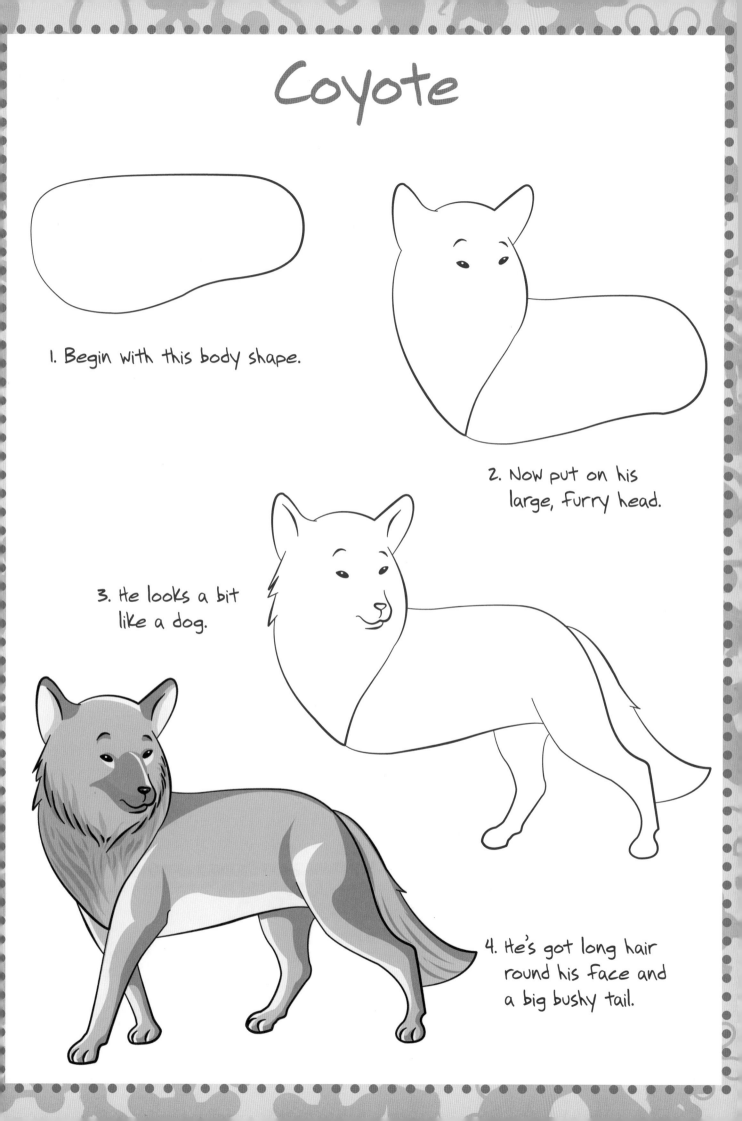

1. Begin with this body shape.

2. Now put on his large, furry head.

3. He looks a bit like a dog.

4. He's got long hair round his face and a big bushy tail.

Leopard

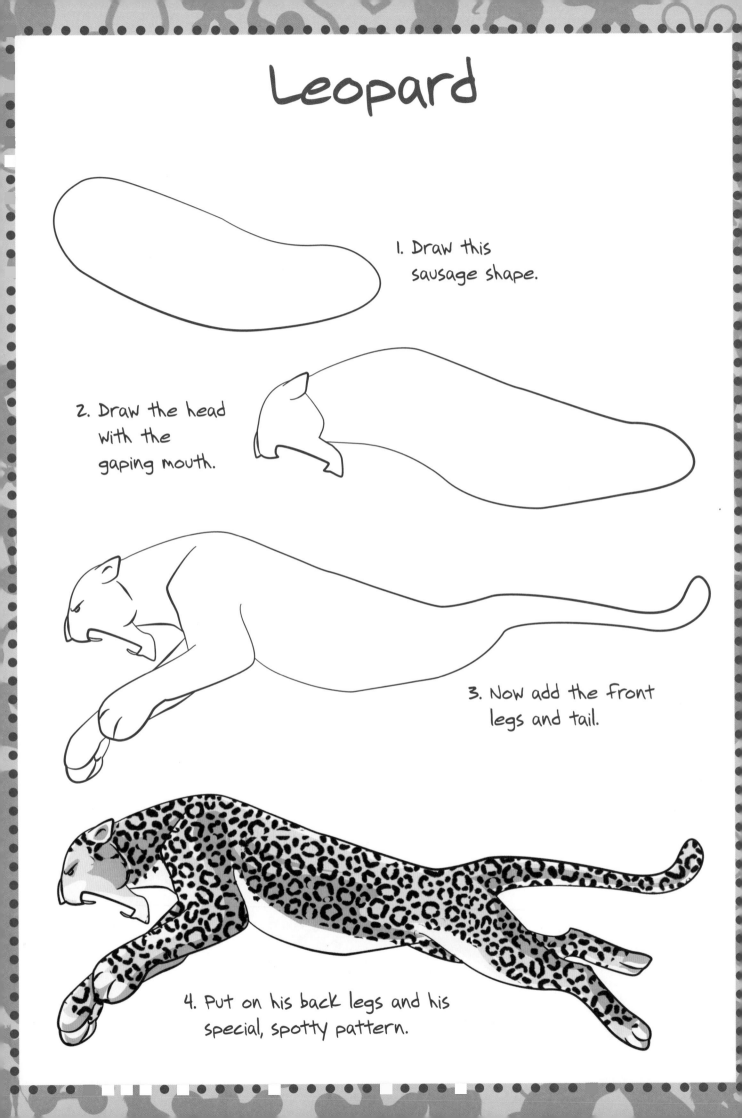

1. Draw this sausage shape.

2. Draw the head with the gaping mouth.

3. Now add the front legs and tail.

4. Put on his back legs and his special, spotty pattern.

orang-utan

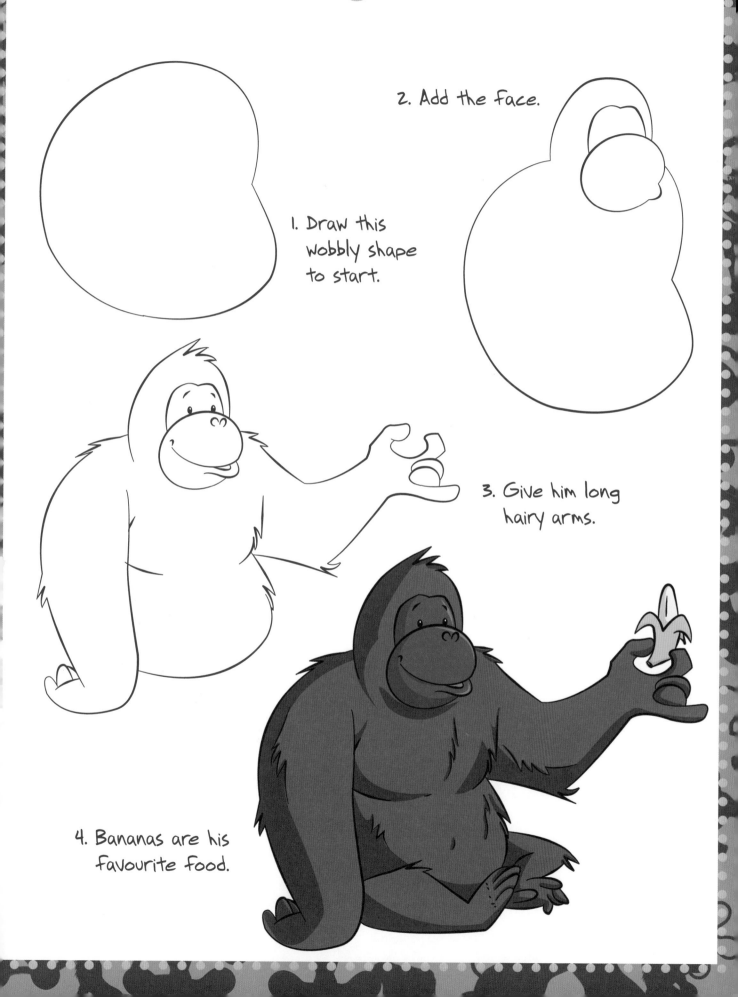

2. Add the face.

1. Draw this wobbly shape to start.

3. Give him long hairy arms.

4. Bananas are his favourite food.

Penguin

1. Draw this shape like a pointy egg.

2. Put the head on with its long beak.

3. Her wings are like flippers.

4. She looks very smart in black and white.

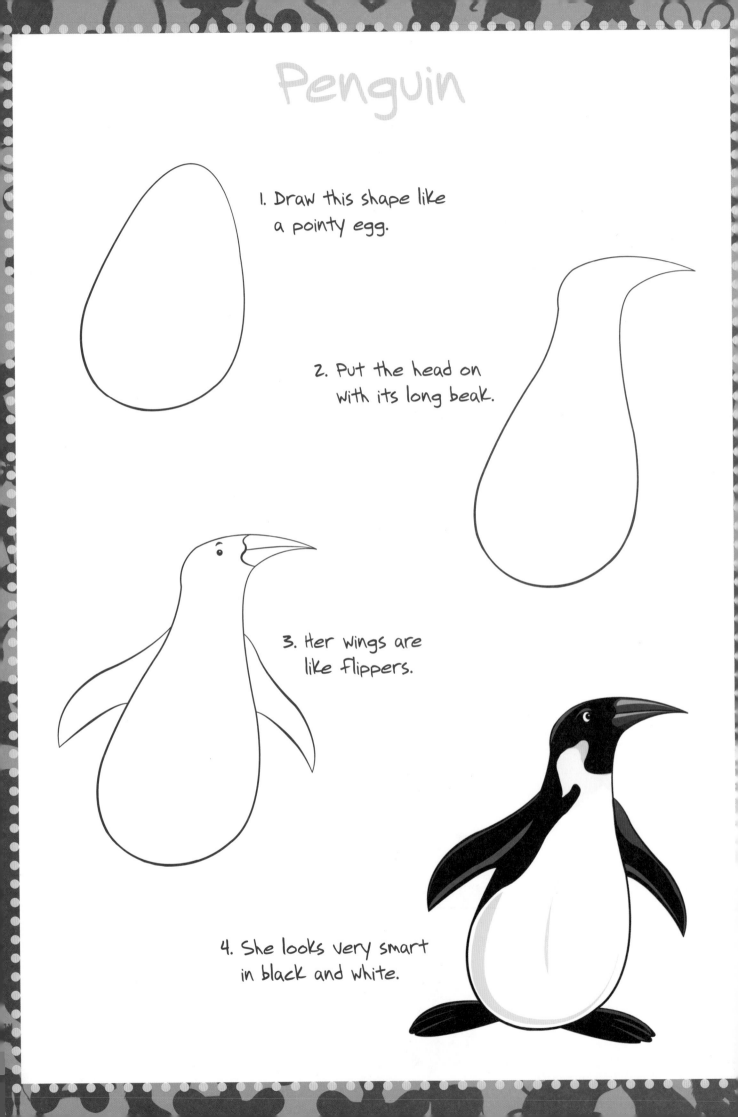

ACTION FIGURES

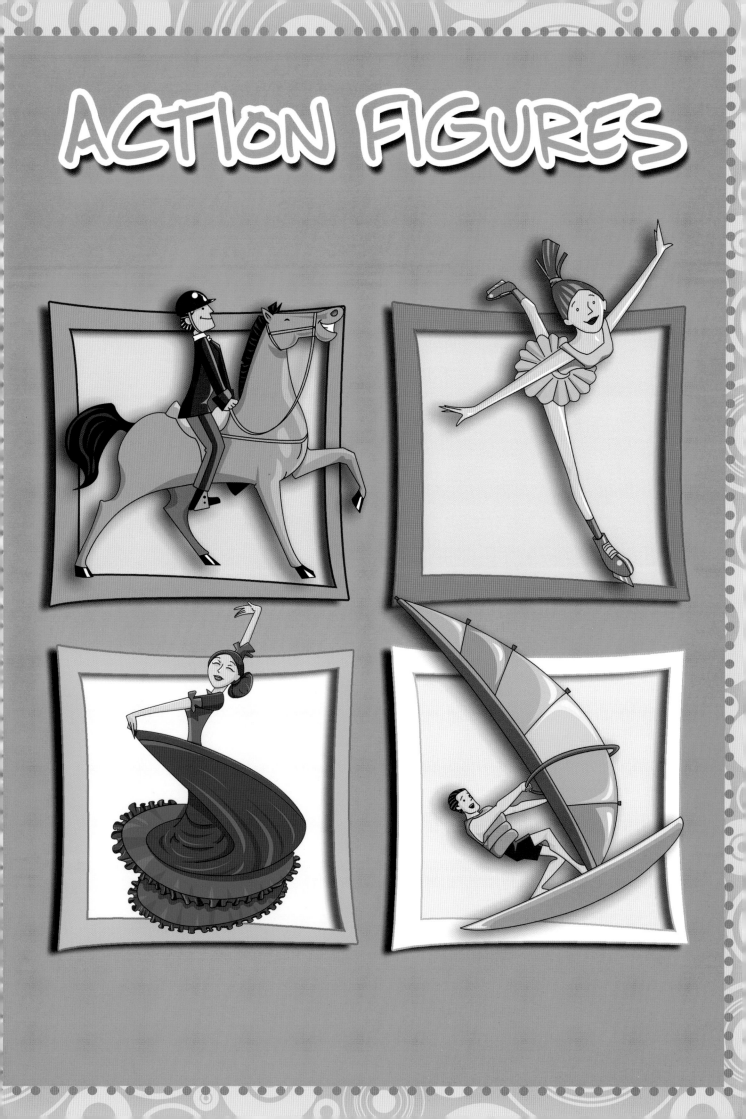

Gymnast

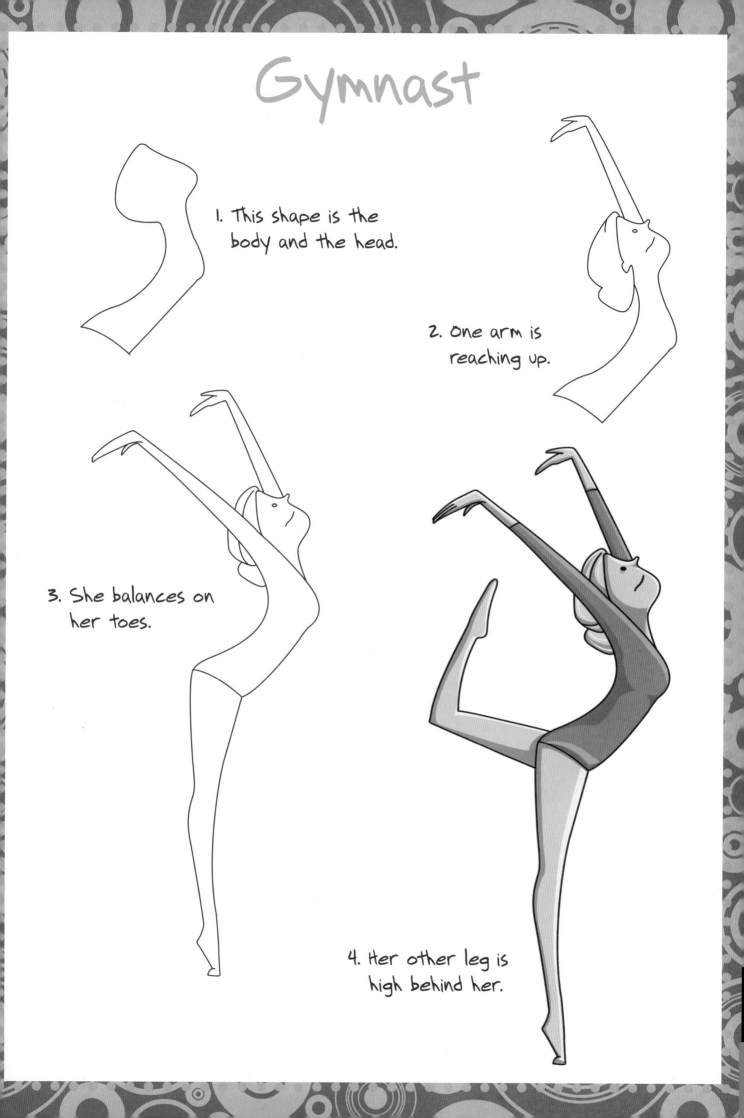

1. This shape is the body and the head.

2. One arm is reaching up.

3. She balances on her toes.

4. Her other leg is high behind her.

Ballet Dancer

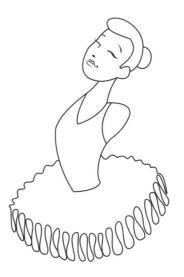

1. Draw her elegant body and frilly skirt.

2. Her hair is put up in a bun.

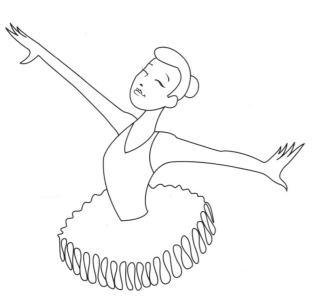

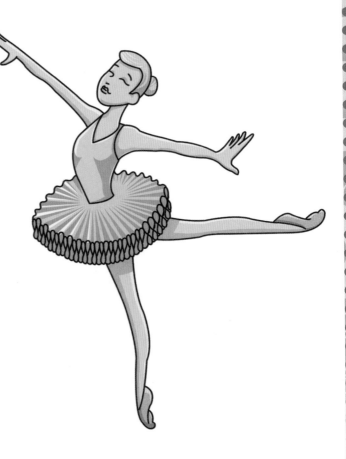

3. Her arms are held out wide for balance.

Horse Rider

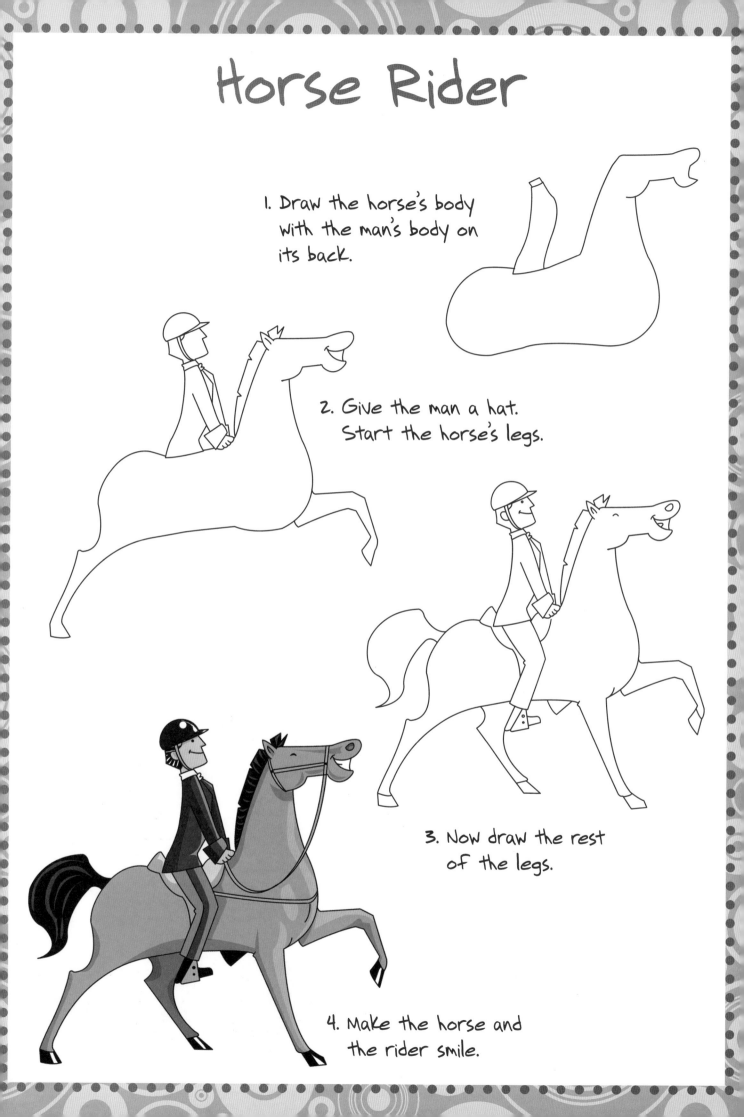

1. Draw the horse's body with the man's body on its back.

2. Give the man a hat. Start the horse's legs.

3. Now draw the rest of the legs.

4. Make the horse and the rider smile.

Skateboarder

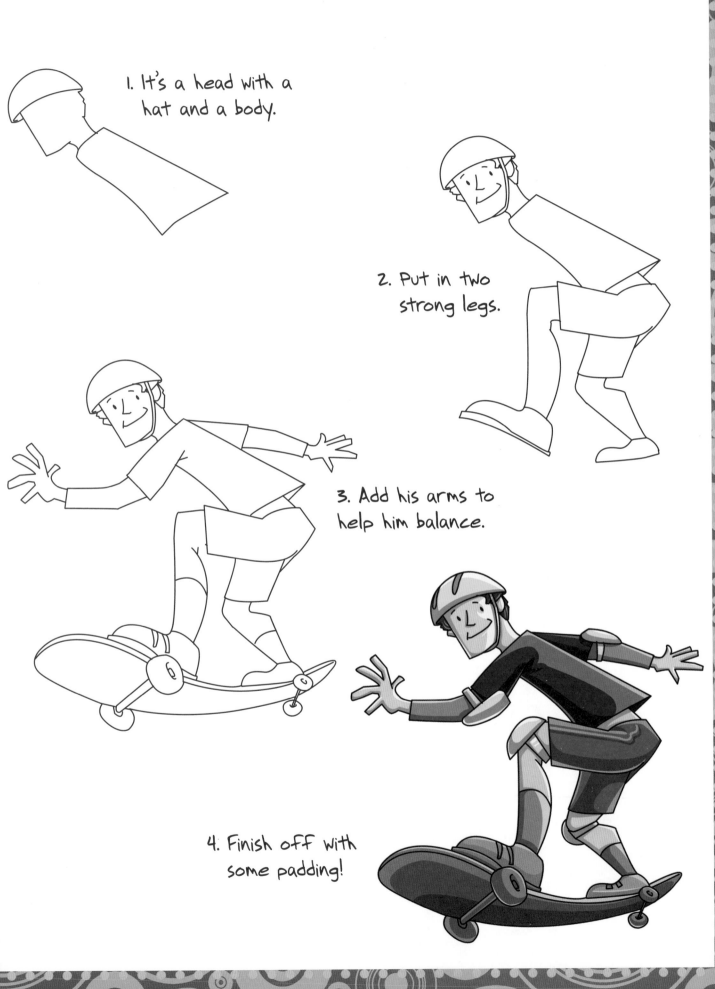

1. It's a head with a hat and a body.

2. Put in two strong legs.

3. Add his arms to help him balance.

4. Finish off with some padding!

Hang Glider

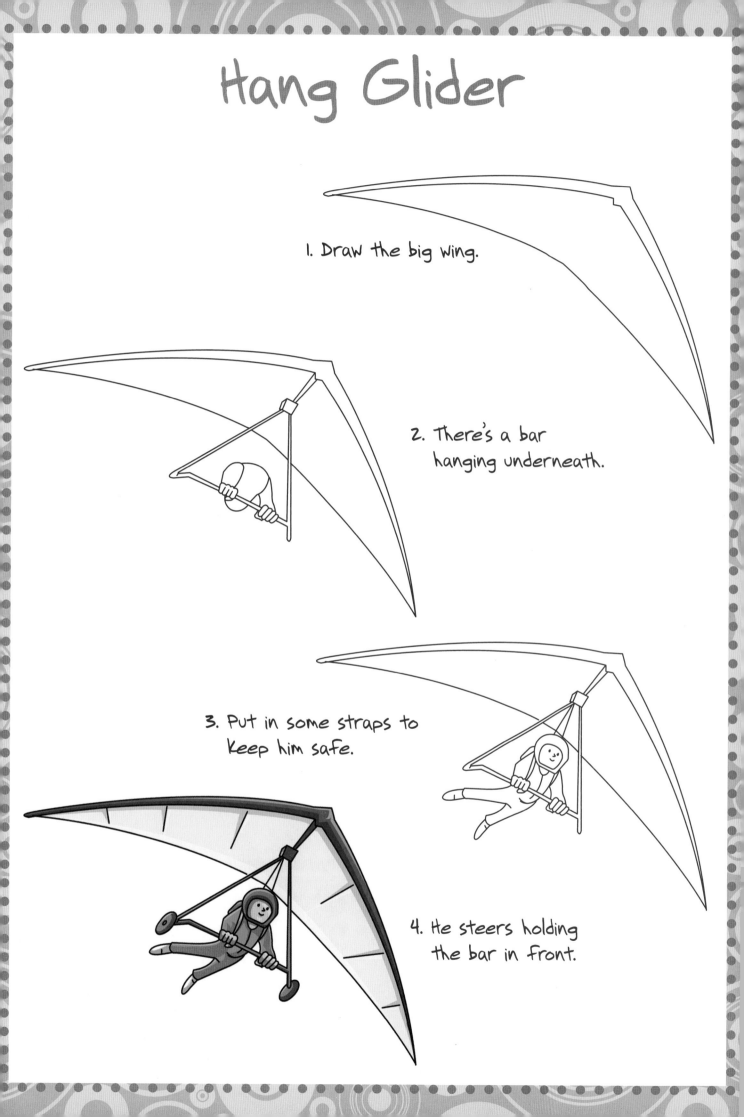

1. Draw the big wing.

2. There's a bar hanging underneath.

3. Put in some straps to keep him safe.

4. He steers holding the bar in front.

Flamenco dancer

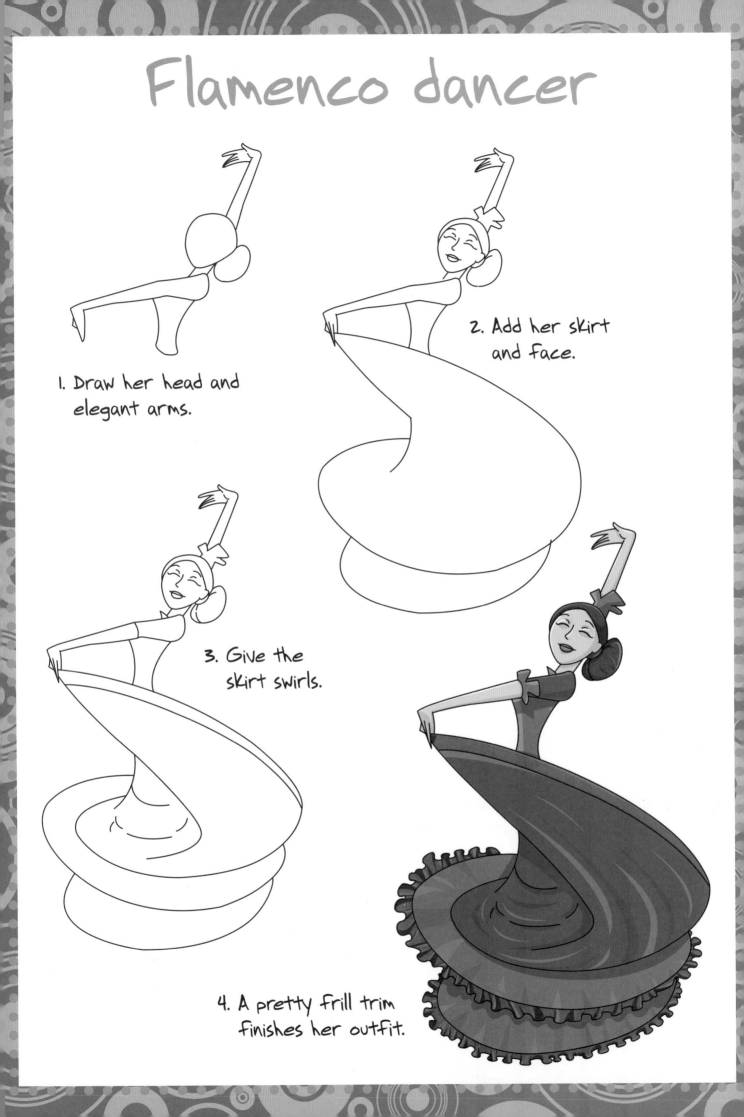

1. Draw her head and elegant arms.

2. Add her skirt and face.

3. Give the skirt swirls.

4. A pretty frill trim finishes her outfit.

Windsurfer

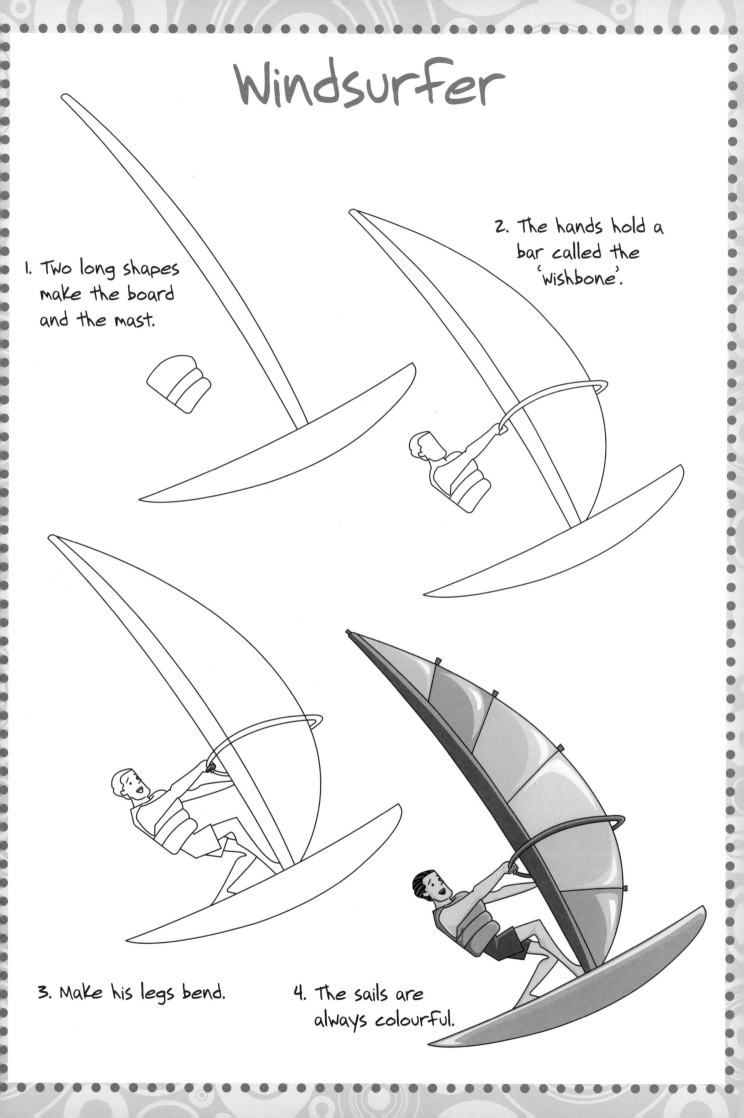

1. Two long shapes make the board and the mast.

2. The hands hold a bar called the 'wishbone'.

3. Make his legs bend.

4. The sails are always colourful.

Roller Skater

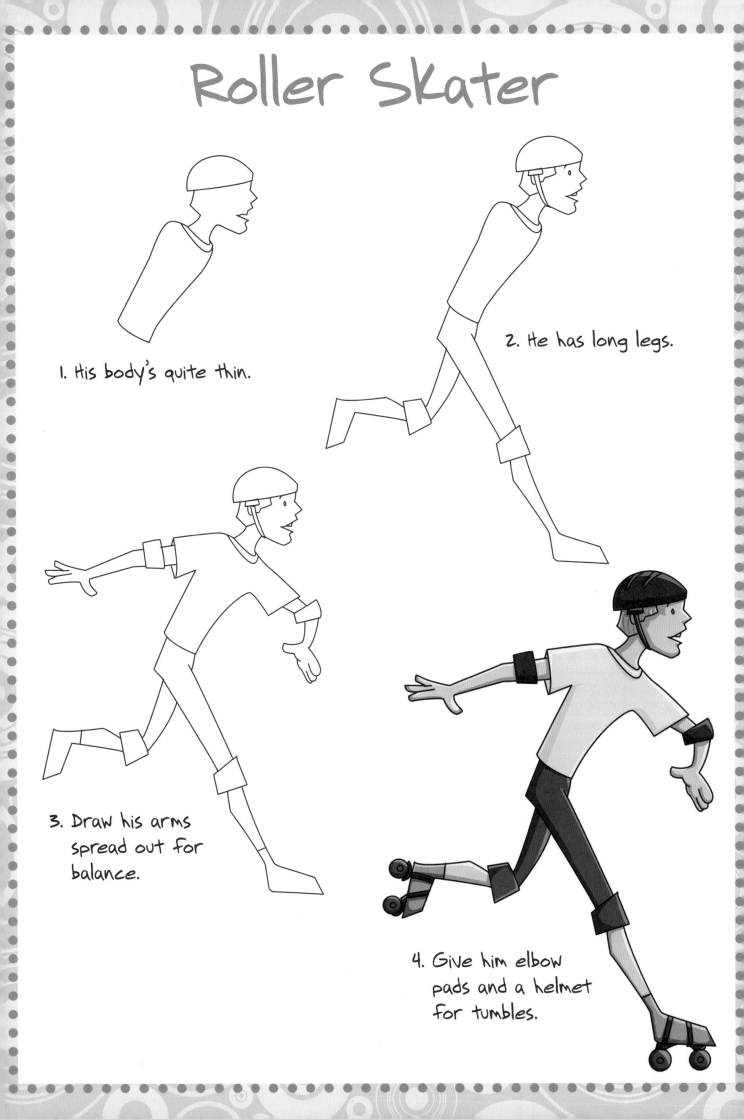

1. His body's quite thin.

2. He has long legs.

3. Draw his arms spread out for balance.

4. Give him elbow pads and a helmet for tumbles.

Tennis Player

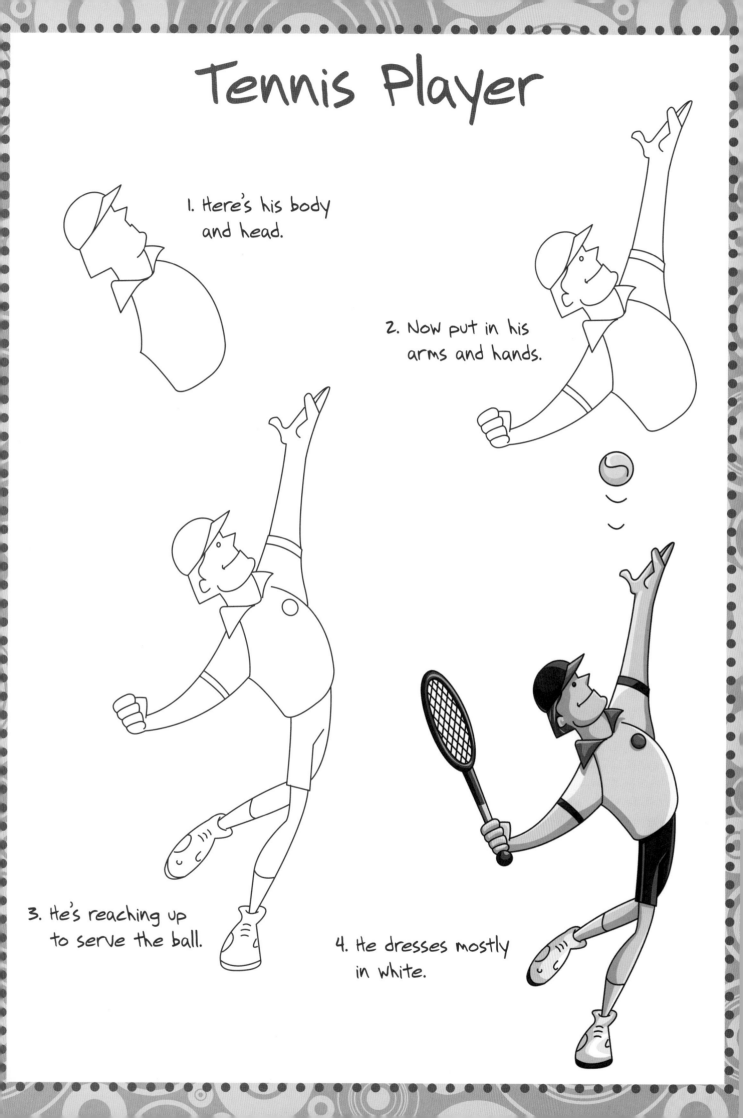

1. Here's his body and head.

2. Now put in his arms and hands.

3. He's reaching up to serve the ball.

4. He dresses mostly in white.

Soldier

1. Start with the top of the body.

2. He's got a pack, a helmet and a gun.

3. He's kneeling down to shoot.

4. Finish him in camouflage colours.

Footballer

1. Draw the body first.

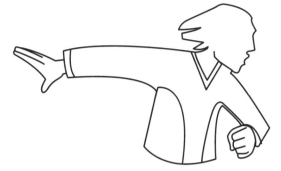

2. Put on his head and arms.

3. His legs show he's not touching the ground.

4. Don't forget the football!

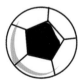

Baseball Player

1. Draw his arms and the top of his body.

2. Add his head.

3. Put in his long legs.

4. He's just hit the ball!

Deep Sea Diver

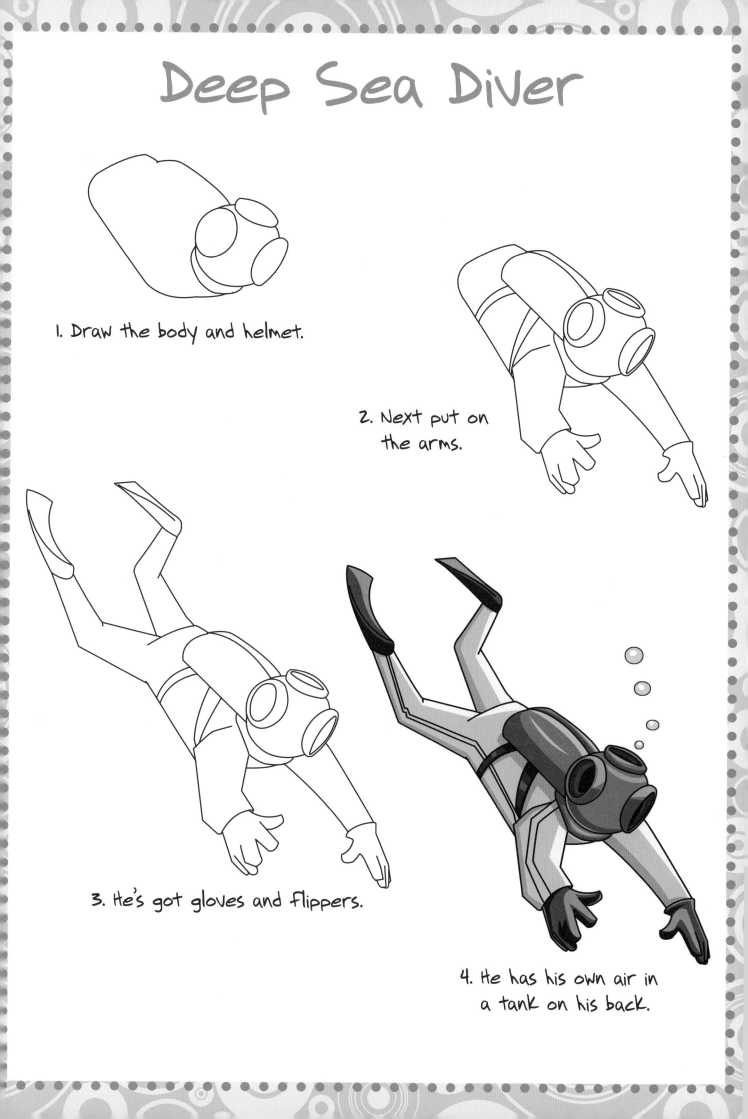

1. Draw the body and helmet.

2. Next put on the arms.

3. He's got gloves and flippers.

4. He has his own air in a tank on his back.

Boxer

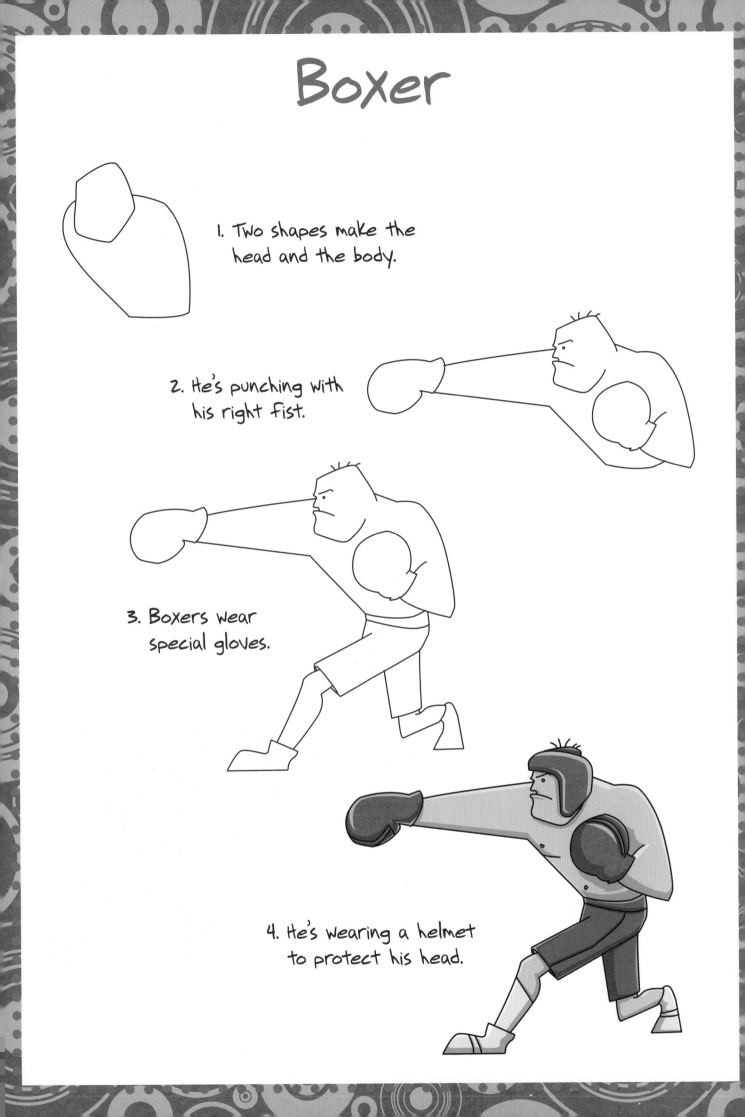

1. Two shapes make the head and the body.

2. He's punching with his right fist.

3. Boxers wear special gloves.

4. He's wearing a helmet to protect his head.

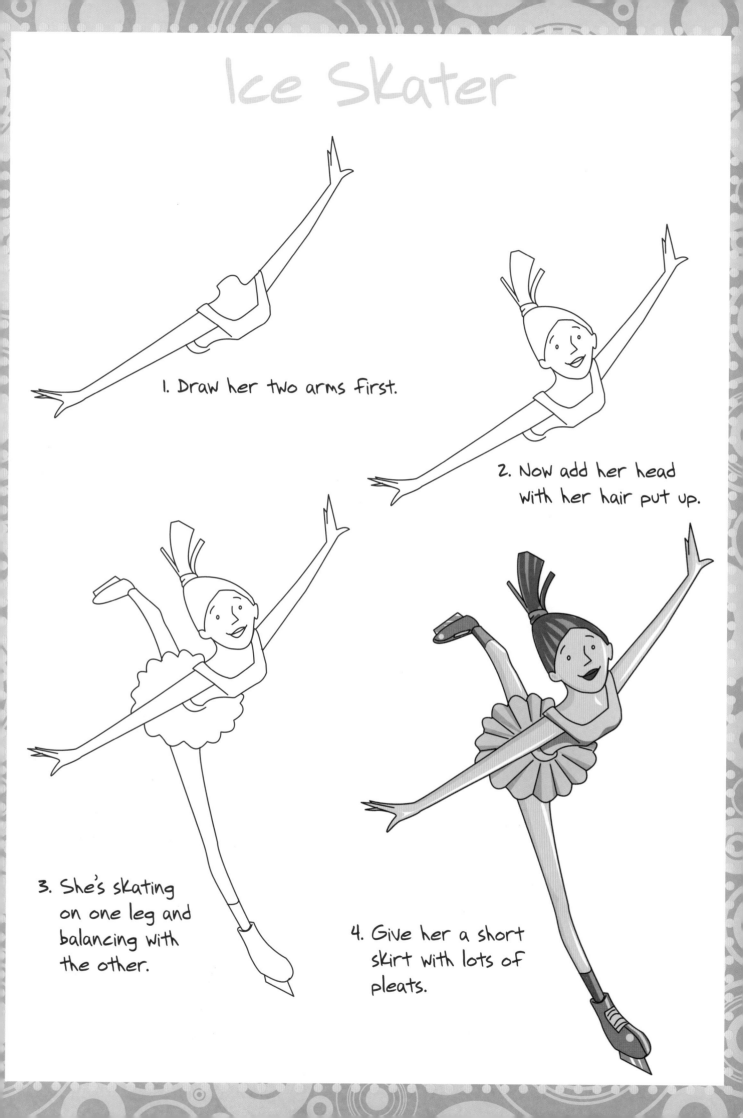

Ice Skater

1. Draw her two arms first.

2. Now add her head with her hair put up.

3. She's skating on one leg and balancing with the other.

4. Give her a short skirt with lots of pleats.

Cricketer

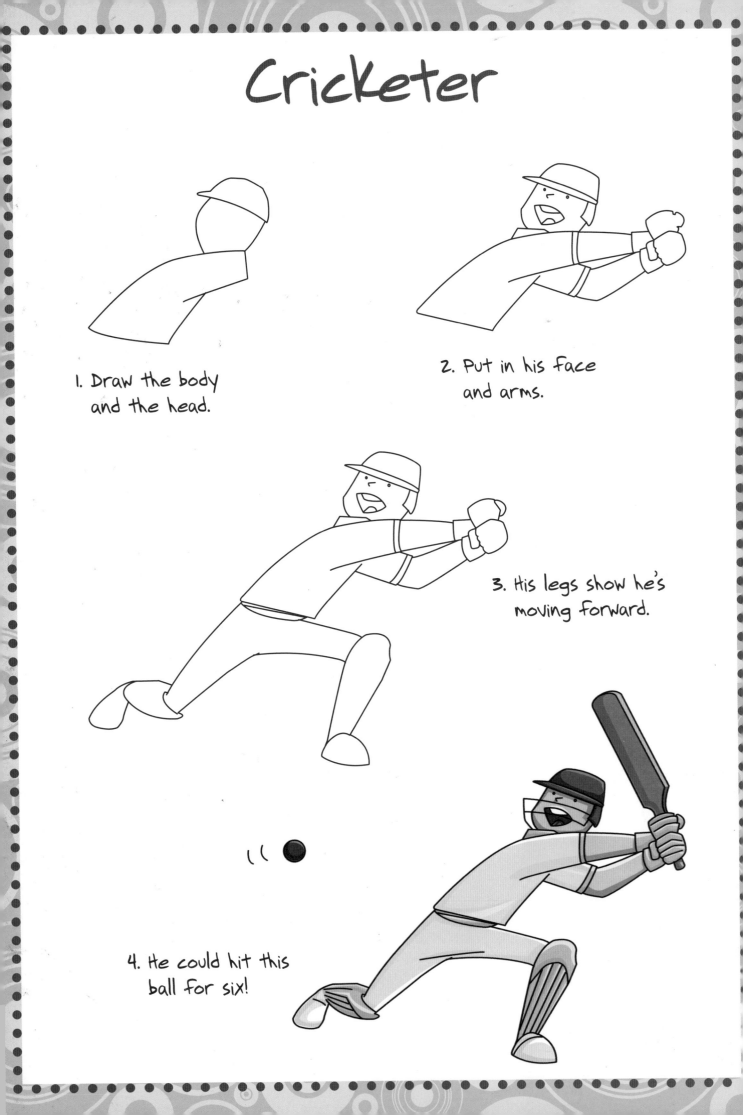

1. Draw the body and the head.

2. Put in his face and arms.

3. His legs show he's moving forward.

4. He could hit this ball for six!

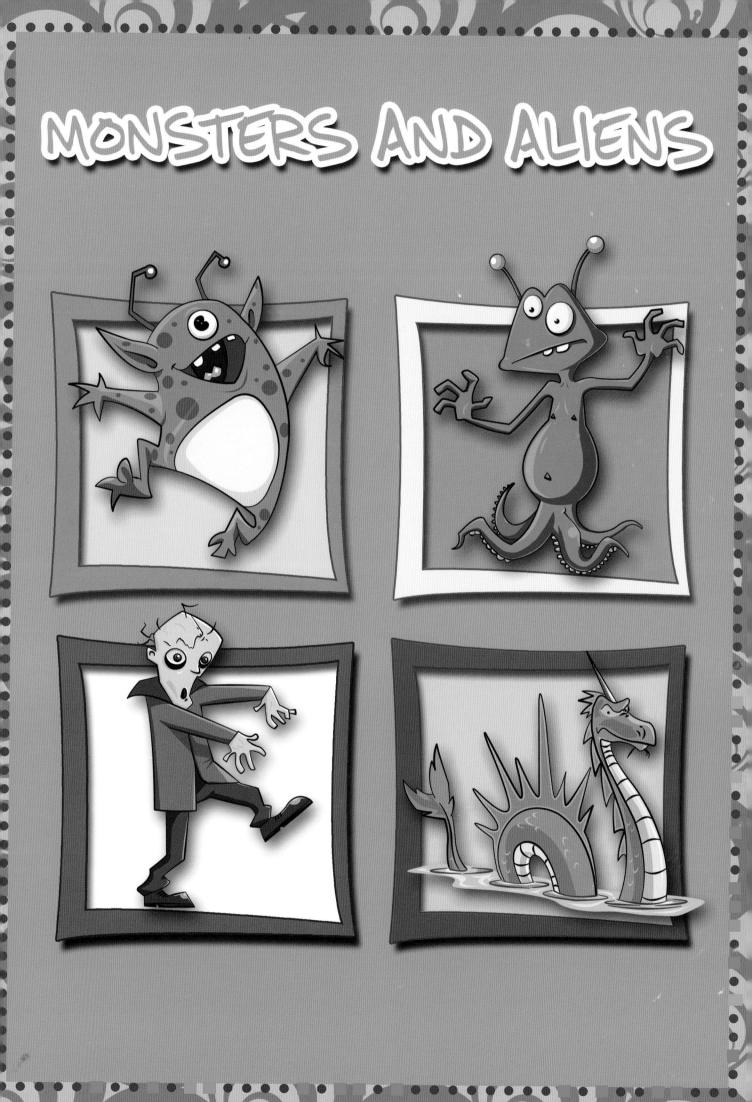

MONSTERS AND ALIENS

Cyclops

1. Draw a shape like a hat.

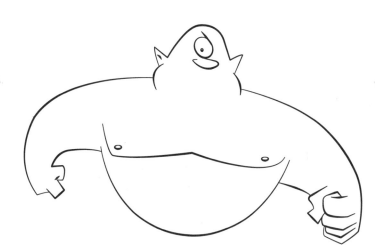

2. Now put in his arms and draw one eye in the middle of his head.

3. A mouth shaped like this makes him look cross.

4. His club's a piece of tree!

Faloogle

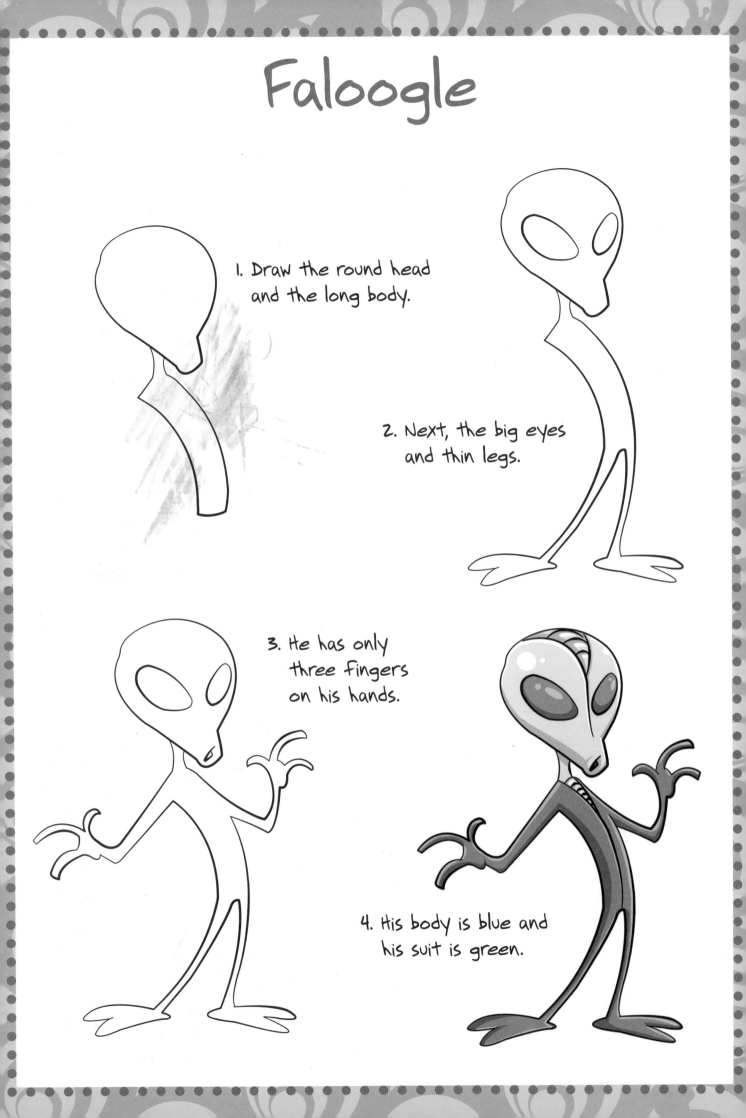

1. Draw the round head and the long body.

2. Next, the big eyes and thin legs.

3. He has only three fingers on his hands.

4. His body is blue and his suit is green.

Zombie

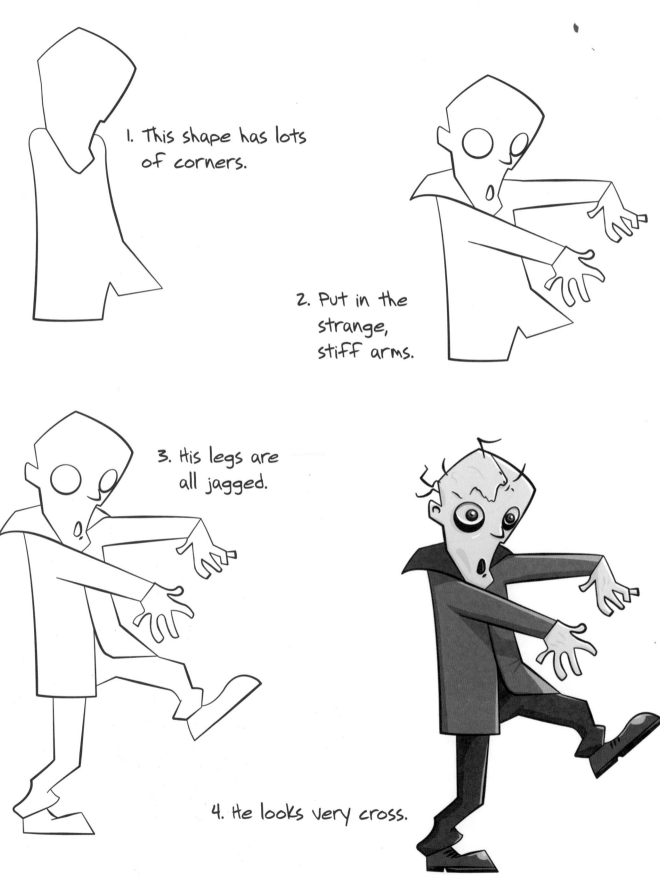

1. This shape has lots of corners.

2. Put in the strange, stiff arms.

3. His legs are all jagged.

4. He looks very cross.

Ogre

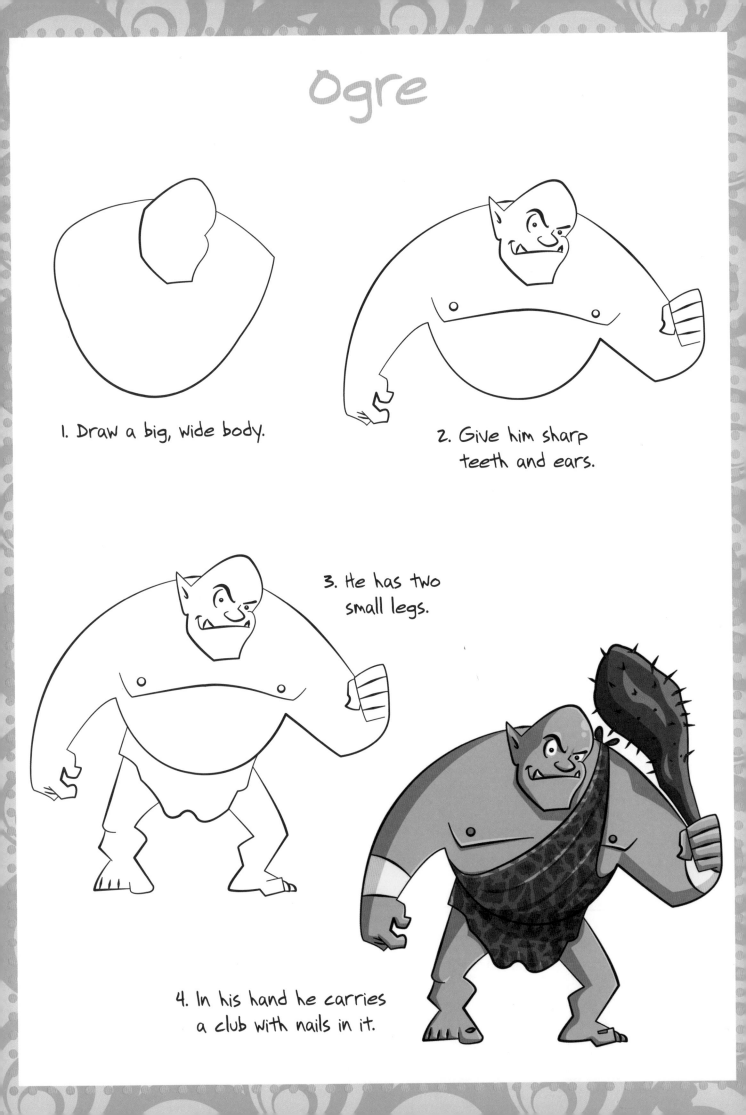

1. Draw a big, wide body.

2. Give him sharp teeth and ears.

3. He has two small legs.

4. In his hand he carries a club with nails in it.

Goblin

1. Sketch this body shape.

2. Give him eyes, ears, sharp teeth and strong, grasping hands.

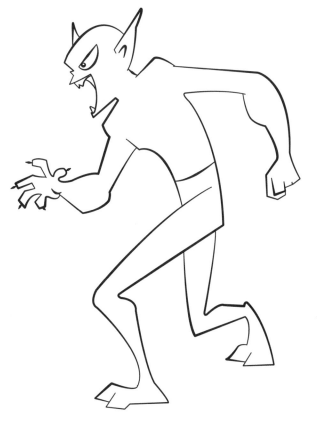

3. He's got animal feet.

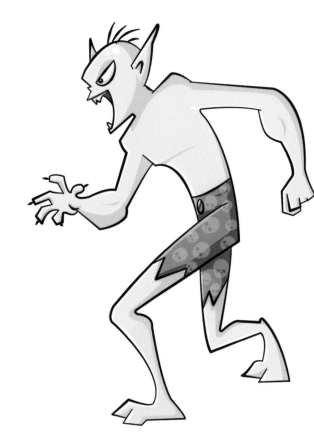

4. There are sharp claws on his fingers.

Mummy

1. Draw his head and rectangular body.

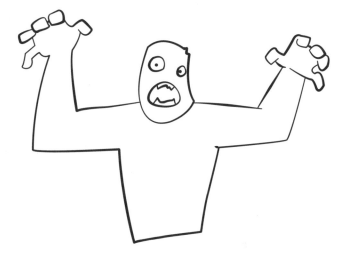

2. Give him staring eyes and make his hands reach out.

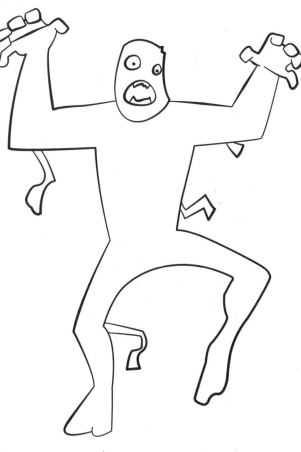

3. He's jumping at us!

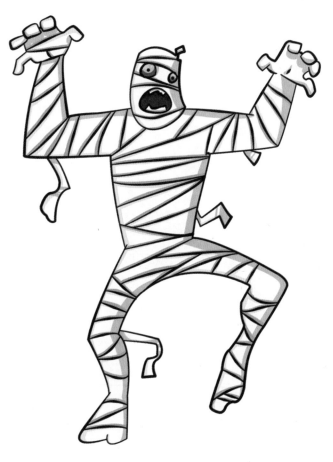

4. Cover him in bandages and give him green eyes.

Loch Ness Monster

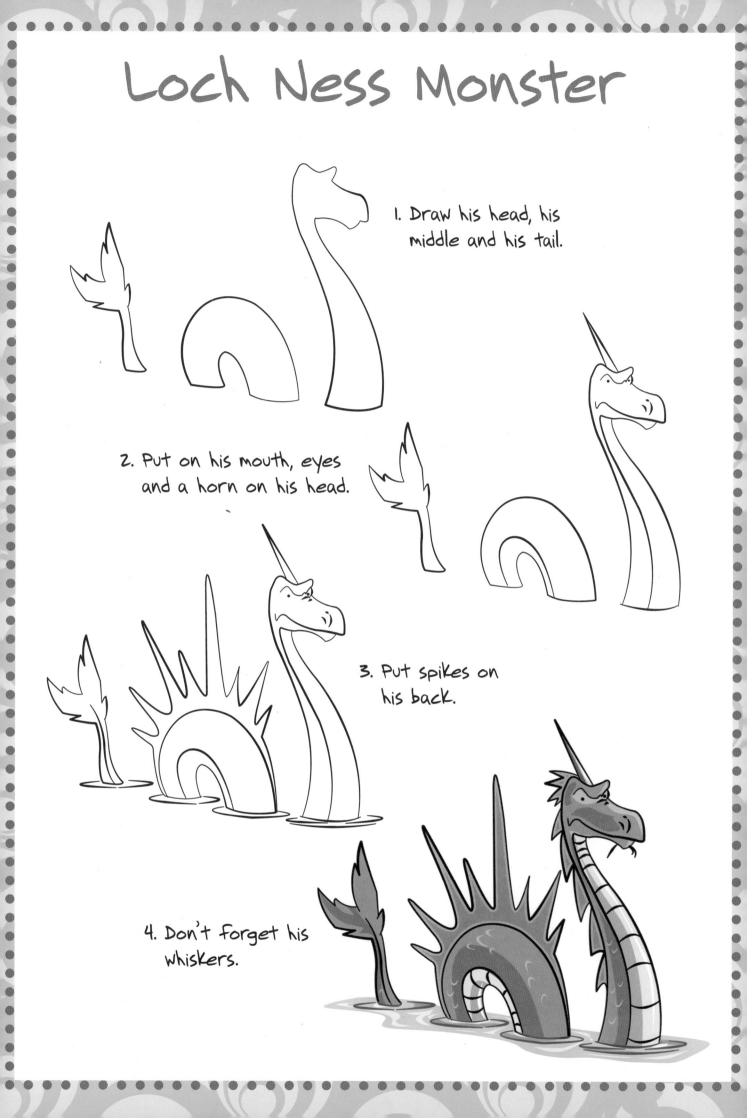

1. Draw his head, his middle and his tail.

2. Put on his mouth, eyes and a horn on his head.

3. Put spikes on his back.

4. Don't forget his whiskers.

Vampire

1. Start with these two shapes.

2. Draw staring eyes and curly fingers.

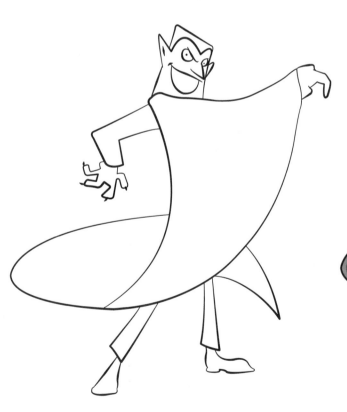

3. His cape swirls around him.

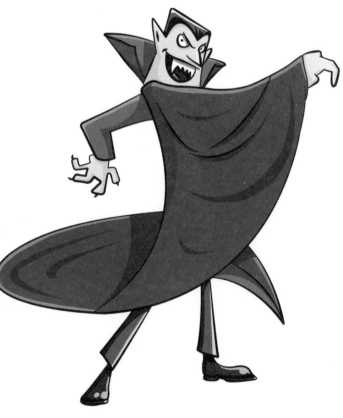

4. Put two sharp fangs in his mouth.

Minotaur

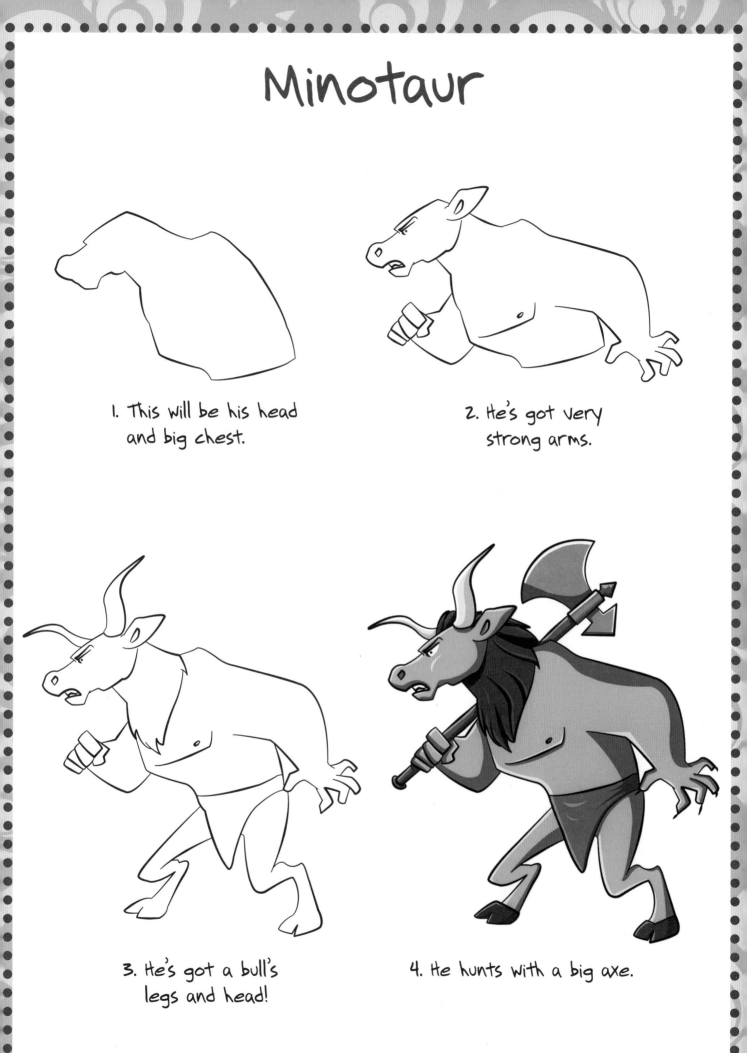

1. This will be his head and big chest.

2. He's got very strong arms.

3. He's got a bull's legs and head!

4. He hunts with a big axe.

Ettin

1. Start with a body with two heads on top.

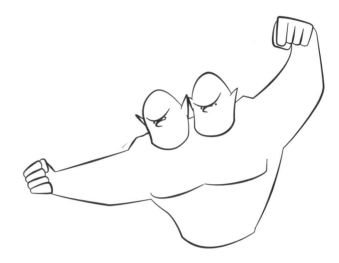

2. Add two strong arms.

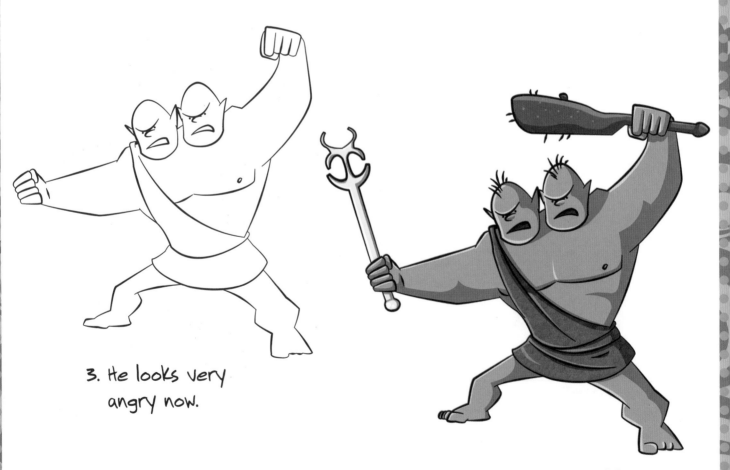

3. He looks very angry now.

4. He carries a magic staff in one hand and a club in the other.

Spikirabot

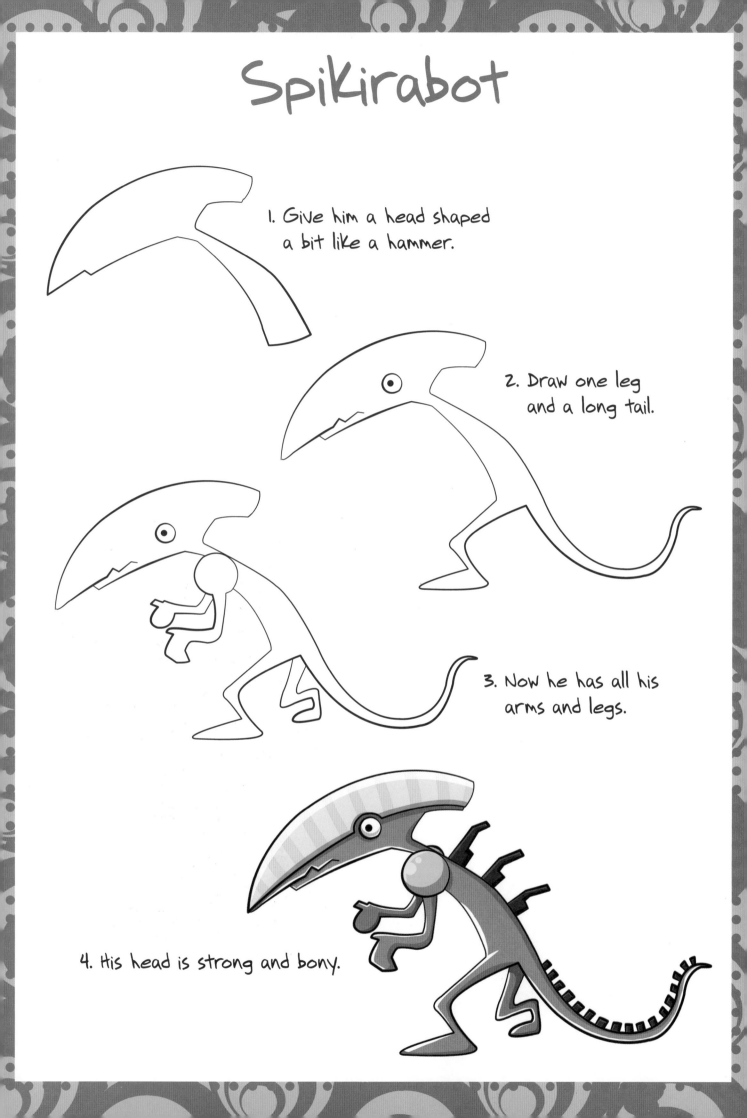

1. Give him a head shaped a bit like a hammer.

2. Draw one leg and a long tail.

3. Now he has all his arms and legs.

4. His head is strong and bony.

Garugula

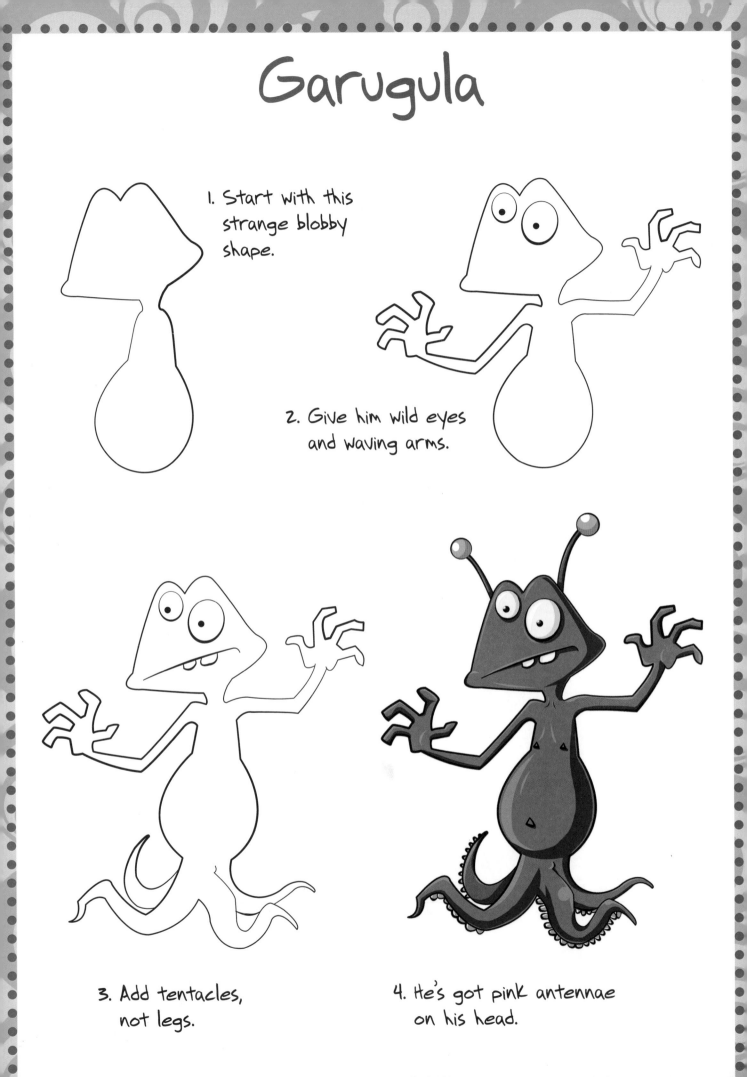

1. Start with this strange blobby shape.

2. Give him wild eyes and waving arms.

3. Add tentacles, not legs.

4. He's got pink antennae on his head.

Hooverikum

1. Draw the head and body in one shape.

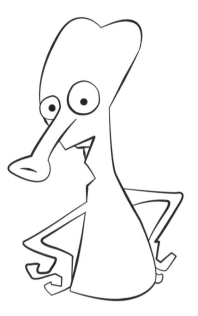

2. Add the trumpet nose and bendy arms.

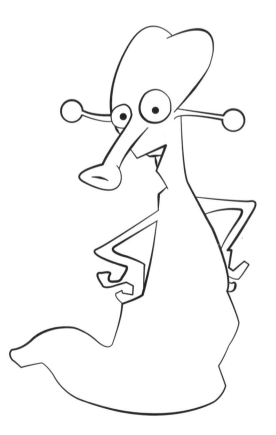

3. Here's the rest of the body.

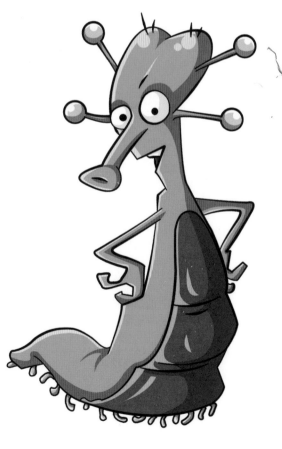

4. He moves on tiny green feet.

Troll

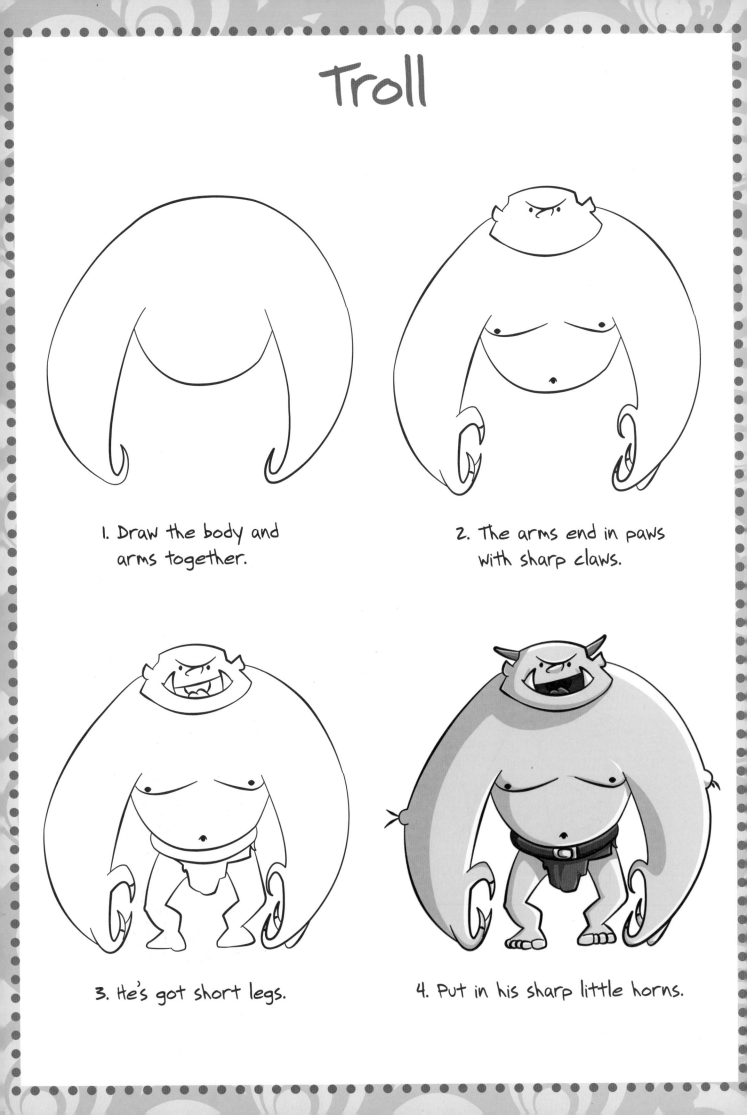

1. Draw the body and arms together.

2. The arms end in paws with sharp claws.

3. He's got short legs.

4. Put in his sharp little horns.

Bing-Bing

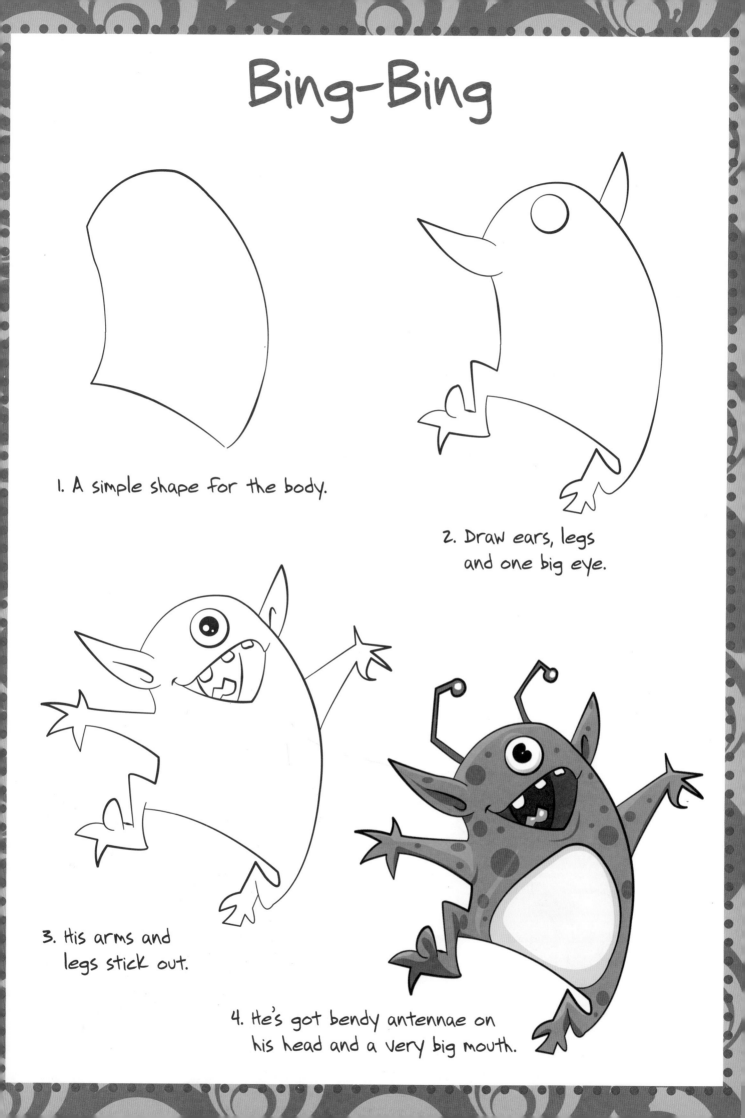

1. A simple shape for the body.

2. Draw ears, legs and one big eye.

3. His arms and legs stick out.

4. He's got bendy antennae on his head and a very big mouth.

Golem

1. He's a very large and square monster.

2. He's made of bits stitched together.

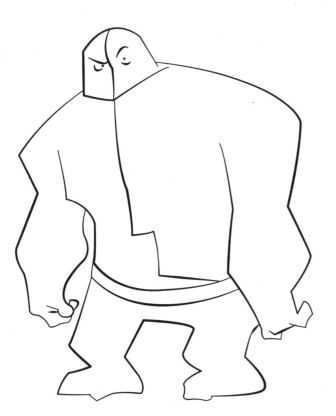

3. Draw big, baggy arms and legs.

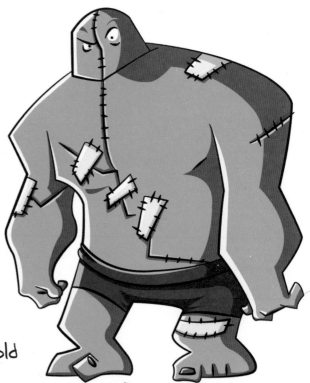

4. Put on some patches to hold him together.

PEOPLE

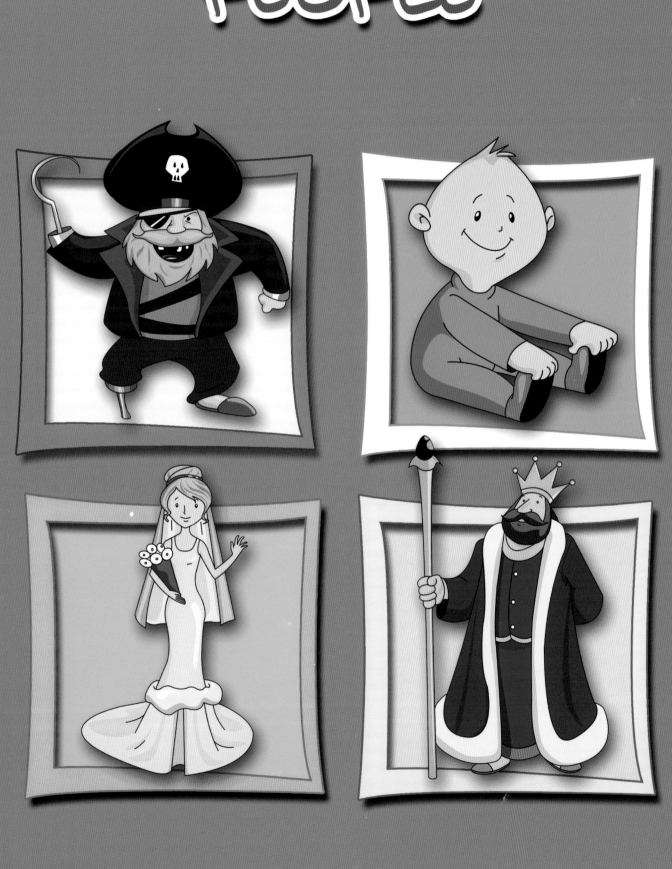

Pirate

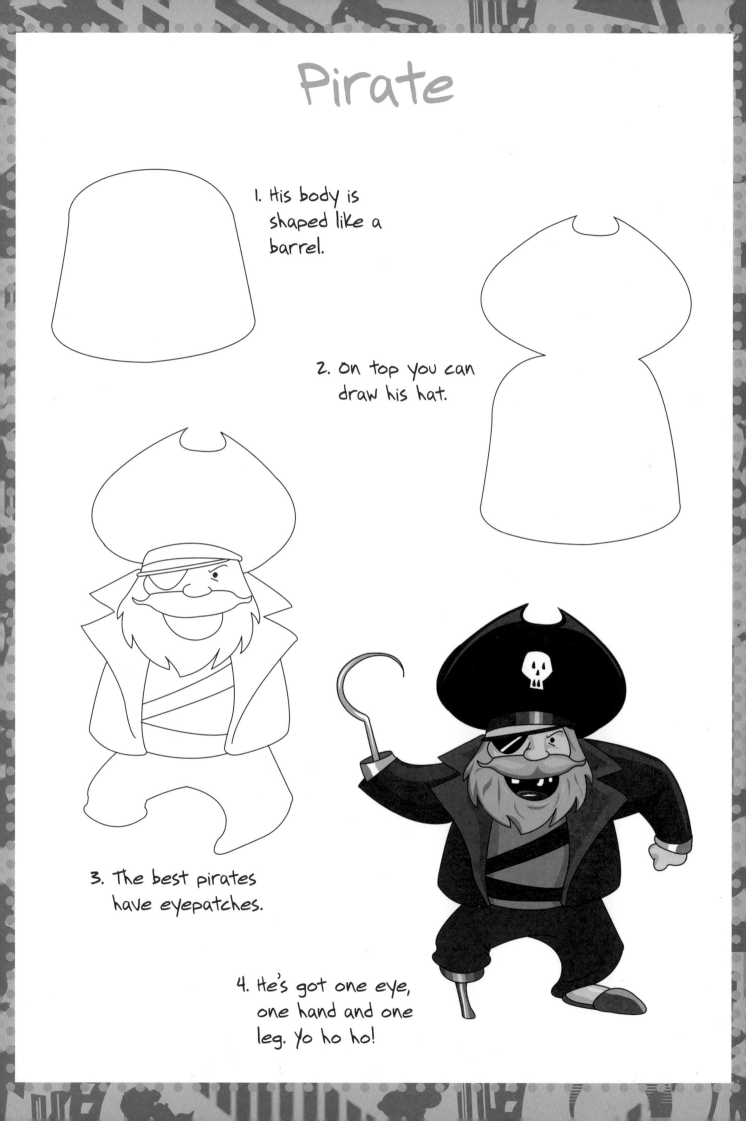

1. His body is shaped like a barrel.

2. On top you can draw his hat.

3. The best pirates have eyepatches.

4. He's got one eye, one hand and one leg. yo ho ho!

Astronaut

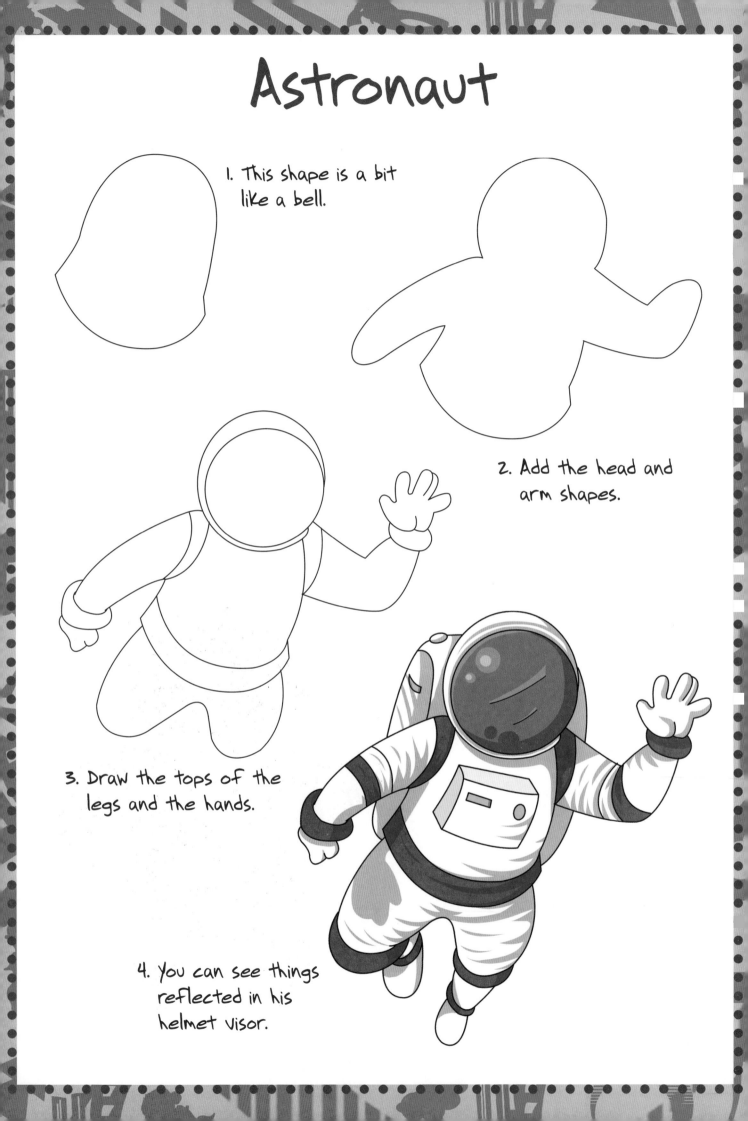

1. This shape is a bit like a bell.

2. Add the head and arm shapes.

3. Draw the tops of the legs and the hands.

4. You can see things reflected in his helmet visor.

Baby

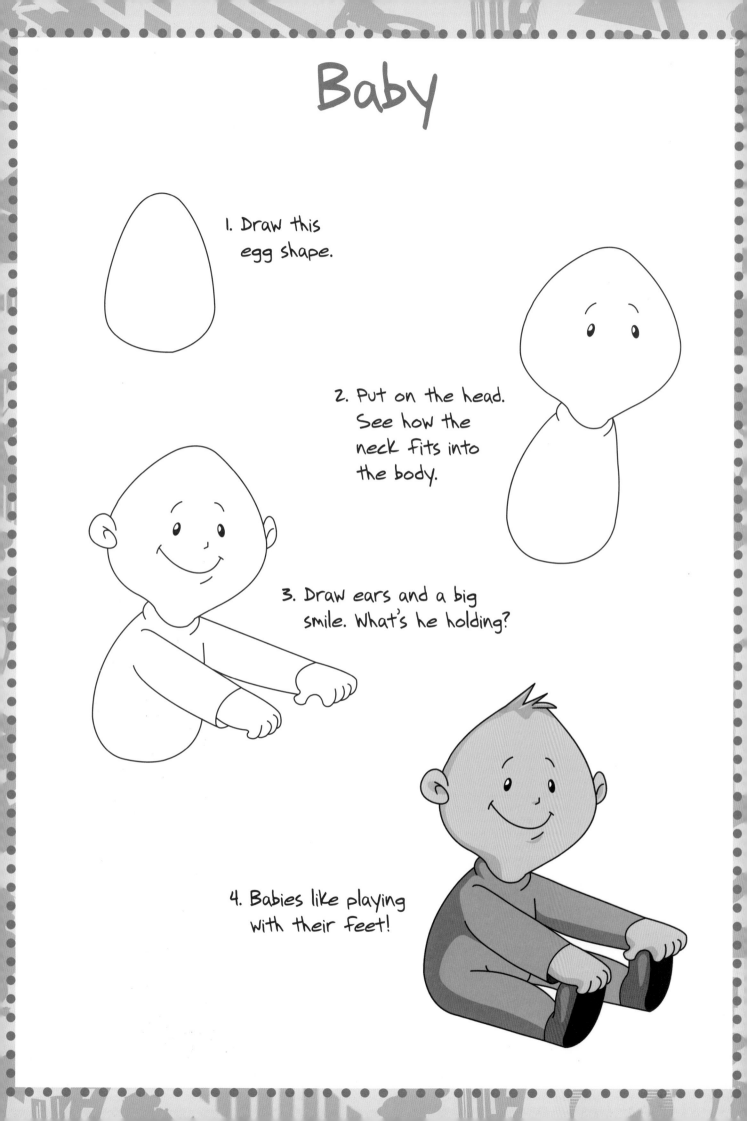

1. Draw this egg shape.

2. Put on the head. See how the neck fits into the body.

3. Draw ears and a big smile. What's he holding?

4. Babies like playing with their feet!

Schoolgirl

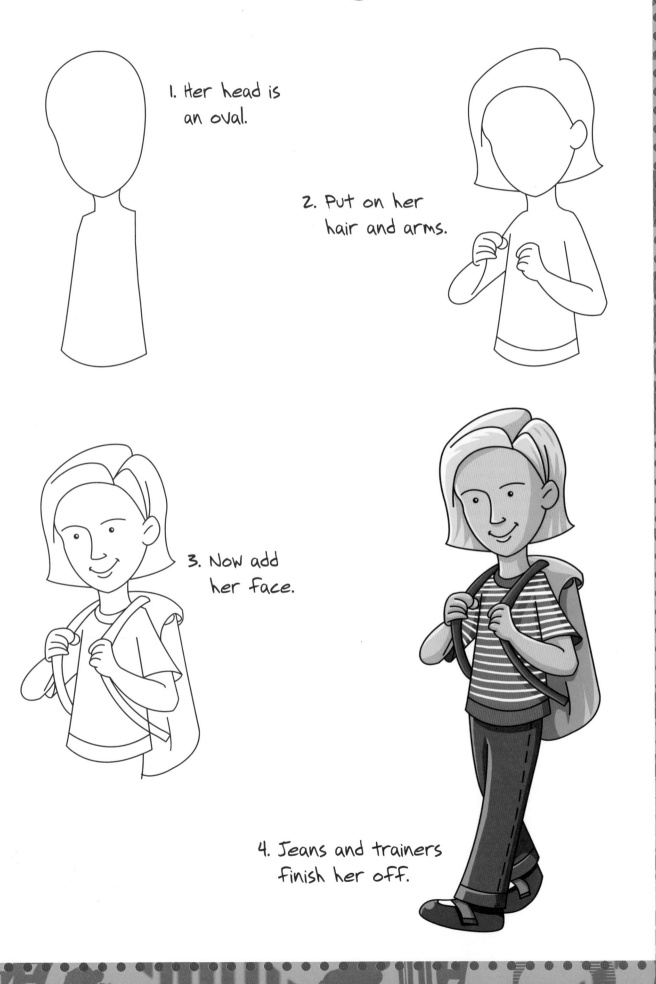

1. Her head is an oval.

2. Put on her hair and arms.

3. Now add her face.

4. Jeans and trainers finish her off.

Doctor

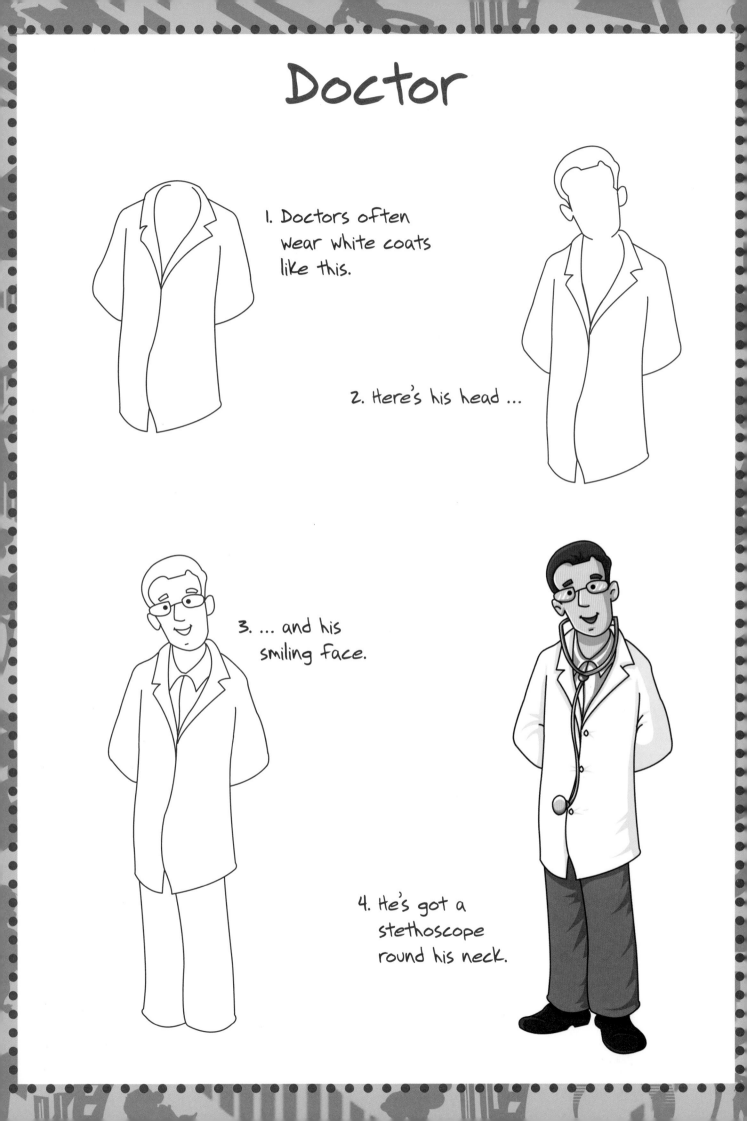

1. Doctors often wear white coats like this.

2. Here's his head ...

3. ... and his smiling face.

4. He's got a stethoscope round his neck.

Queen

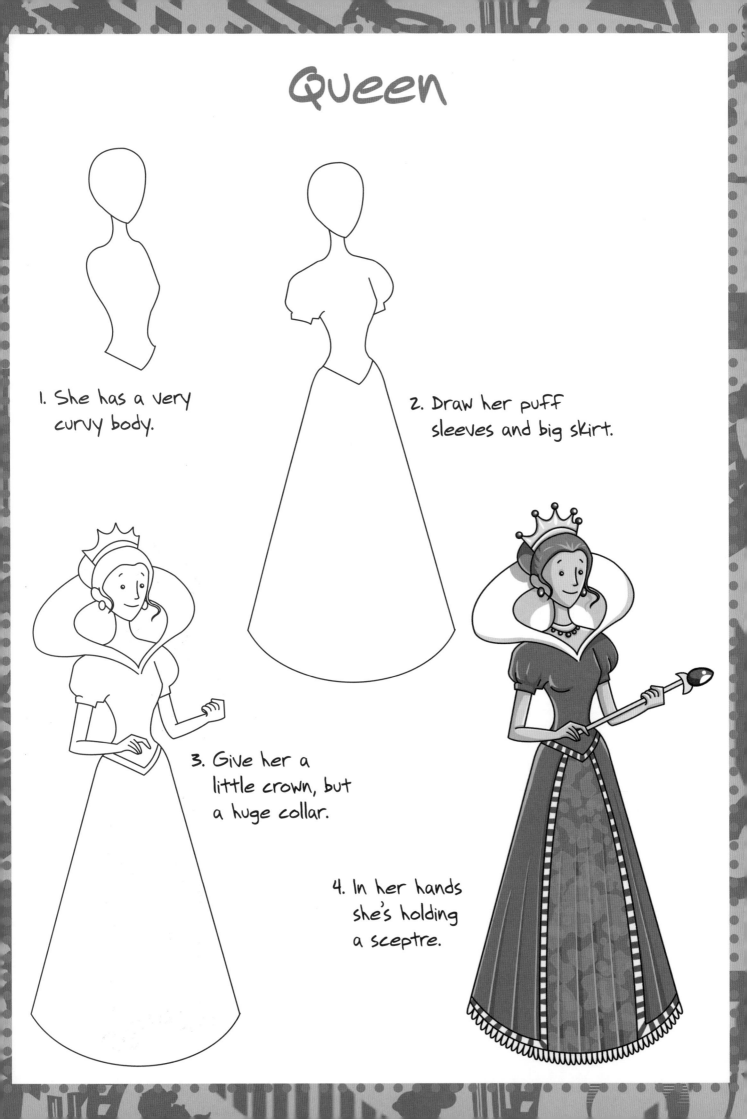

1. She has a very curvy body.

2. Draw her puff sleeves and big skirt.

3. Give her a little crown, but a huge collar.

4. In her hands she's holding a sceptre.

King

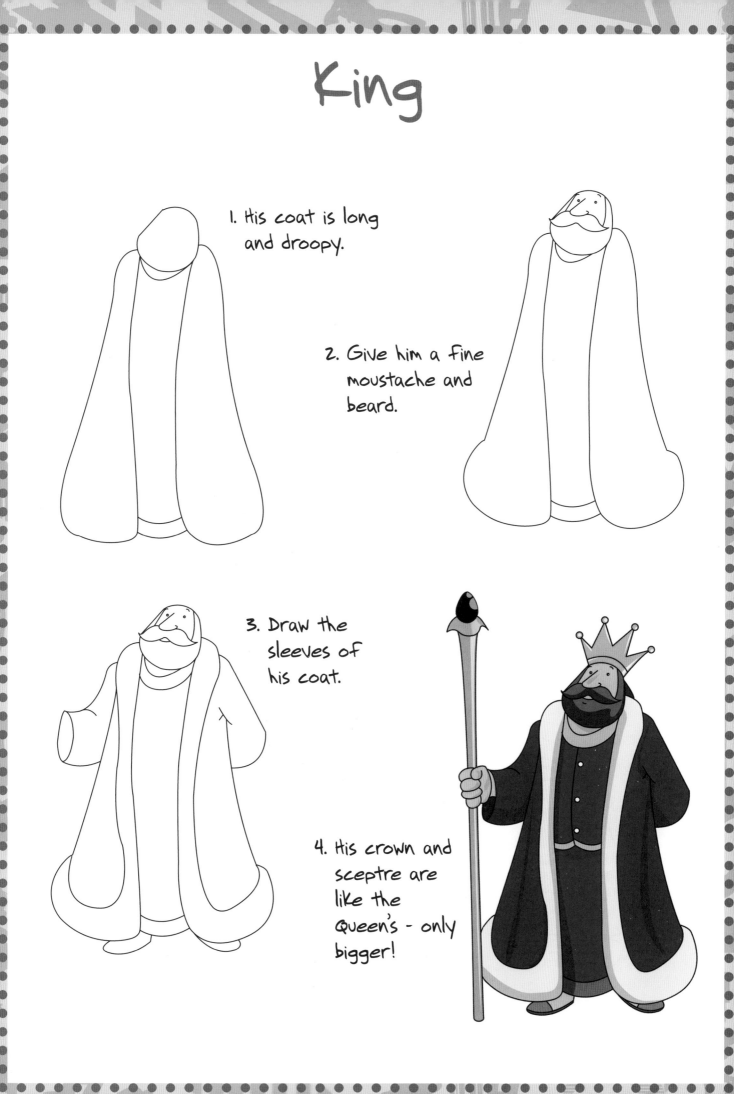

1. His coat is long and droopy.

2. Give him a fine moustache and beard.

3. Draw the sleeves of his coat.

4. His crown and sceptre are like the Queen's - only bigger!

Nurse

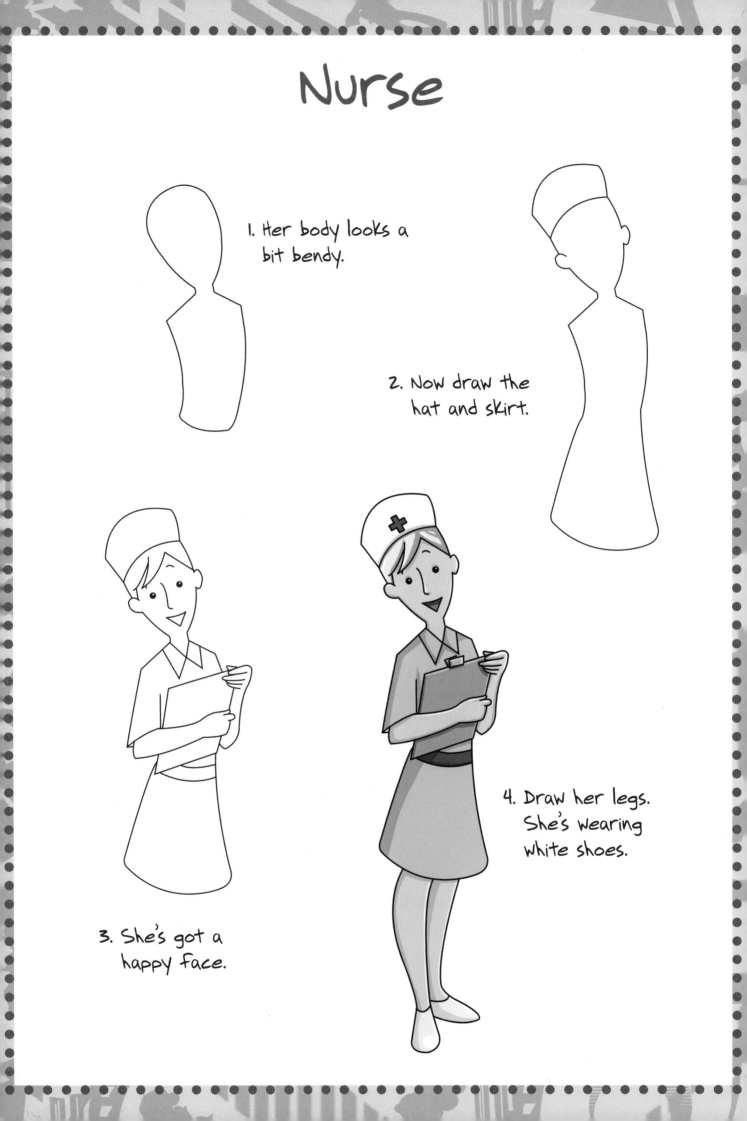

1. Her body looks a bit bendy.

2. Now draw the hat and skirt.

3. She's got a happy face.

4. Draw her legs. She's wearing white shoes.

Pharaoh

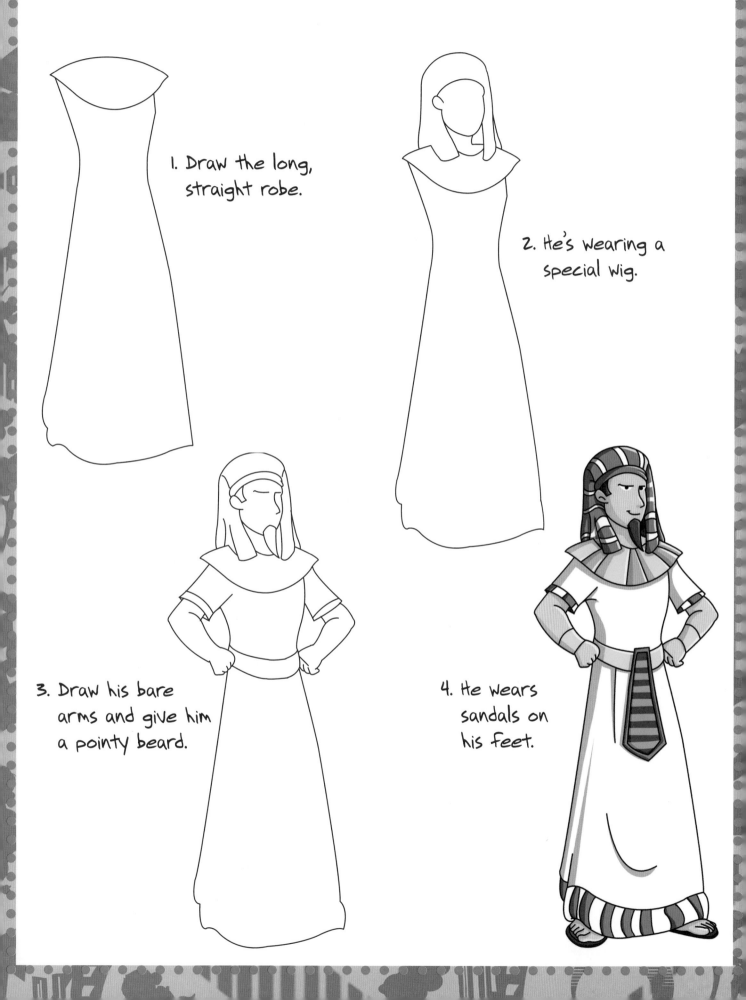

1. Draw the long, straight robe.

2. He's wearing a special wig.

3. Draw his bare arms and give him a pointy beard.

4. He wears sandals on his feet.

Clown

1. Draw the waistcoat and trousers first.

2. Next are the arms, head, hat and curly wig.

3. Give him a huge tie.

4. Make sure his colours are really bright!

Bride

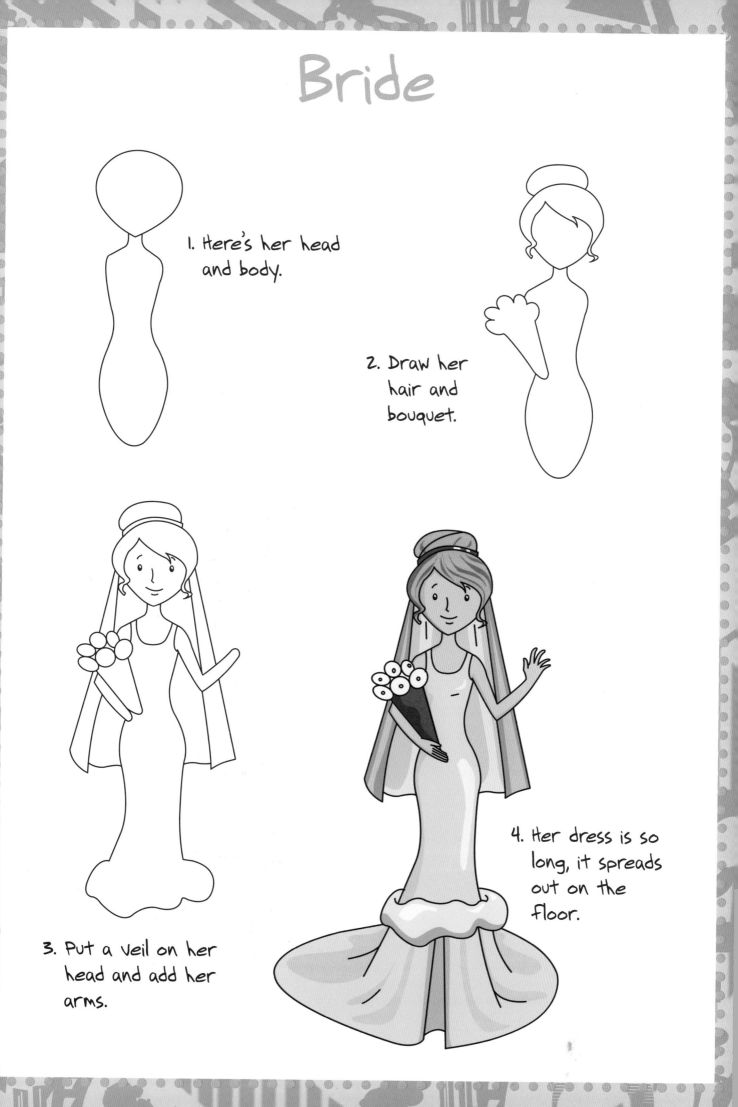

1. Here's her head and body.

2. Draw her hair and bouquet.

3. Put a veil on her head and add her arms.

4. Her dress is so long, it spreads out on the floor.

Musician

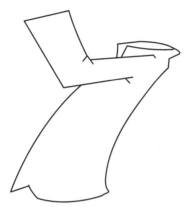

1. Let's start with his coat.

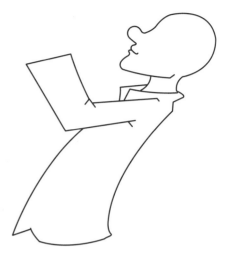

2. Now draw his head.

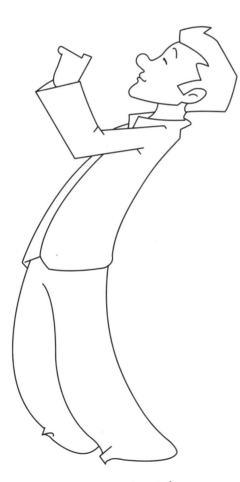

3. Make his arms and legs sweep round in a curve.

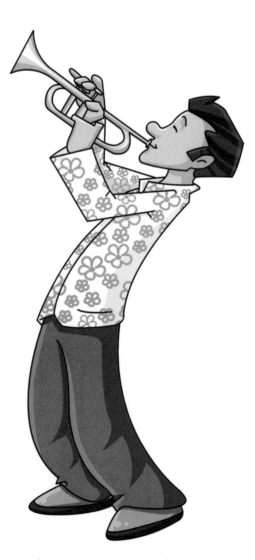

4. He's holding his trumpet up to play a high note!

Cowboy

1. He's holding his arms out.

2. His hands are ready,
his hat's pulled down.

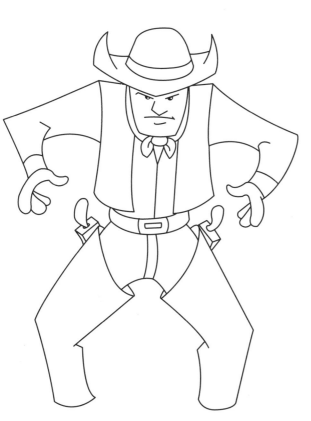

3. He's got chaps on his legs
and guns at his sides.

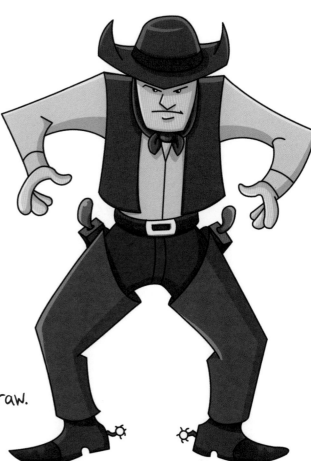

4. He's ready to draw.
Are you?

Mechanic

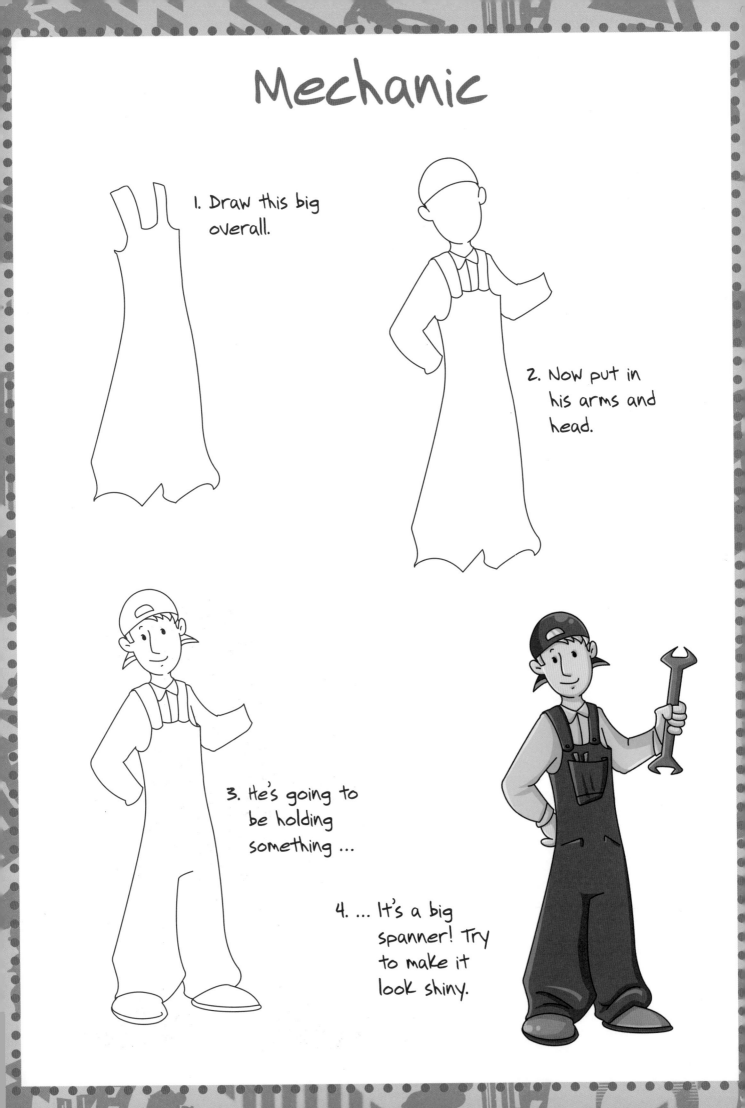

1. Draw this big overall.

2. Now put in his arms and head.

3. He's going to be holding something ...

4. ... It's a big spanner! Try to make it look shiny.

Artist

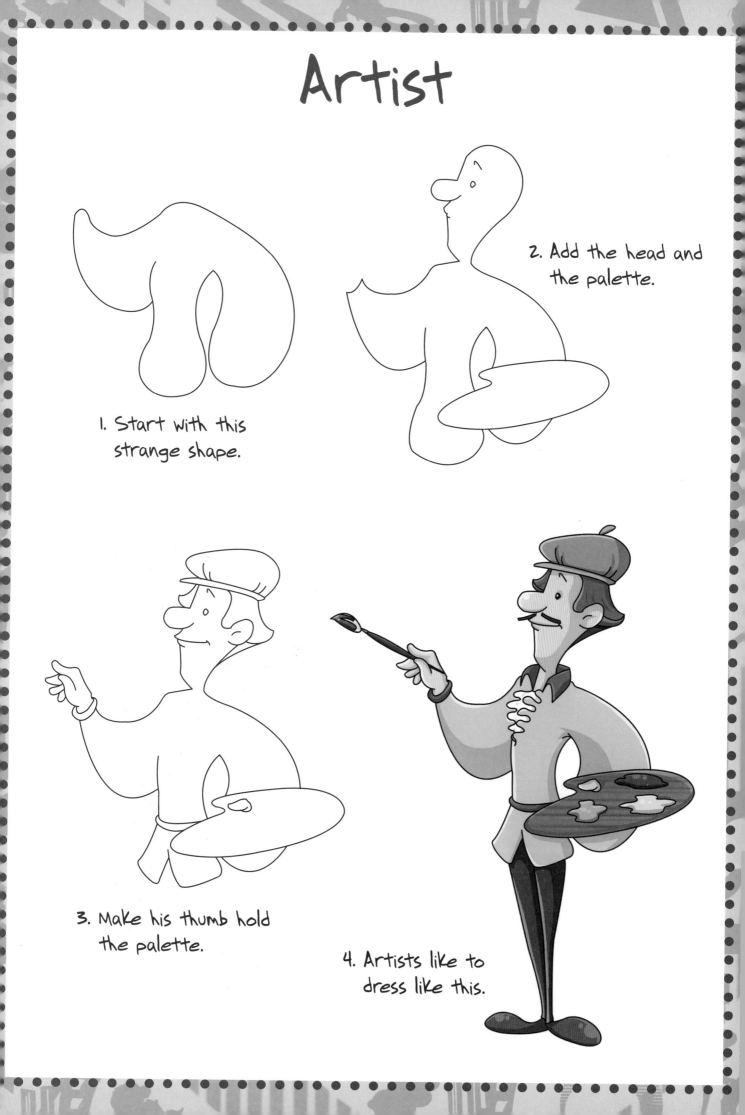

1. Start with this strange shape.

2. Add the head and the palette.

3. Make his thumb hold the palette.

4. Artists like to dress like this.

Fireman

1. Draw the special fireproof coat.

2. He has to wear a special hat, too.

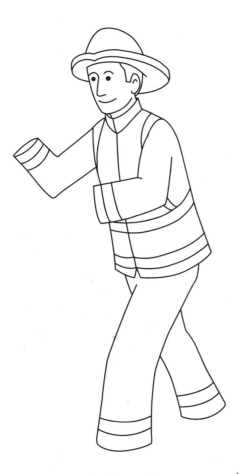

3. Put the stripes on his coat and trousers.

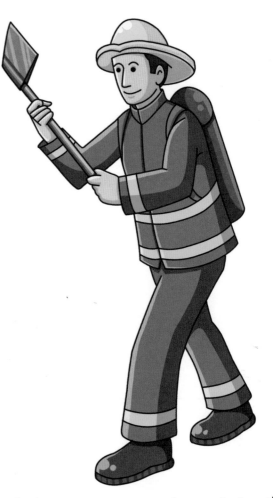

4. He uses an axe to get to the fire to put it out.

SPEED MACHINES

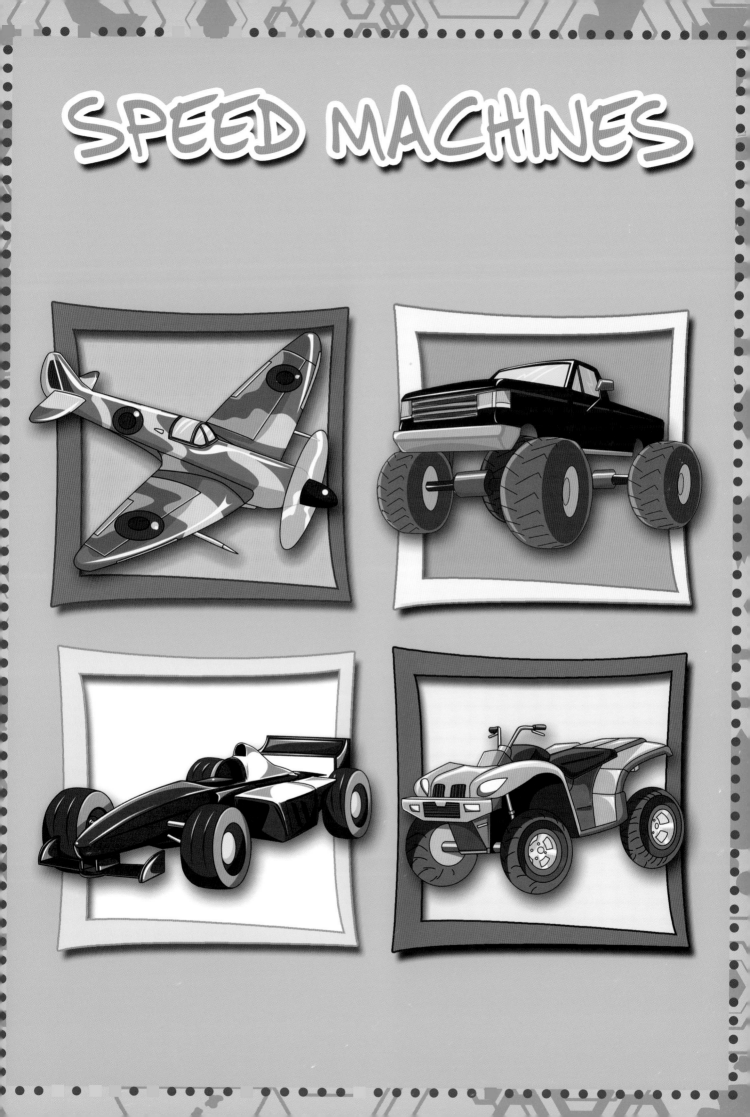

Monster Truck

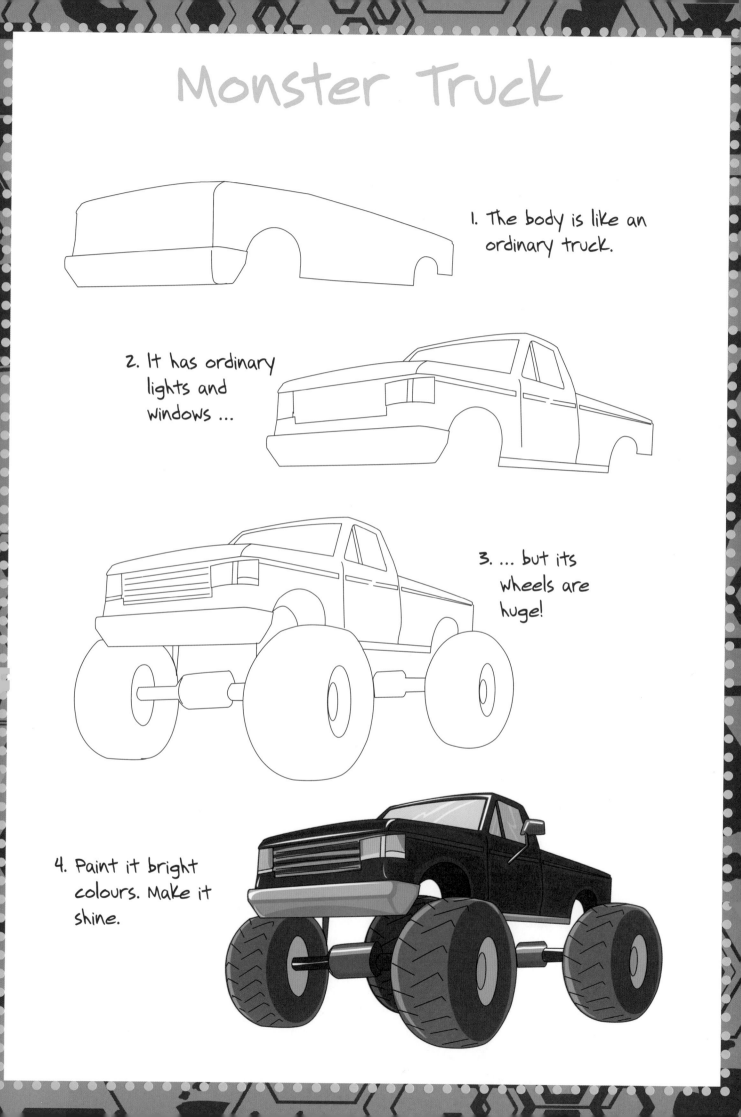

1. The body is like an ordinary truck.

2. It has ordinary lights and windows ...

3. ... but its wheels are huge!

4. Paint it bright colours. Make it shine.

Bullet Train

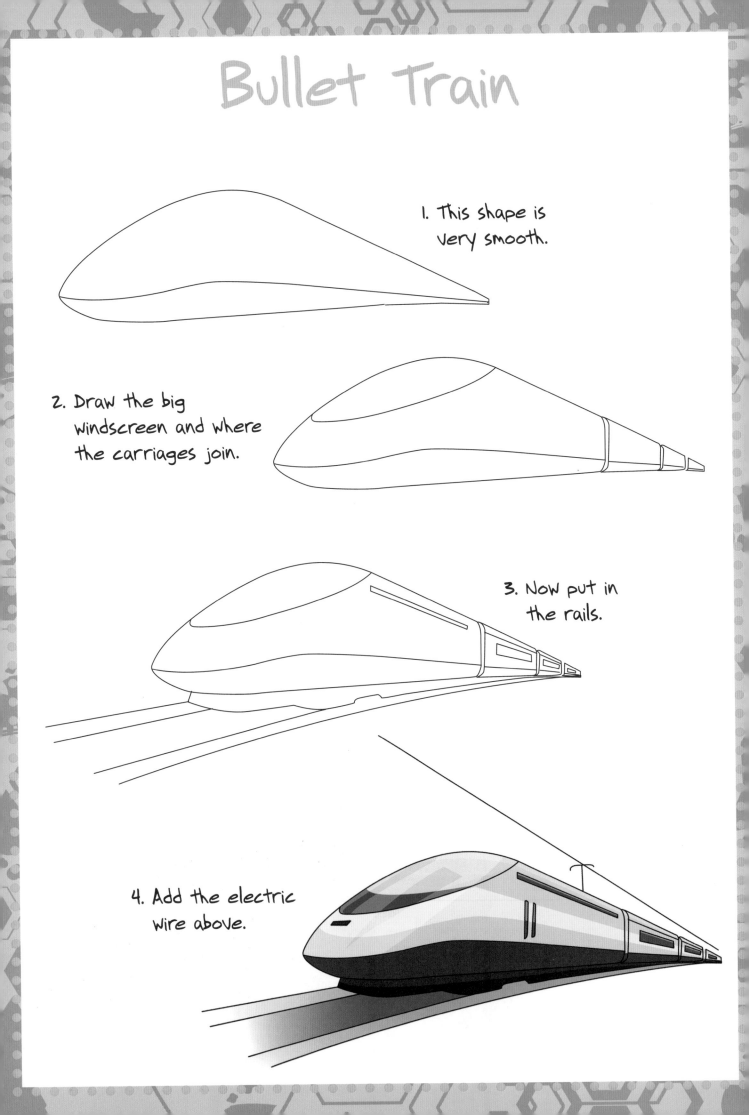

1. This shape is very smooth.

2. Draw the big windscreen and where the carriages join.

3. Now put in the rails.

4. Add the electric wire above.

Racing Car

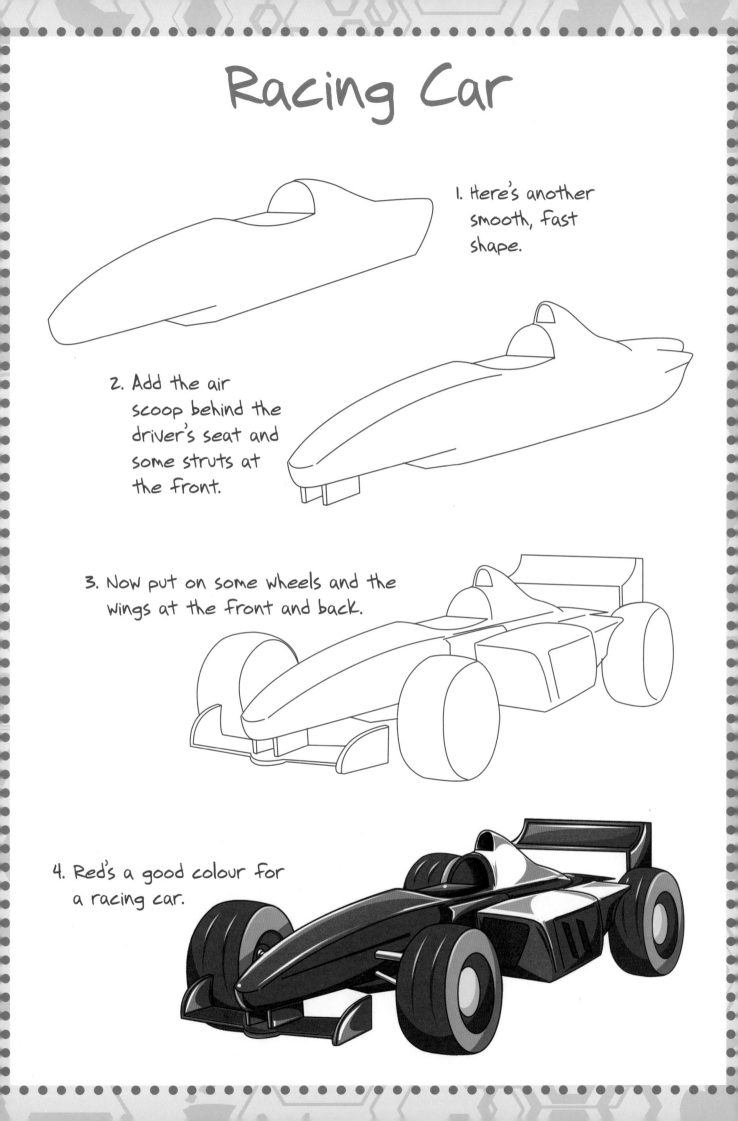

1. Here's another smooth, fast shape.

2. Add the air scoop behind the driver's seat and some struts at the front.

3. Now put on some wheels and the wings at the front and back.

4. Red's a good colour for a racing car.

Spitfire Plane

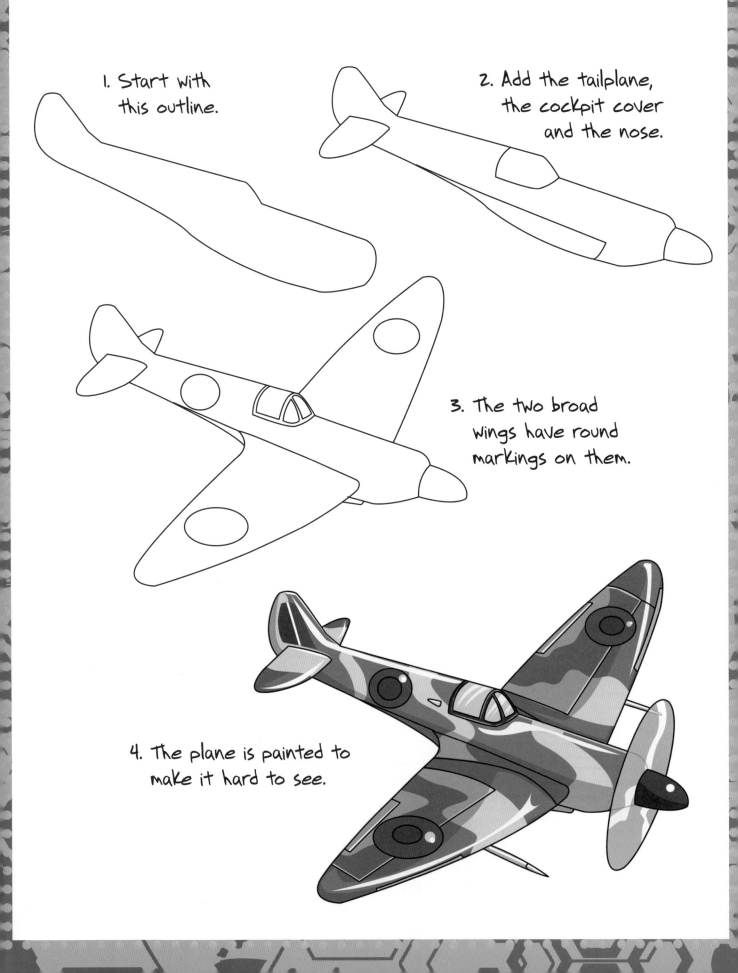

1. Start with this outline.

2. Add the tailplane, the cockpit cover and the nose.

3. The two broad wings have round markings on them.

4. The plane is painted to make it hard to see.

Speedboat

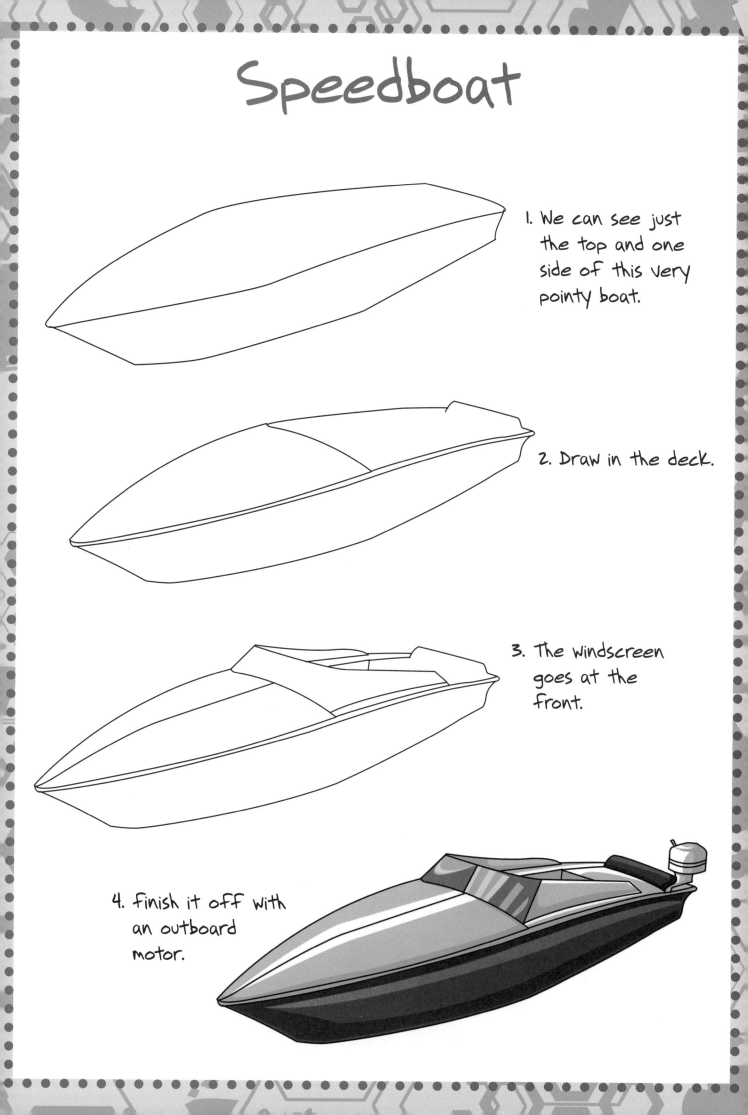

1. We can see just the top and one side of this very pointy boat.

2. Draw in the deck.

3. The windscreen goes at the front.

4. finish it off with an outboard motor.

Space Shuttle

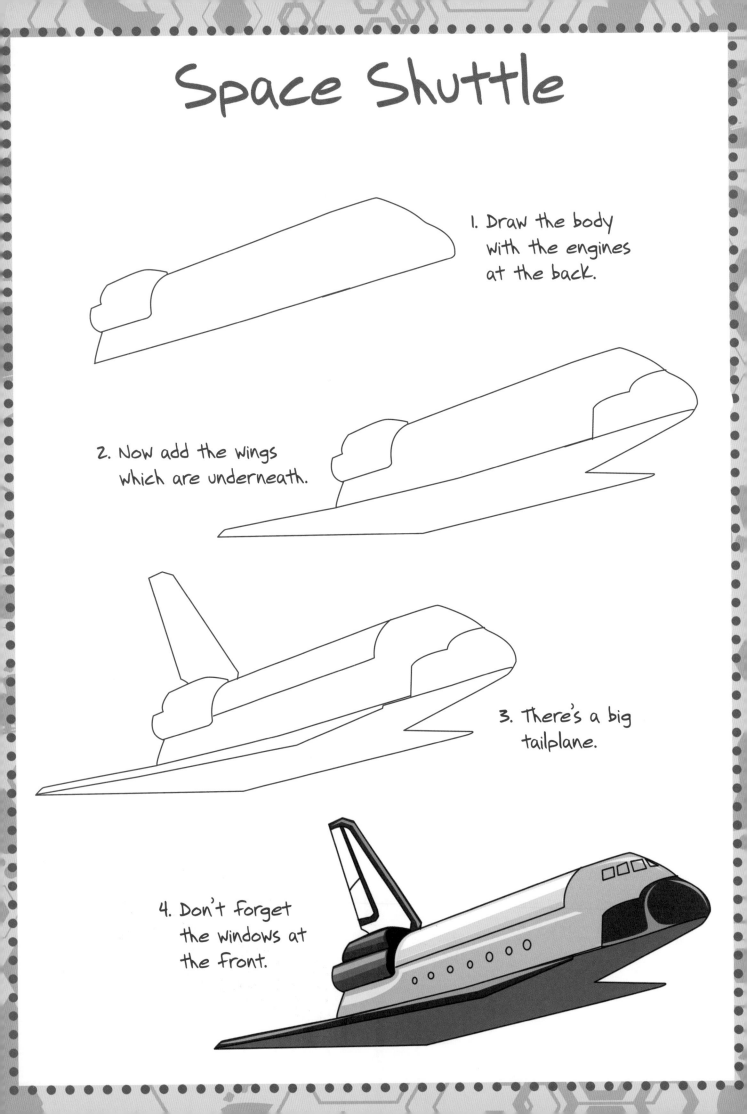

1. Draw the body with the engines at the back.

2. Now add the wings which are underneath.

3. There's a big tailplane.

4. Don't forget the windows at the front.

Motorbike

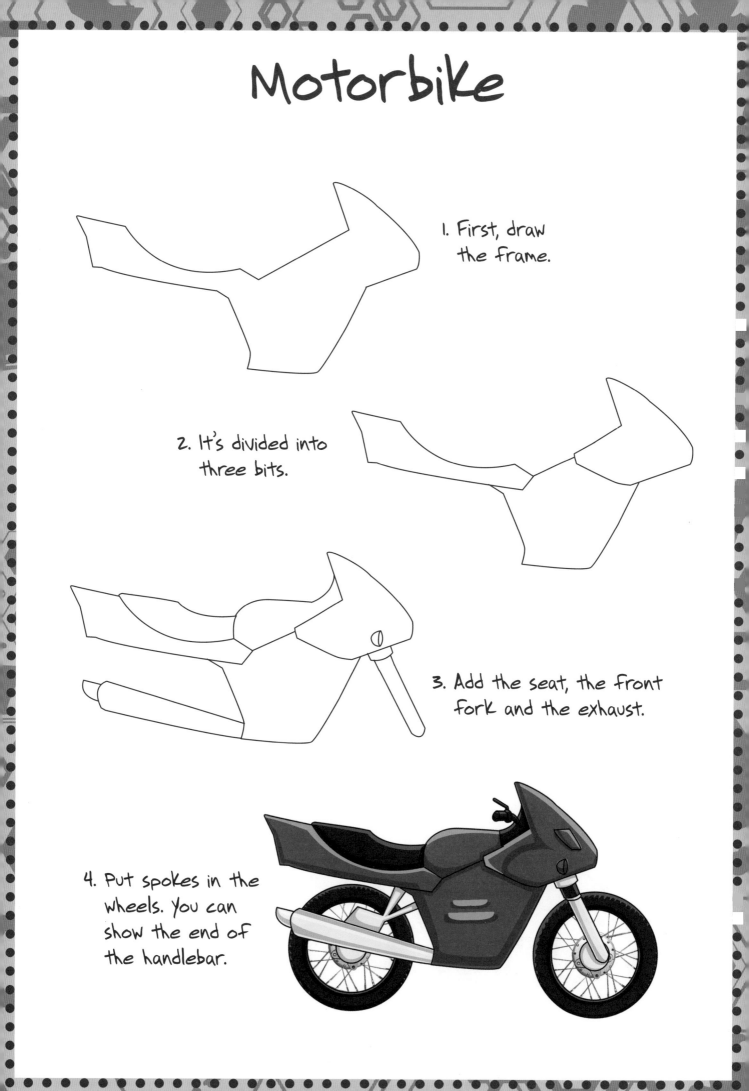

1. First, draw the frame.

2. It's divided into three bits.

3. Add the seat, the front fork and the exhaust.

4. Put spokes in the wheels. You can show the end of the handlebar.

Jet Ski

1. Draw this thin, flat shape for the bottom.

2. The soft seat goes in the middle.

3. It's getting taller.

4. Give it a handlebar like a motorbike.

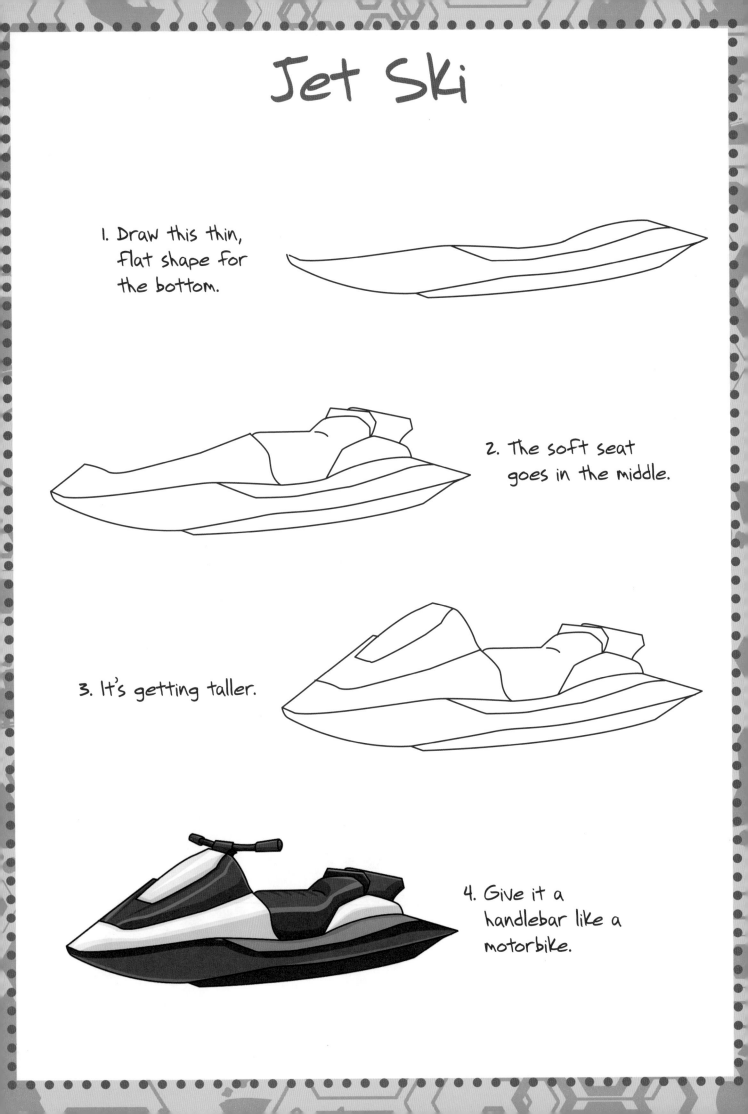

Hydrofoil

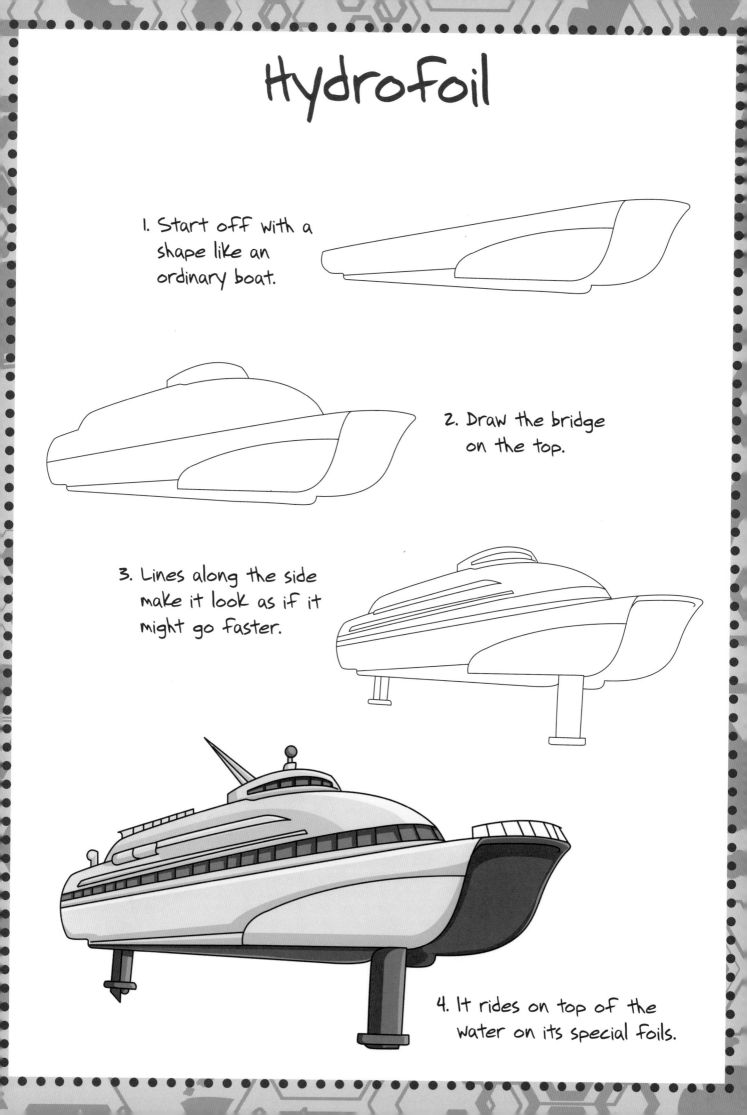

1. Start off with a shape like an ordinary boat.

2. Draw the bridge on the top.

3. Lines along the side make it look as if it might go faster.

4. It rides on top of the water on its special foils.

Stealth Bomber

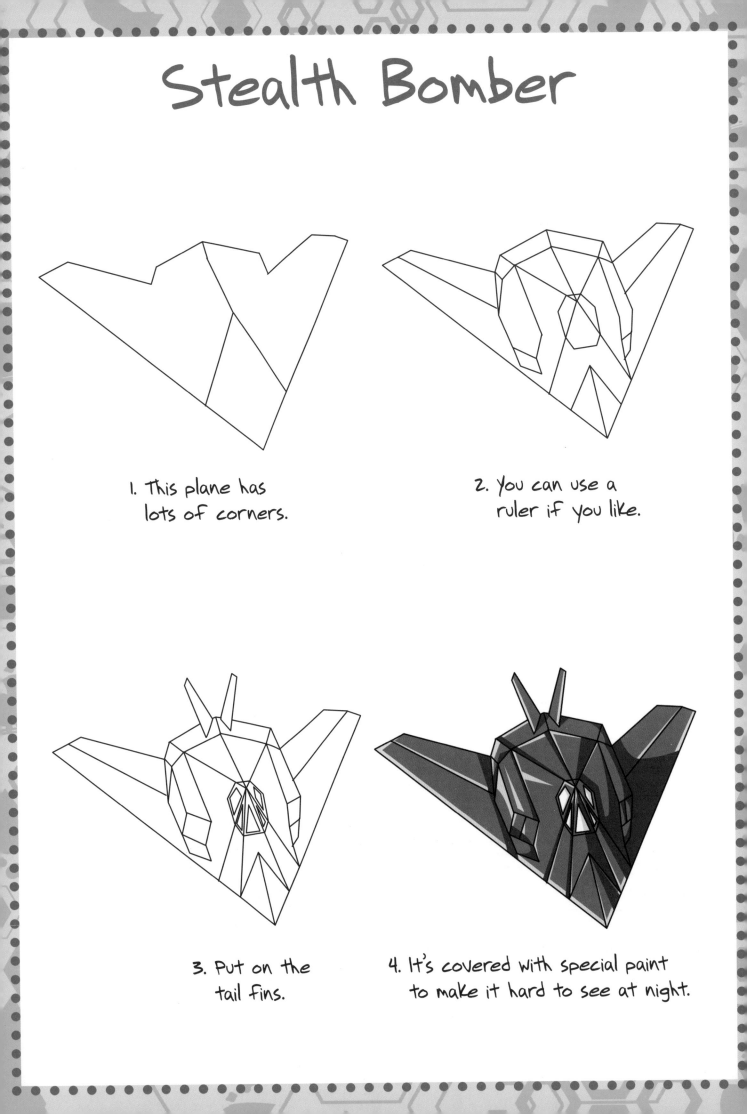

1. This plane has lots of corners.

2. You can use a ruler if you like.

3. Put on the tail fins.

4. It's covered with special paint to make it hard to see at night.

Quad Bike

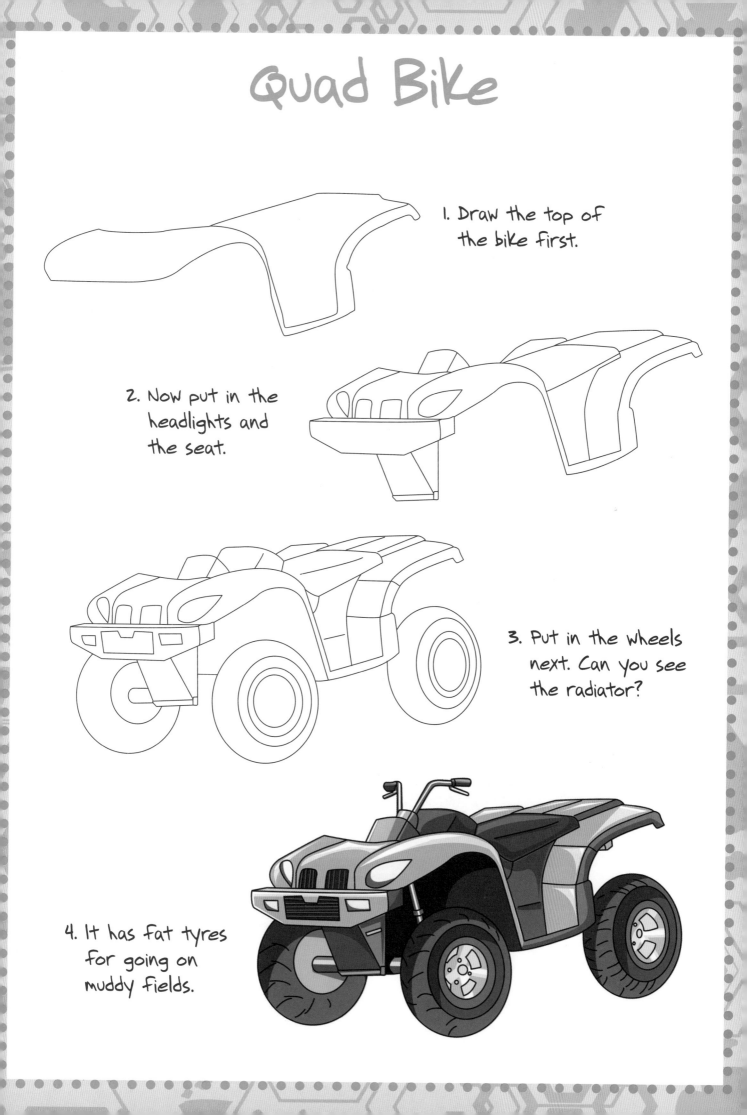

1. Draw the top of the bike first.

2. Now put in the headlights and the seat.

3. Put in the wheels next. Can you see the radiator?

4. It has fat tyres for going on muddy fields.

Fighter Plane

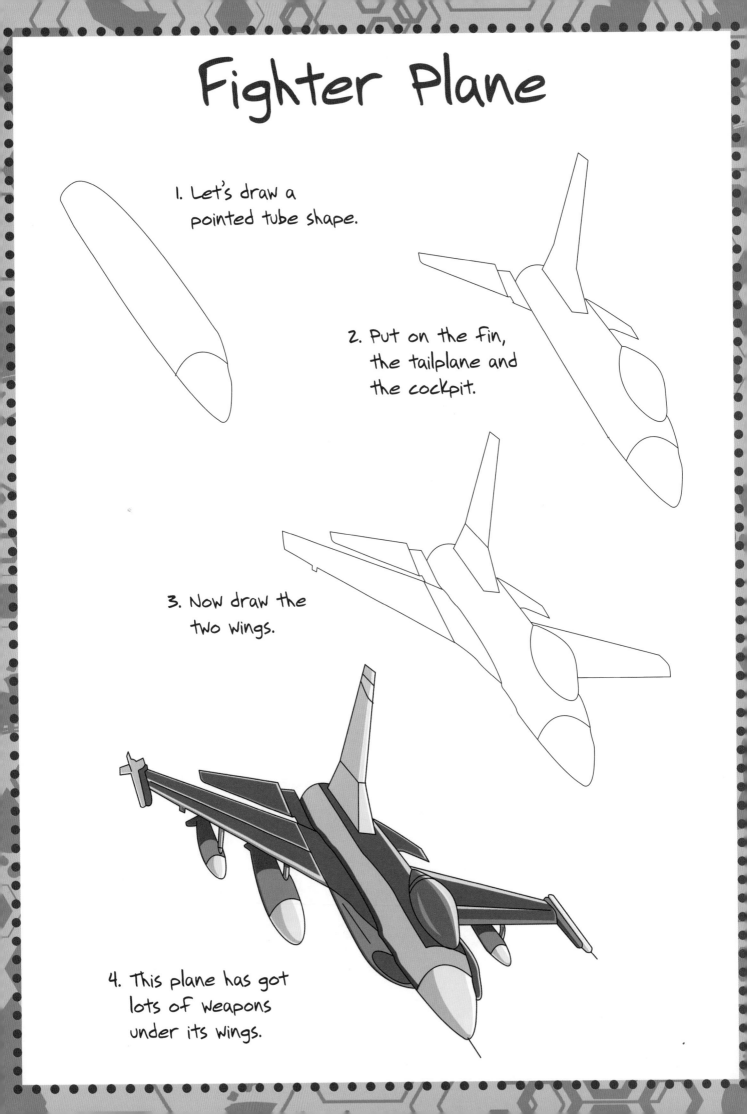

1. Let's draw a pointed tube shape.

2. Put on the fin, the tailplane and the cockpit.

3. Now draw the two wings.

4. This plane has got lots of weapons under its wings.

Sports Car

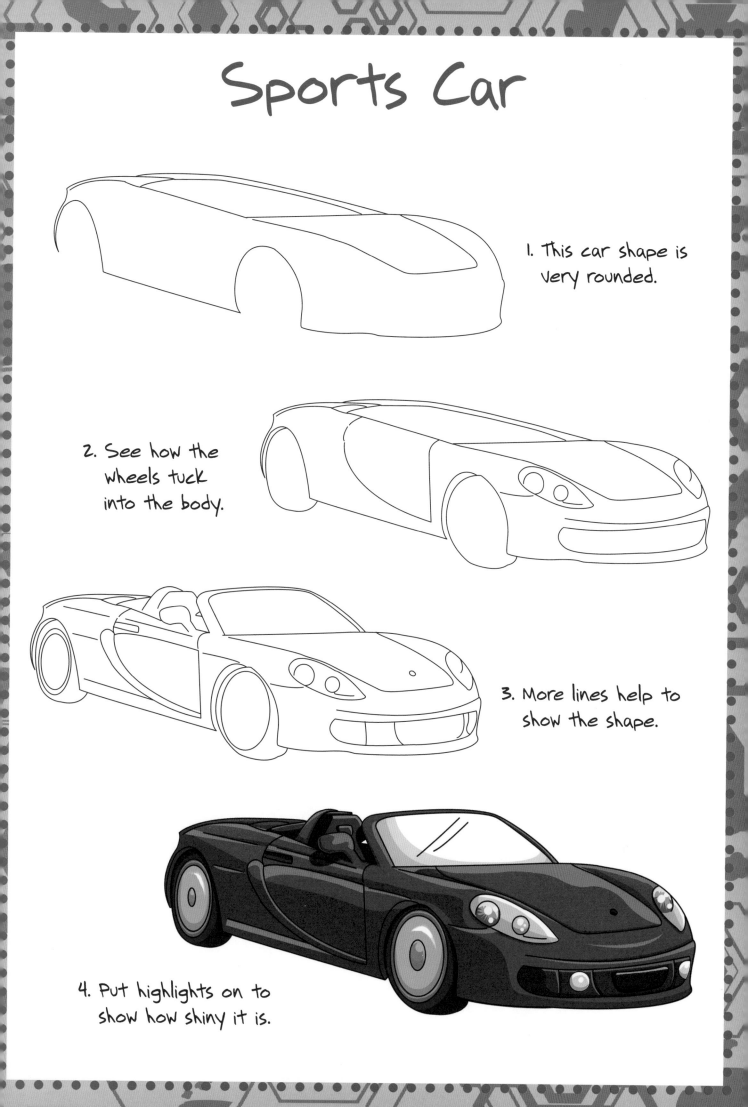

1. This car shape is very rounded.

2. See how the wheels tuck into the body.

3. More lines help to show the shape.

4. Put highlights on to show how shiny it is.

Rocket

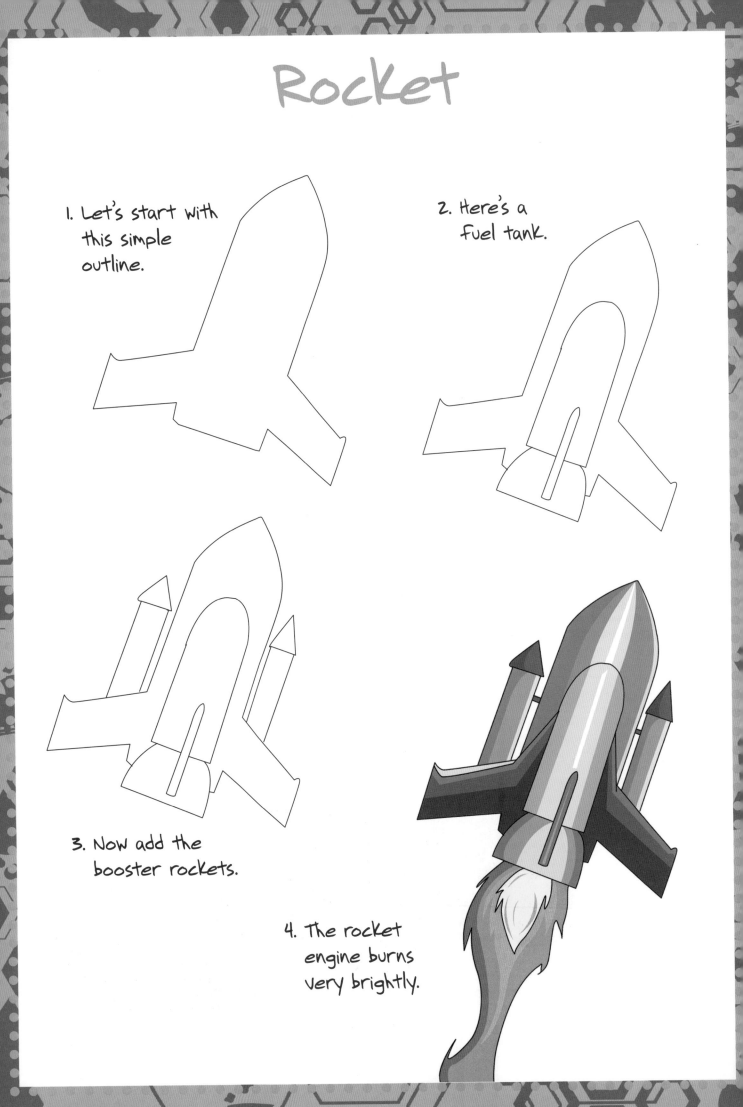

1. Let's start with this simple outline.

2. Here's a fuel tank.

3. Now add the booster rockets.

4. The rocket engine burns very brightly.

Snowmobile

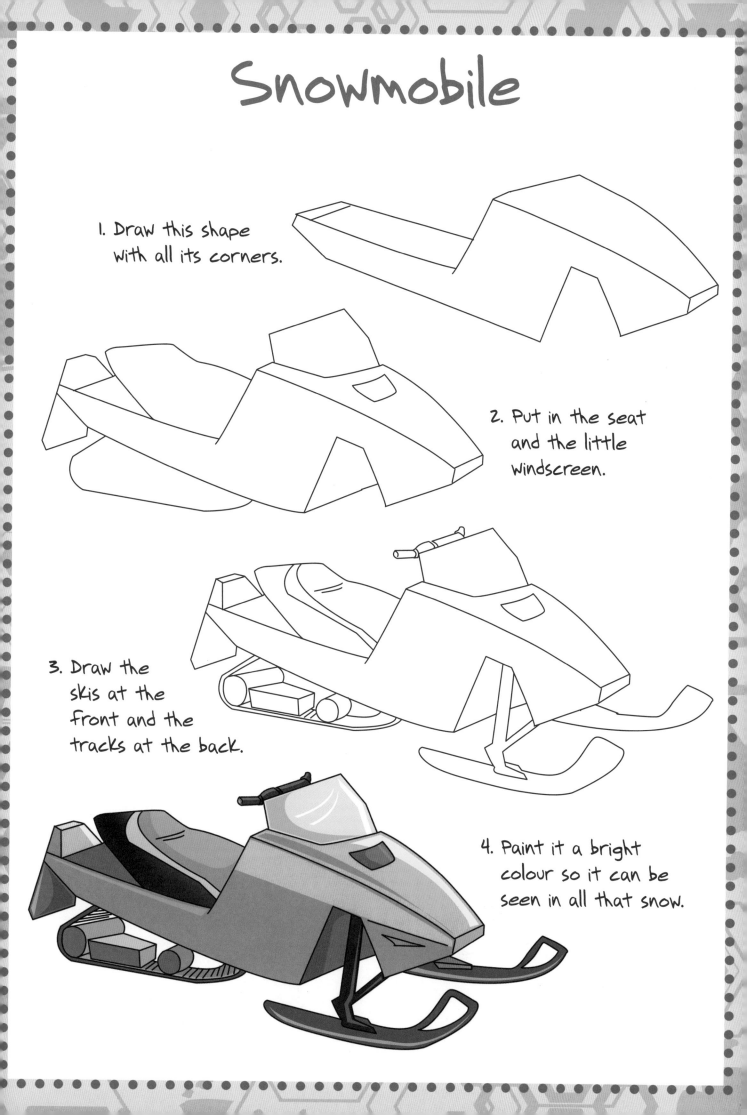

1. Draw this shape with all its corners.

2. Put in the seat and the little windscreen.

3. Draw the skis at the front and the tracks at the back.

4. Paint it a bright colour so it can be seen in all that snow.

Lear Jet

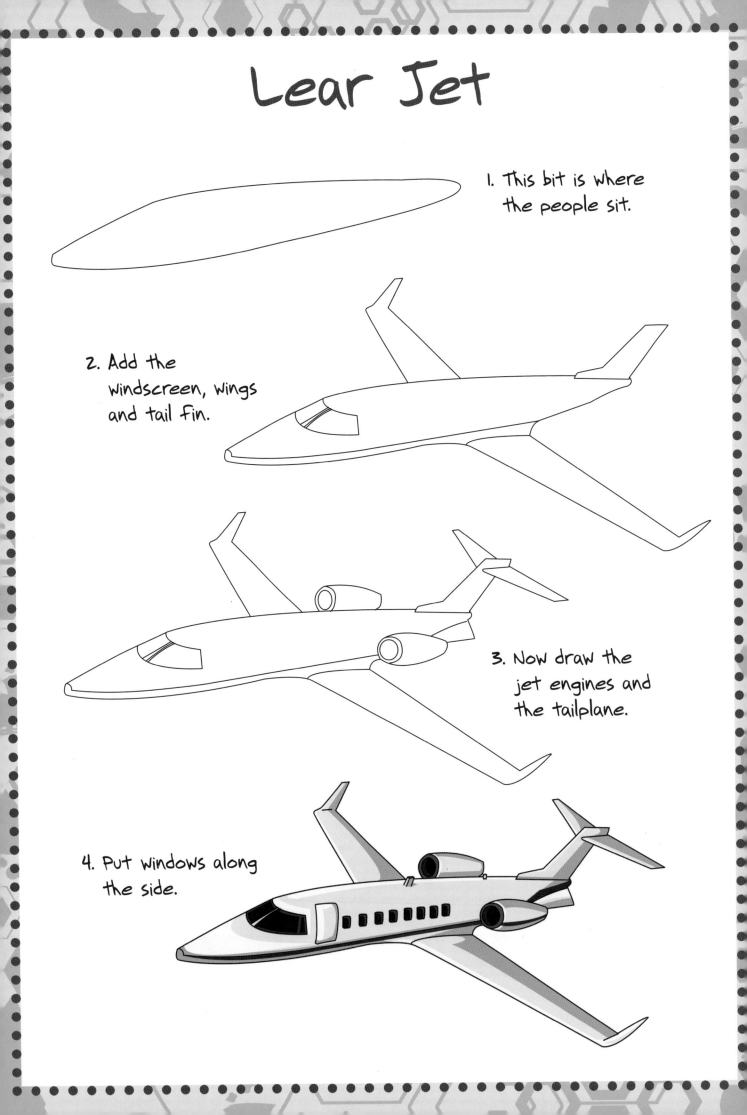

1. This bit is where the people sit.

2. Add the windscreen, wings and tail fin.

3. Now draw the jet engines and the tailplane.

4. Put windows along the side.

MANGA

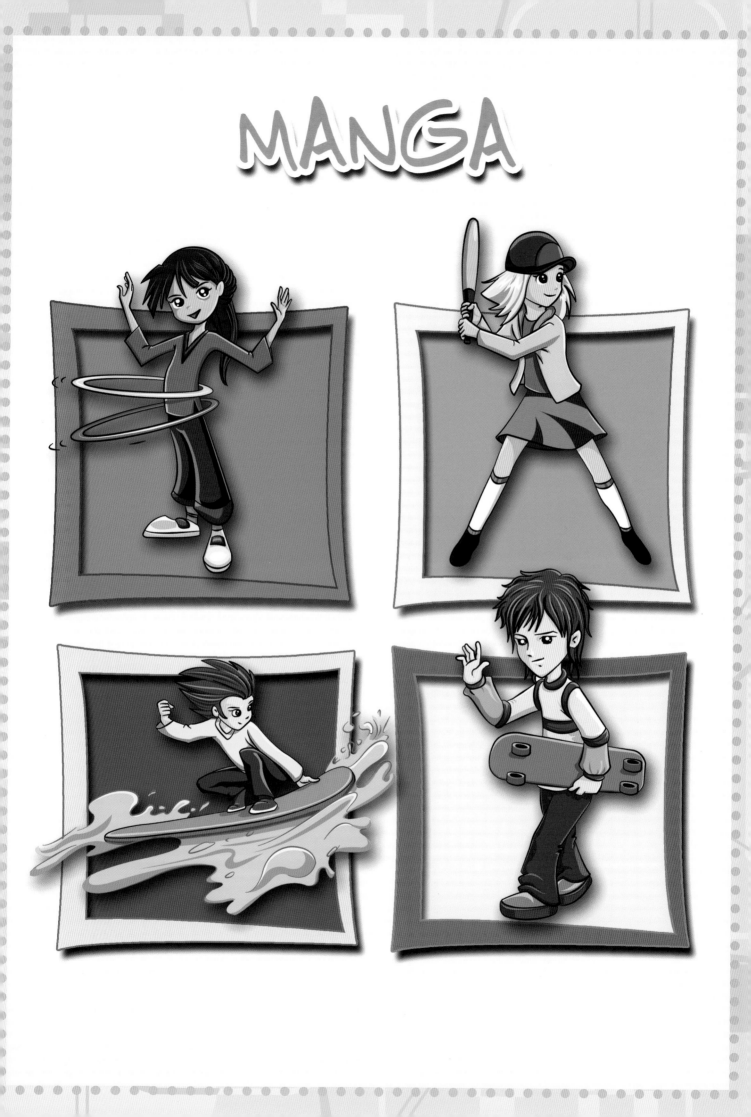

YUKI

1. Here's the head and body.

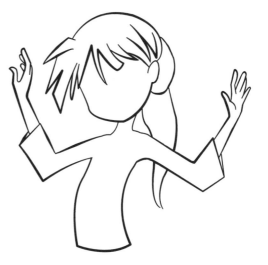

2. Put in the hair and arms.

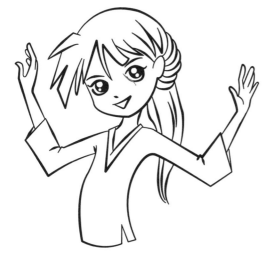

3. Add the face.

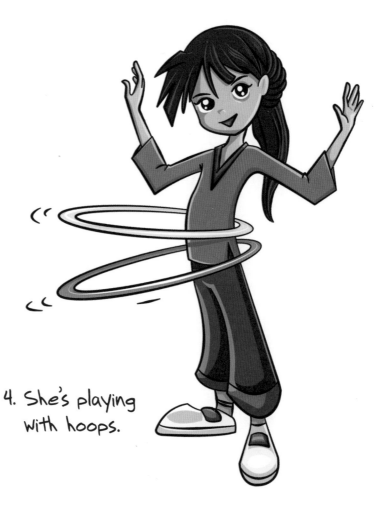

4. She's playing with hoops.

Takiko

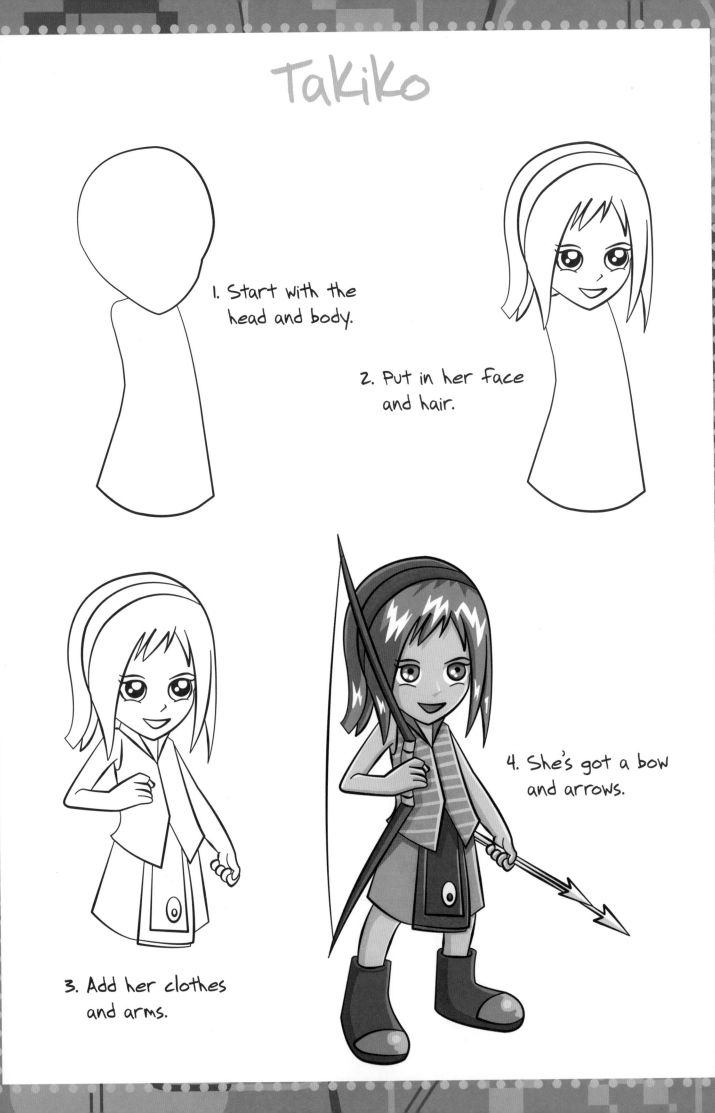

1. Start with the head and body.

2. Put in her face and hair.

3. Add her clothes and arms.

4. She's got a bow and arrows.

Junji

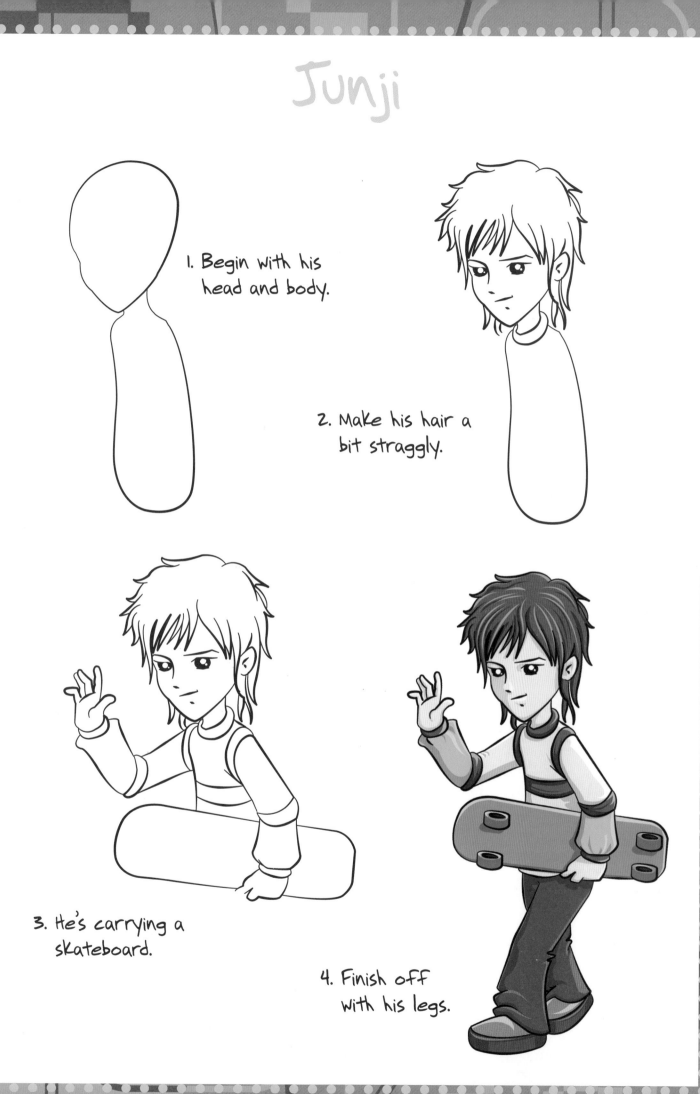

1. Begin with his head and body.

2. Make his hair a bit straggly.

3. He's carrying a skateboard.

4. Finish off with his legs.

Sasuke

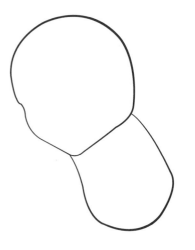

1. Draw the head and body.

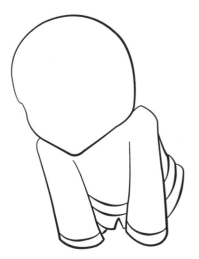

2. Now put in her arms.

3. Add her face and hands.

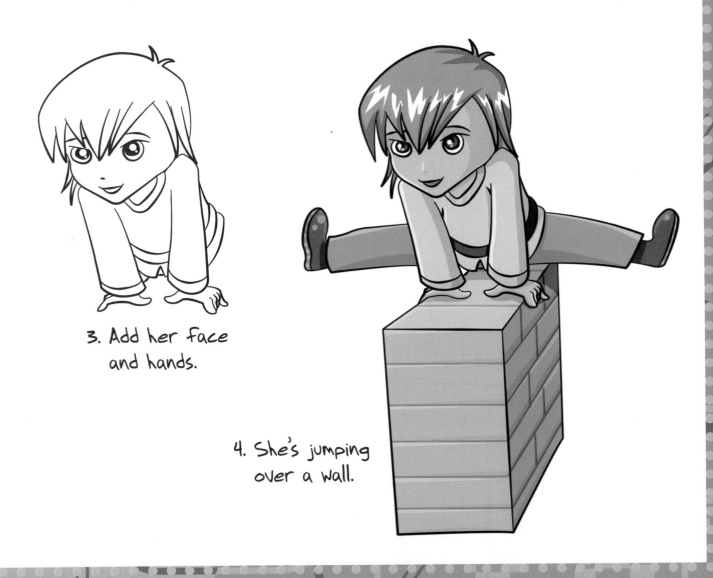

4. She's jumping over a wall.

Miki

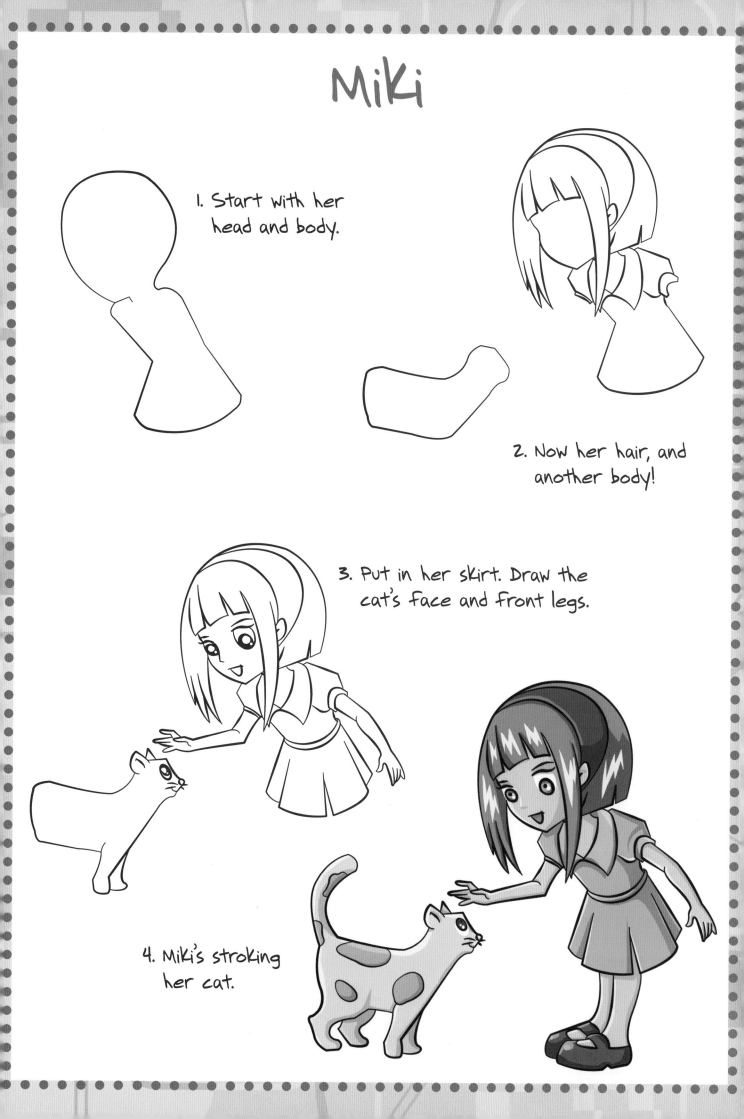

1. Start with her head and body.

2. Now her hair, and another body!

3. Put in her skirt. Draw the cat's face and front legs.

4. Miki's stroking her cat.

Kyoko

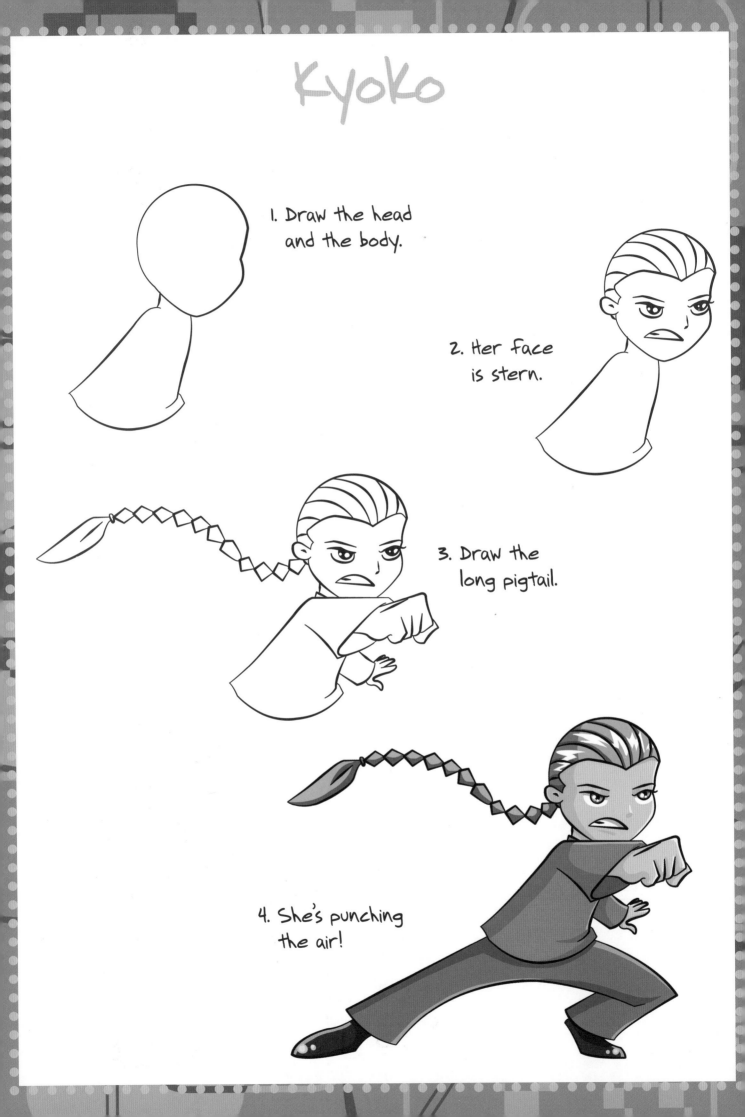

1. Draw the head and the body.

2. Her face is stern.

3. Draw the long pigtail.

4. She's punching the air!

Baku

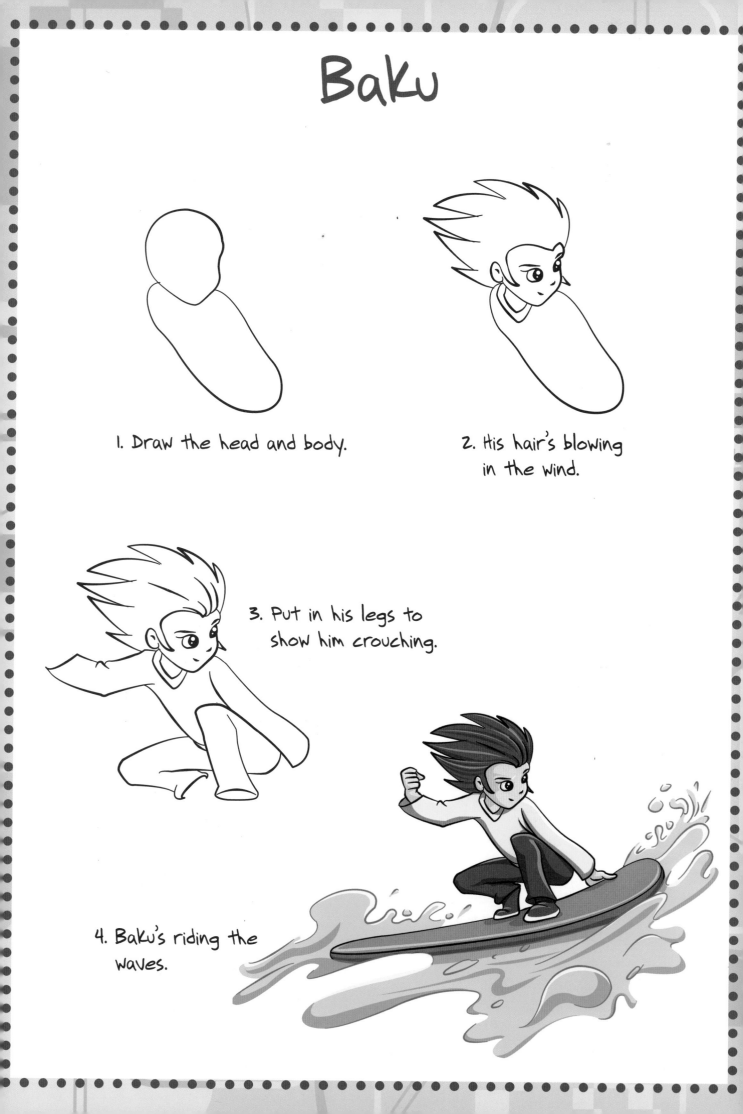

1. Draw the head and body.

2. His hair's blowing in the wind.

3. Put in his legs to show him crouching.

4. Baku's riding the waves.

Anju

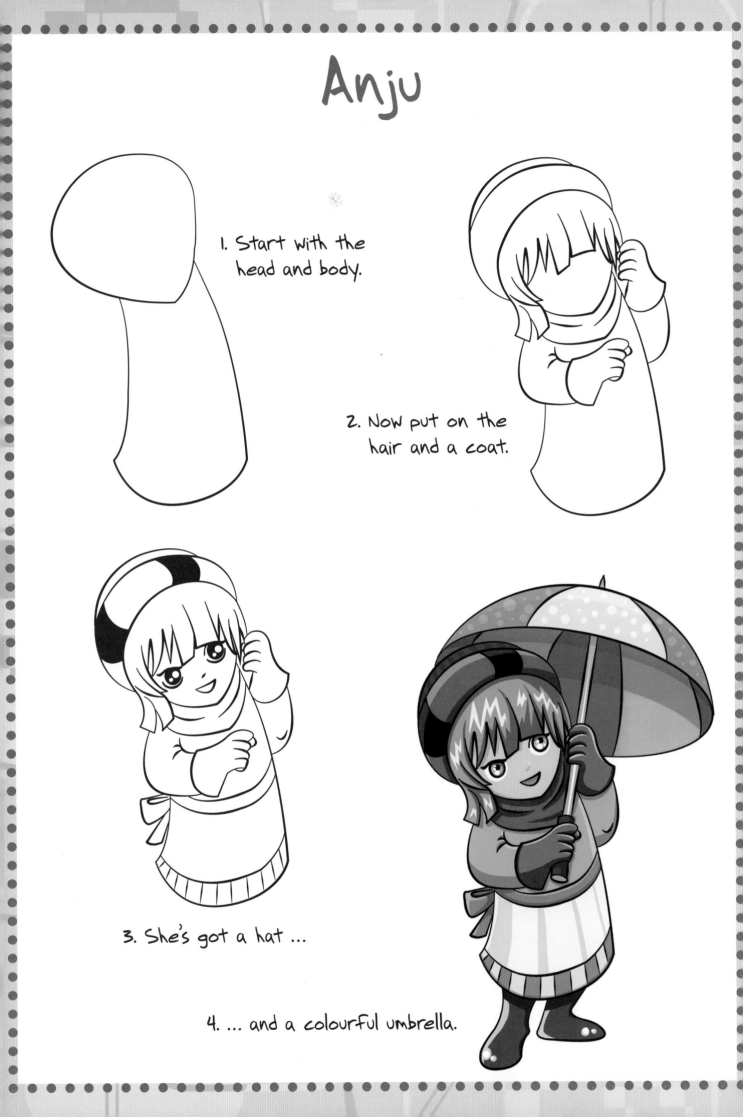

1. Start with the head and body.

2. Now put on the hair and a coat.

3. She's got a hat ...

4. ... and a colourful umbrella.

Takahiro

1. Draw the head and body.

2. Add some spiky hair.

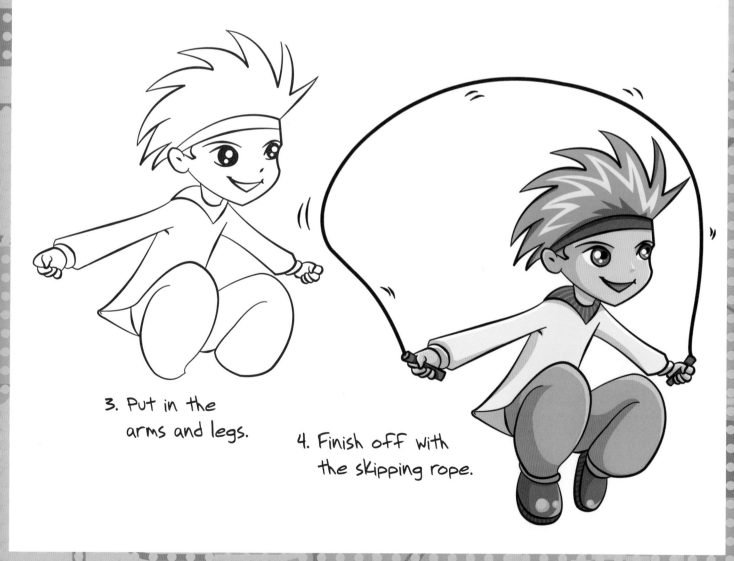

3. Put in the arms and legs.

4. Finish off with the skipping rope.

Akio

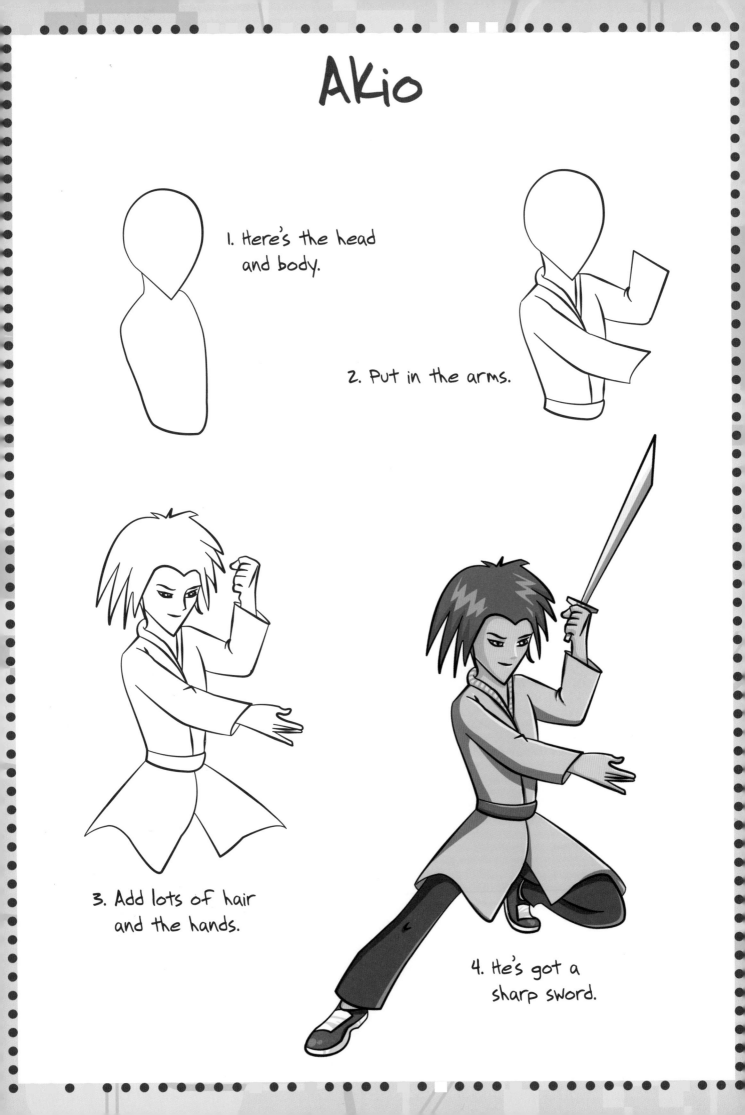

1. Here's the head and body.

2. Put in the arms.

3. Add lots of hair and the hands.

4. He's got a sharp sword.

Riya

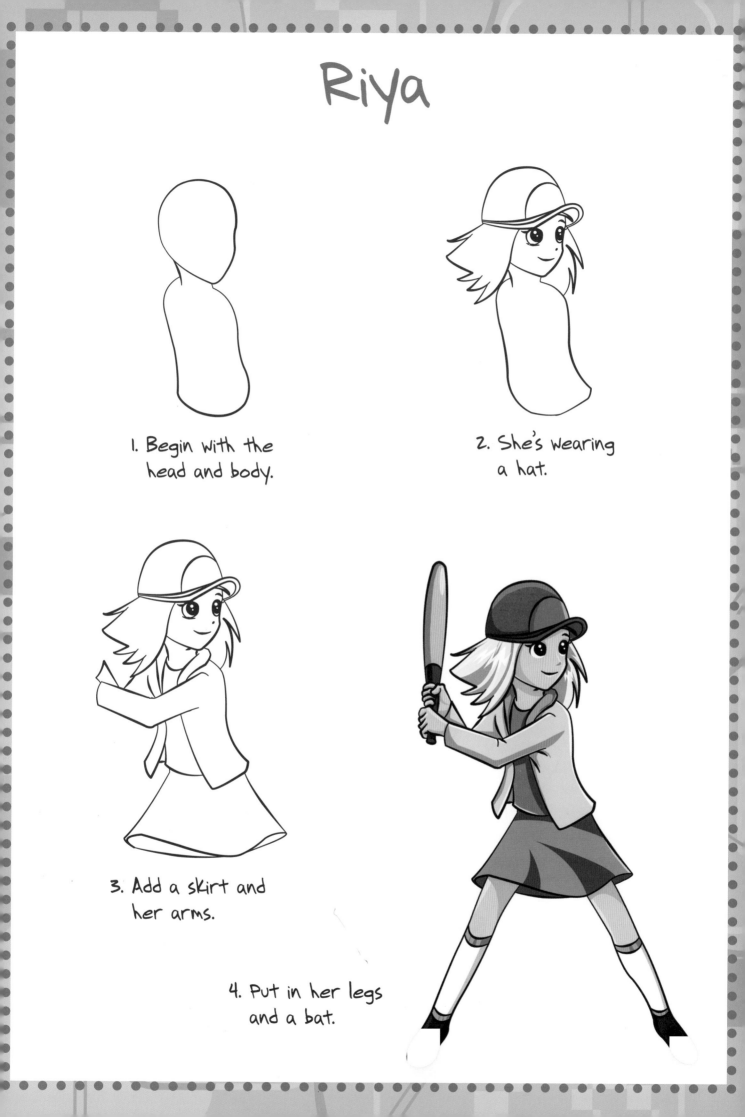

1. Begin with the head and body.

2. She's wearing a hat.

3. Add a skirt and her arms.

4. Put in her legs and a bat.

Kiyoshi

1. Draw the body and head.

2. Now add the arms.

3. Put in the face.

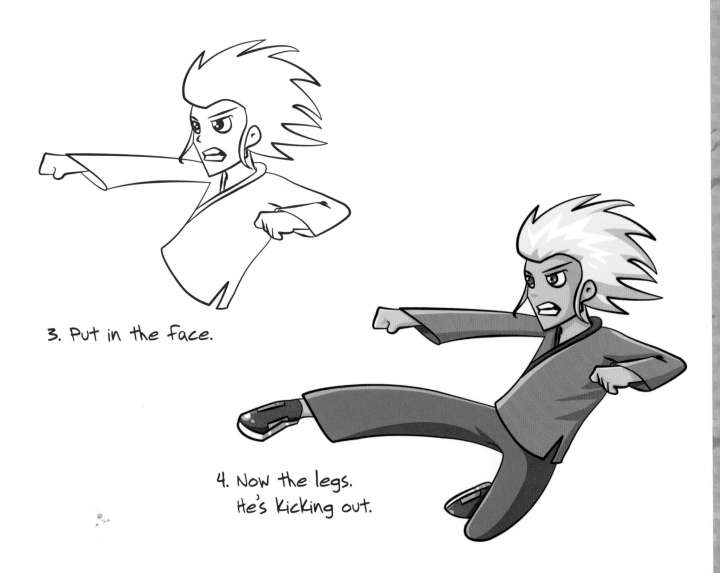

4. Now the legs.
He's kicking out.

Akira

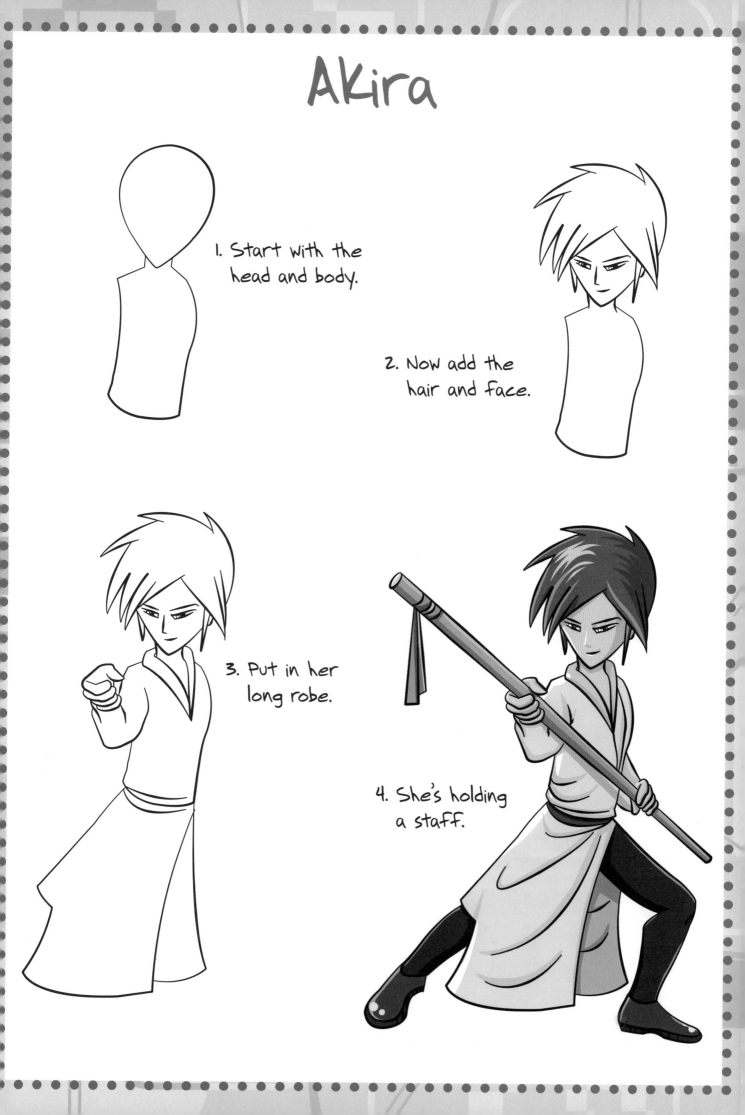

1. Start with the head and body.

2. Now add the hair and face.

3. Put in her long robe.

4. She's holding a staff.

YUZO

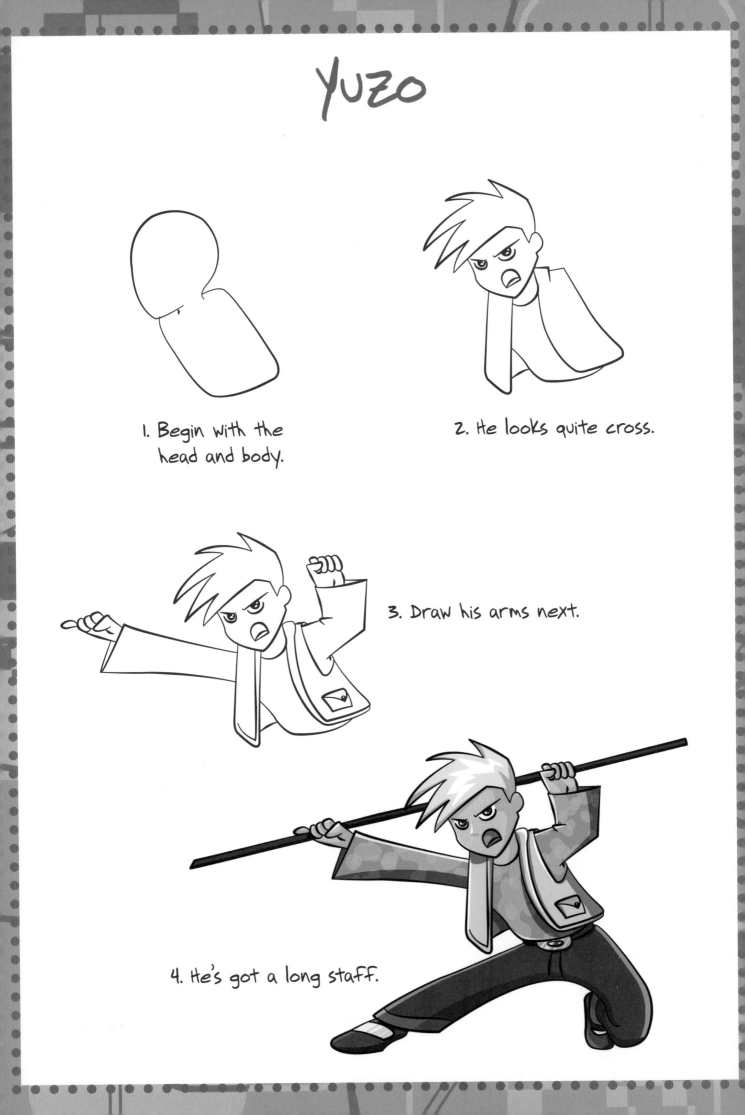

1. Begin with the head and body.

2. He looks quite cross.

3. Draw his arms next.

4. He's got a long staff.

Benika

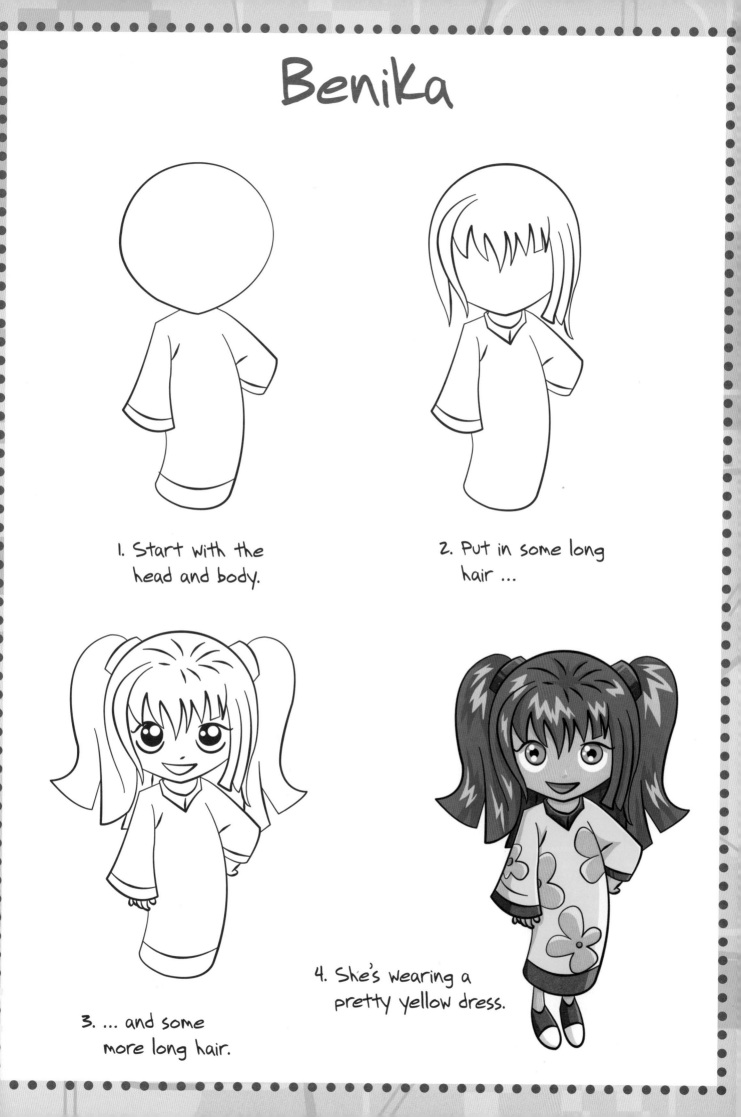

1. Start with the head and body.

2. Put in some long hair ...

3. ... and some more long hair.

4. She's wearing a pretty yellow dress.

Taigo

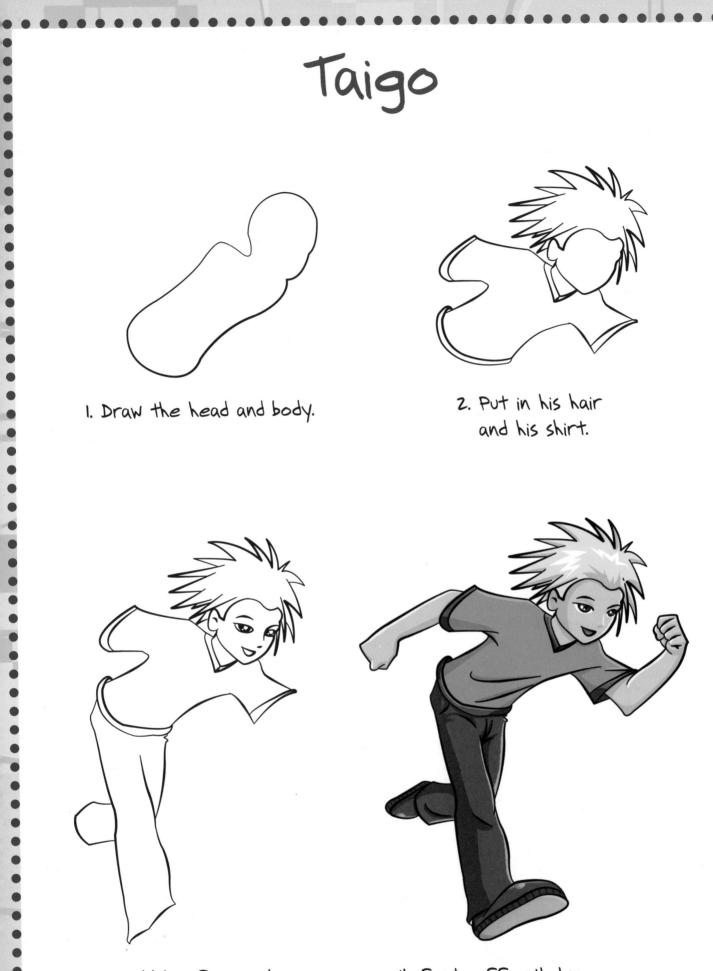

1. Draw the head and body.

2. Put in his hair and his shirt.

3. Now add his face and his running legs.

4. Finish off with his arms and feet.

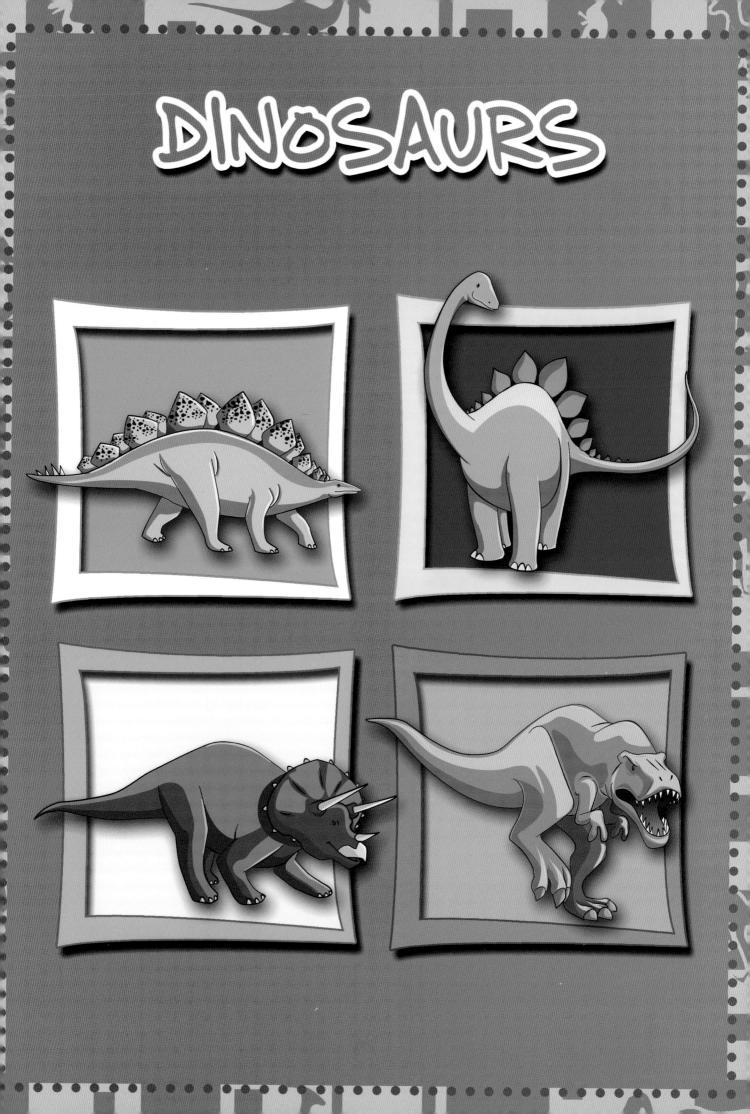

DINOSAURS

Diplodocus

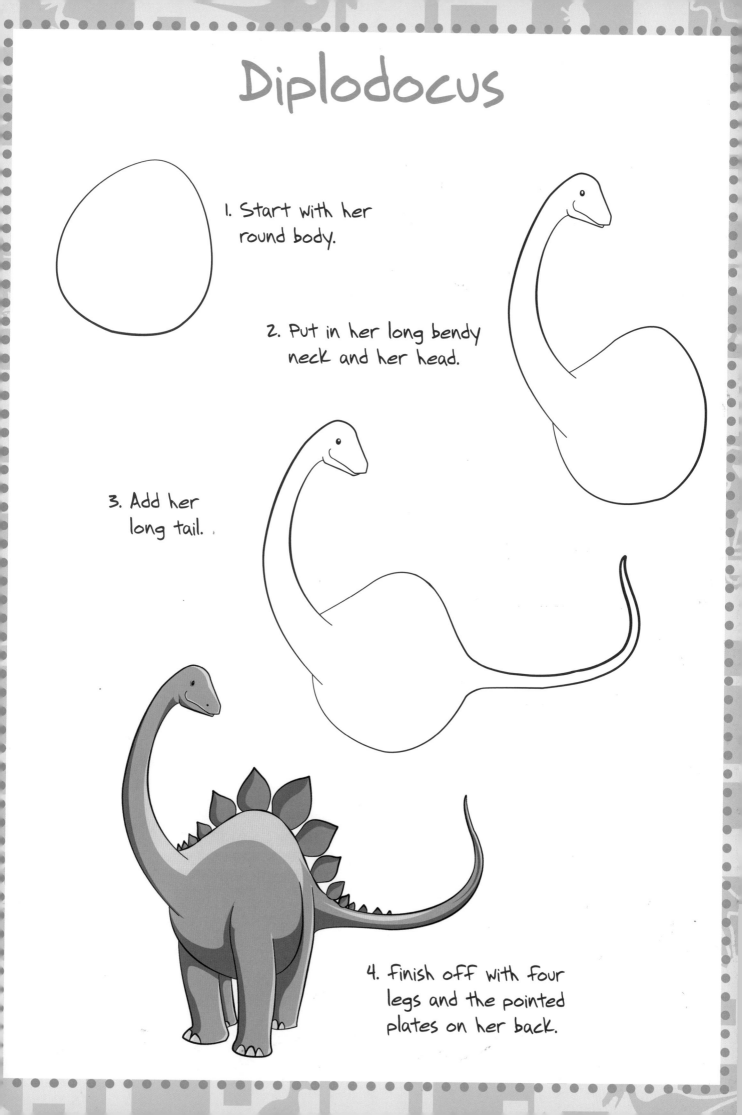

1. Start with her round body.

2. Put in her long bendy neck and her head.

3. Add her long tail.

4. Finish off with four legs and the pointed plates on her back.

Brontosaurus

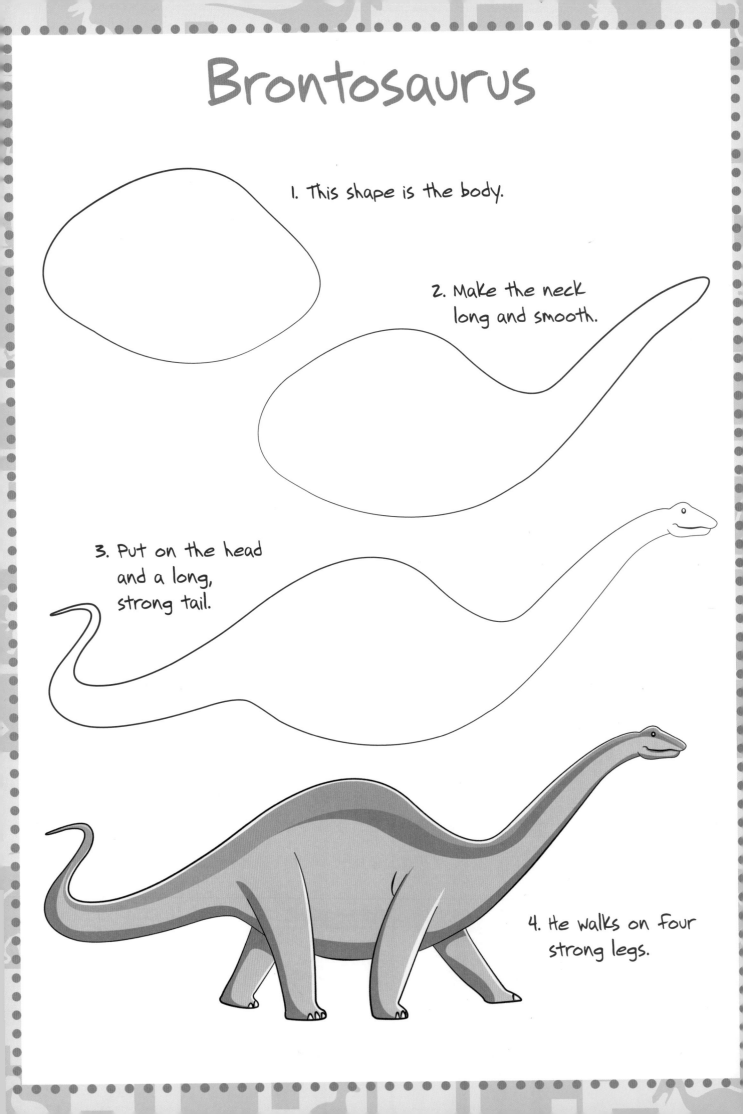

1. This shape is the body.

2. Make the neck long and smooth.

3. Put on the head and a long, strong tail.

4. He walks on four strong legs.

Tyrannosaurus Rex

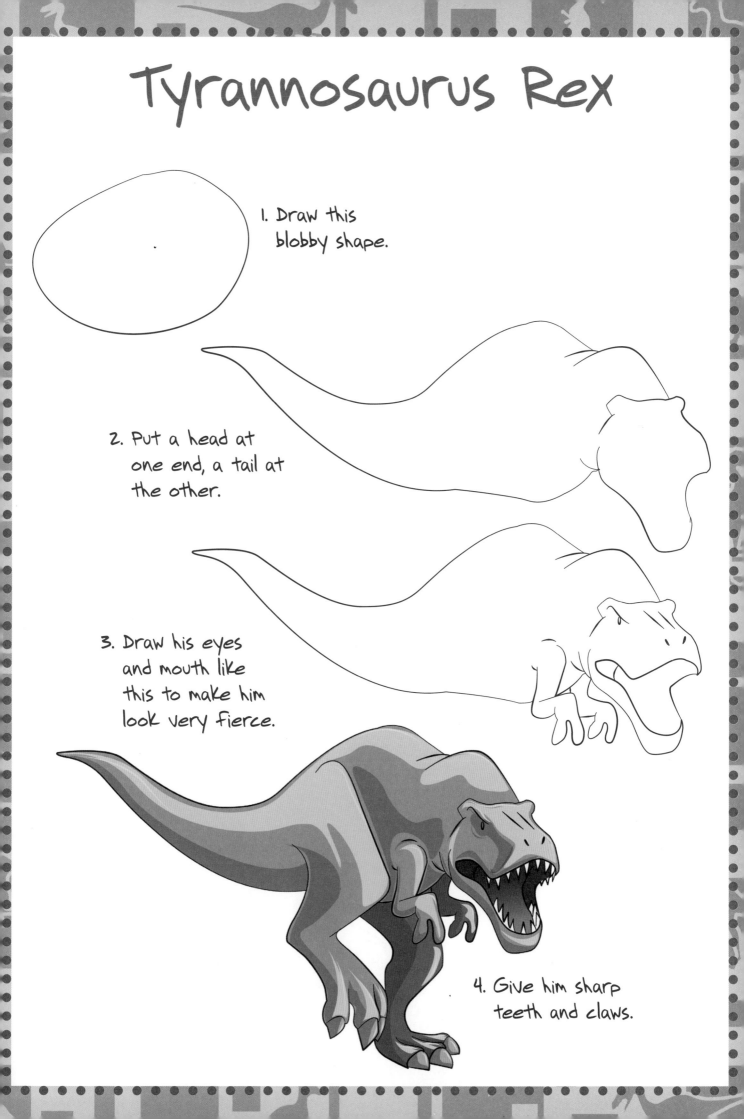

1. Draw this blobby shape.

2. Put a head at one end, a tail at the other.

3. Draw his eyes and mouth like this to make him look very fierce.

4. Give him sharp teeth and claws.

Pterodactyl

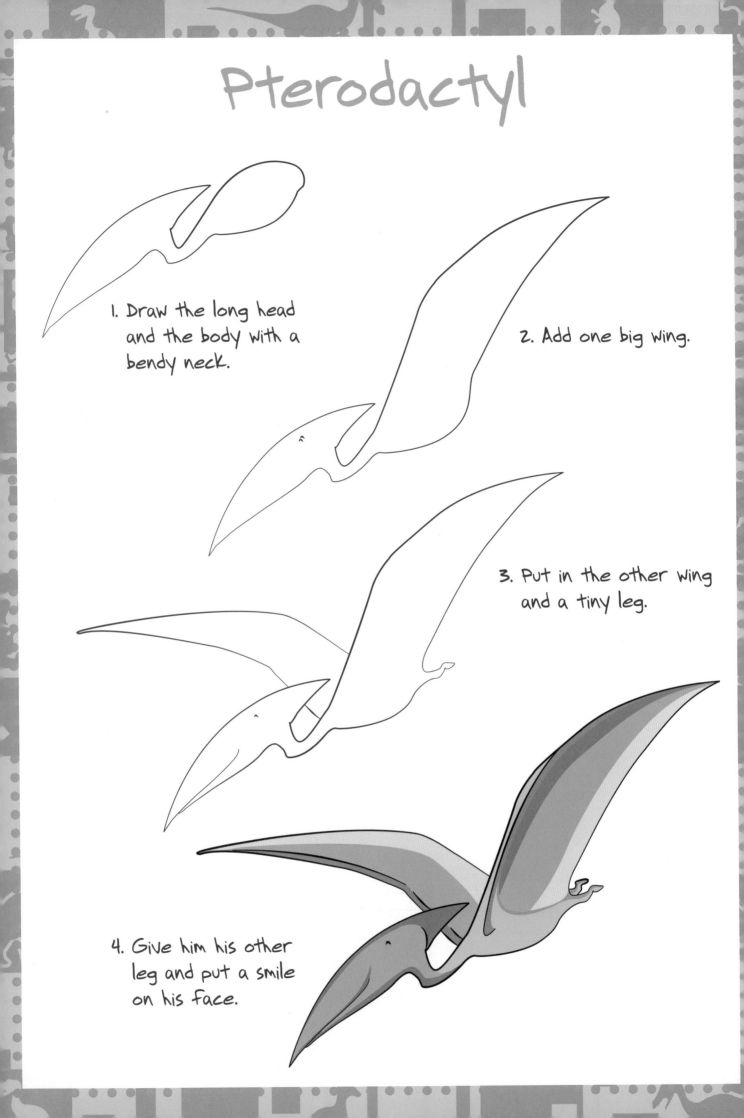

1. Draw the long head and the body with a bendy neck.

2. Add one big wing.

3. Put in the other wing and a tiny leg.

4. Give him his other leg and put a smile on his face.

Triceratops

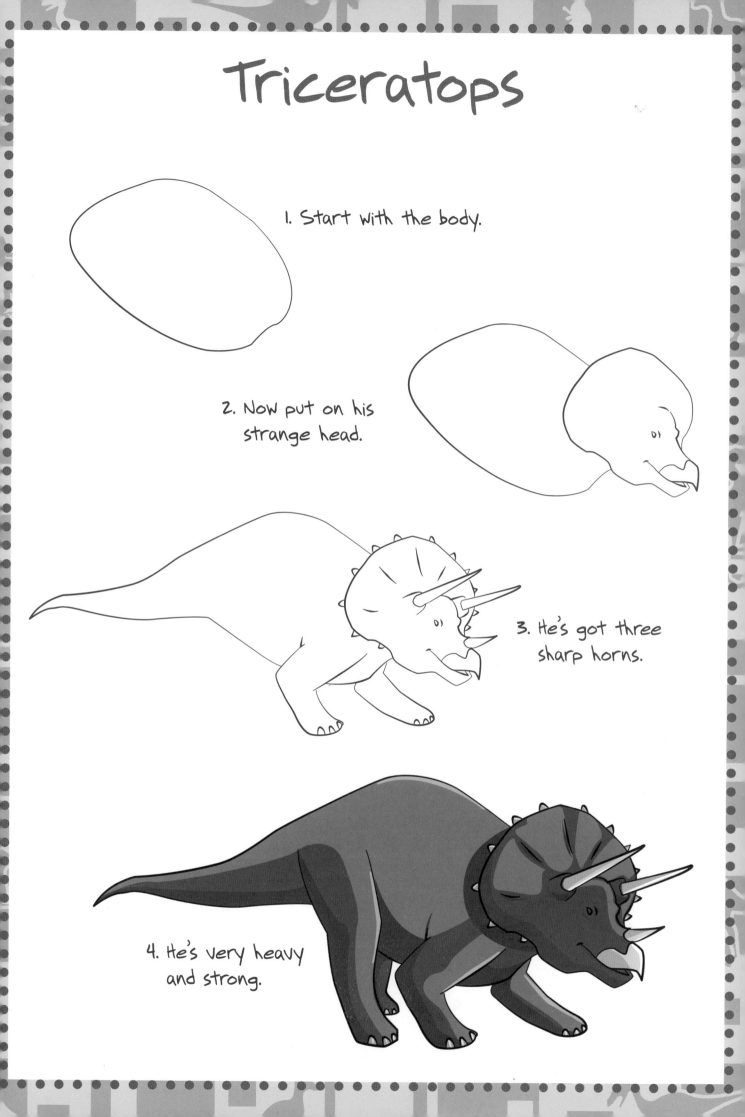

1. Start with the body.

2. Now put on his strange head.

3. He's got three sharp horns.

4. He's very heavy and strong.

Seismosaurus

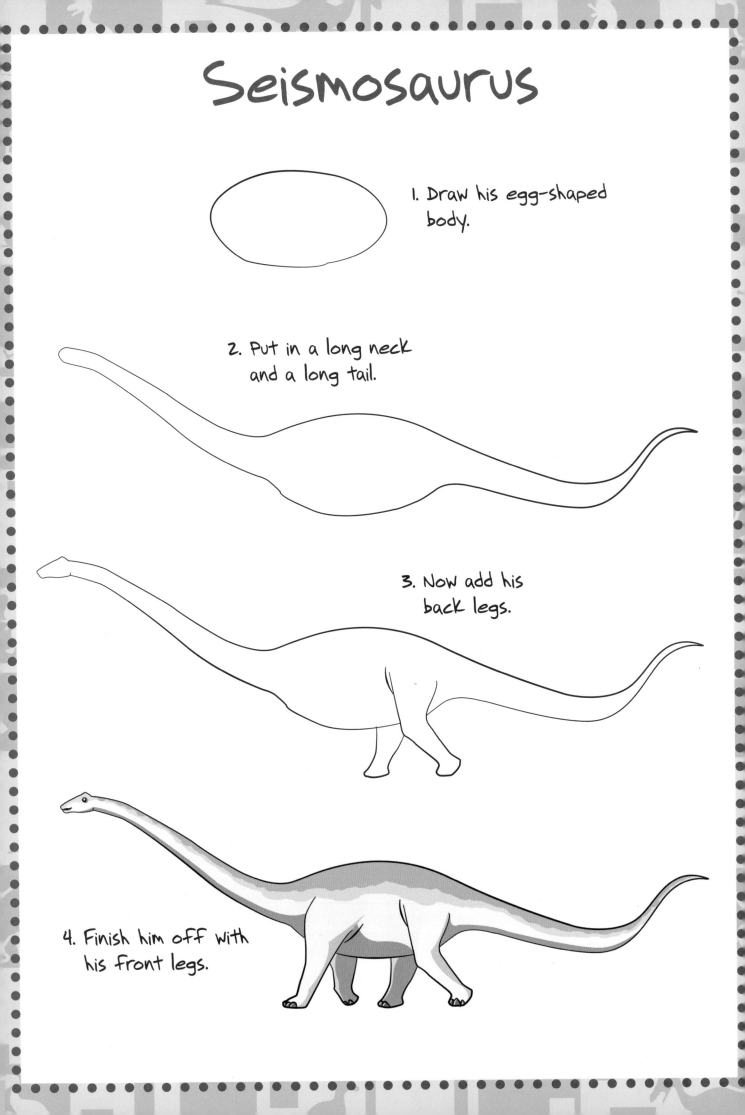

1. Draw his egg-shaped body.

2. Put in a long neck and a long tail.

3. Now add his back legs.

4. Finish him off with his front legs.

Velociraptor

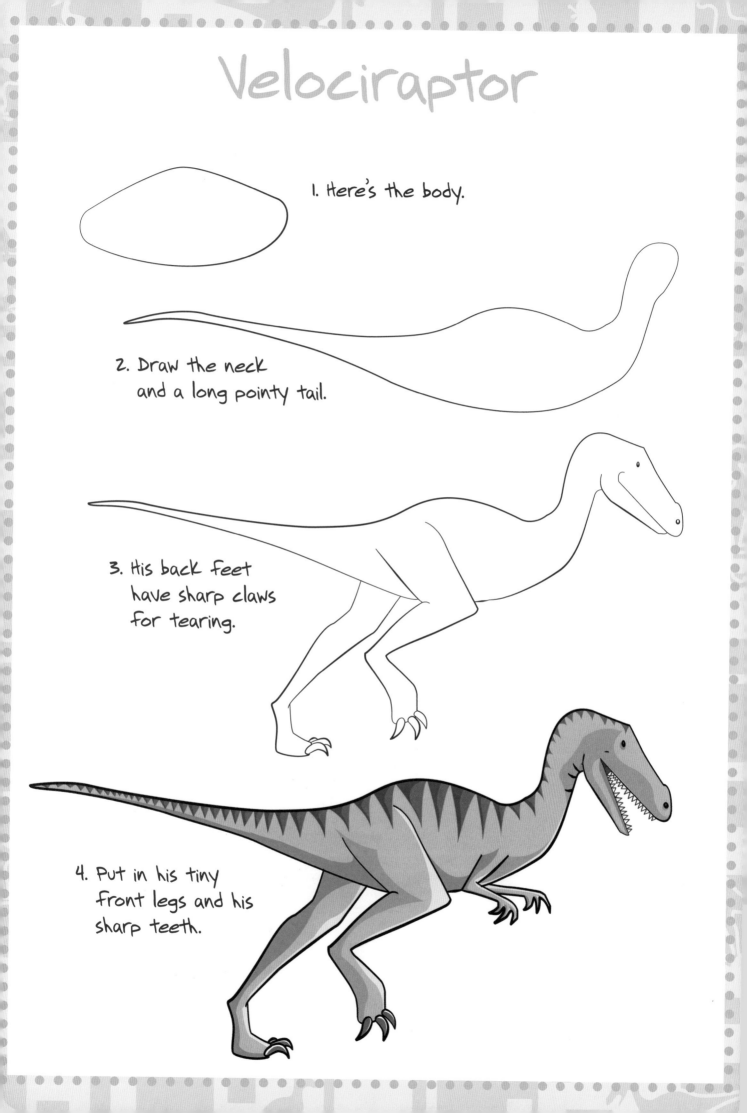

1. Here's the body.

2. Draw the neck
and a long pointy tail.

3. His back feet
have sharp claws
for tearing.

4. Put in his tiny
front legs and his
sharp teeth.

Archaeopteryx

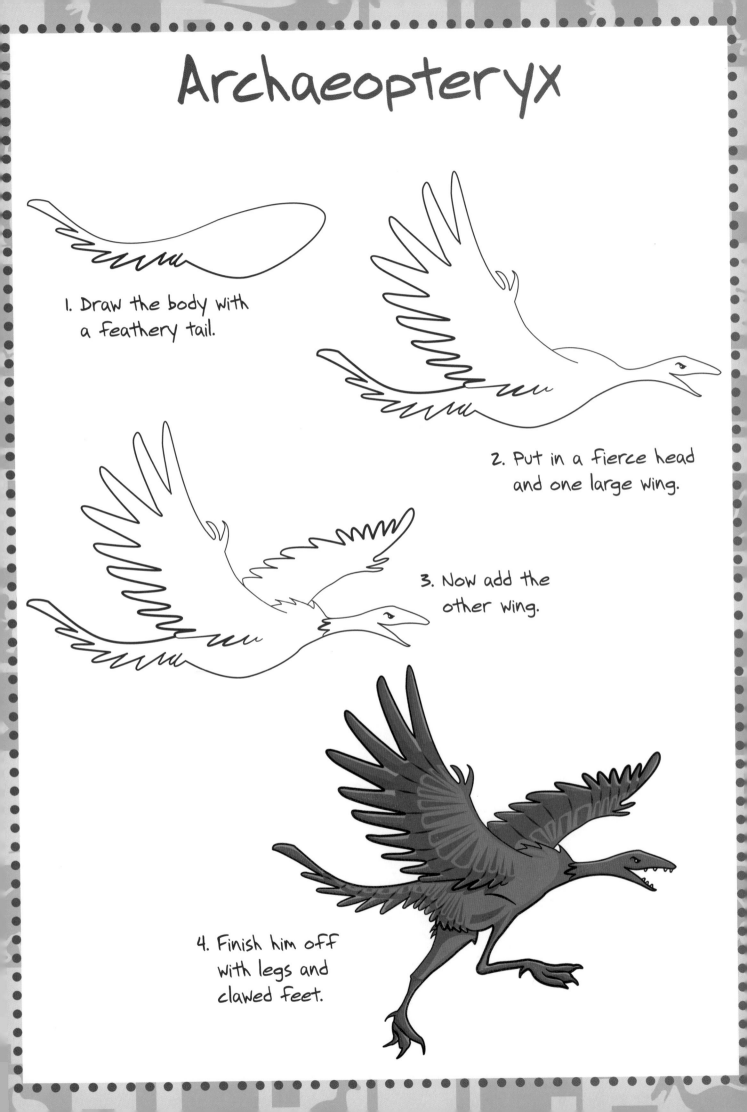

1. Draw the body with a feathery tail.

2. Put in a fierce head and one large wing.

3. Now add the other wing.

4. Finish him off with legs and clawed feet.

Iguanodon

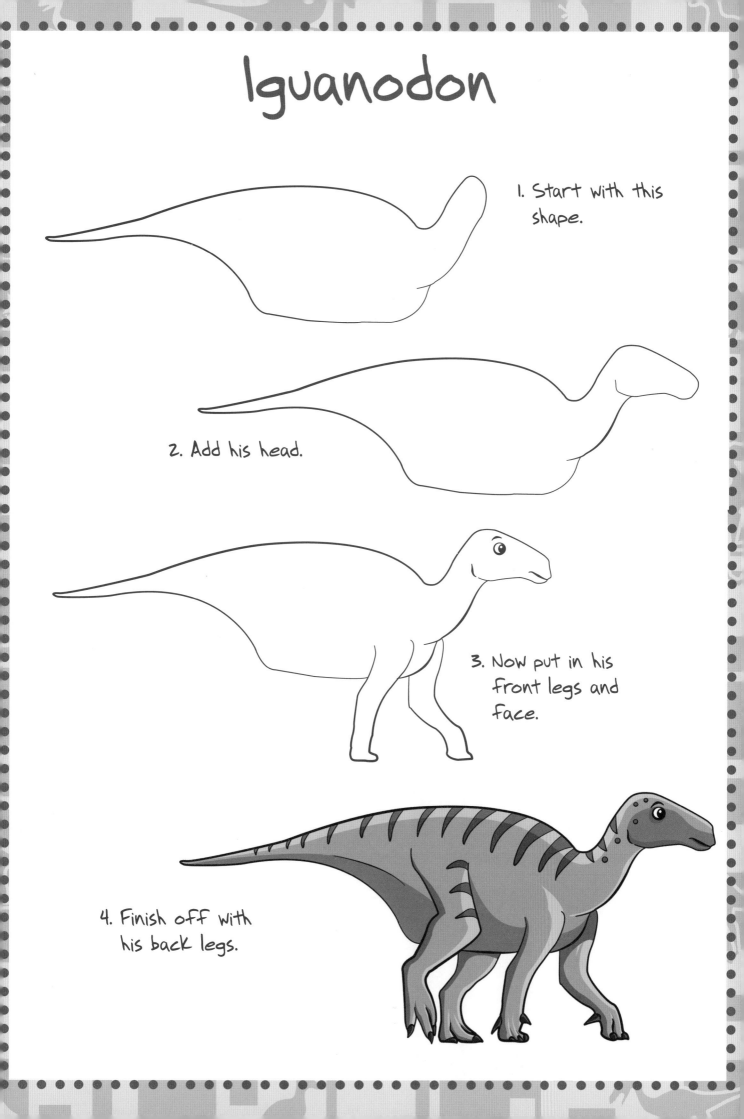

1. Start with this shape.

2. Add his head.

3. Now put in his front legs and face.

4. Finish off with his back legs.

Leaellynasaura

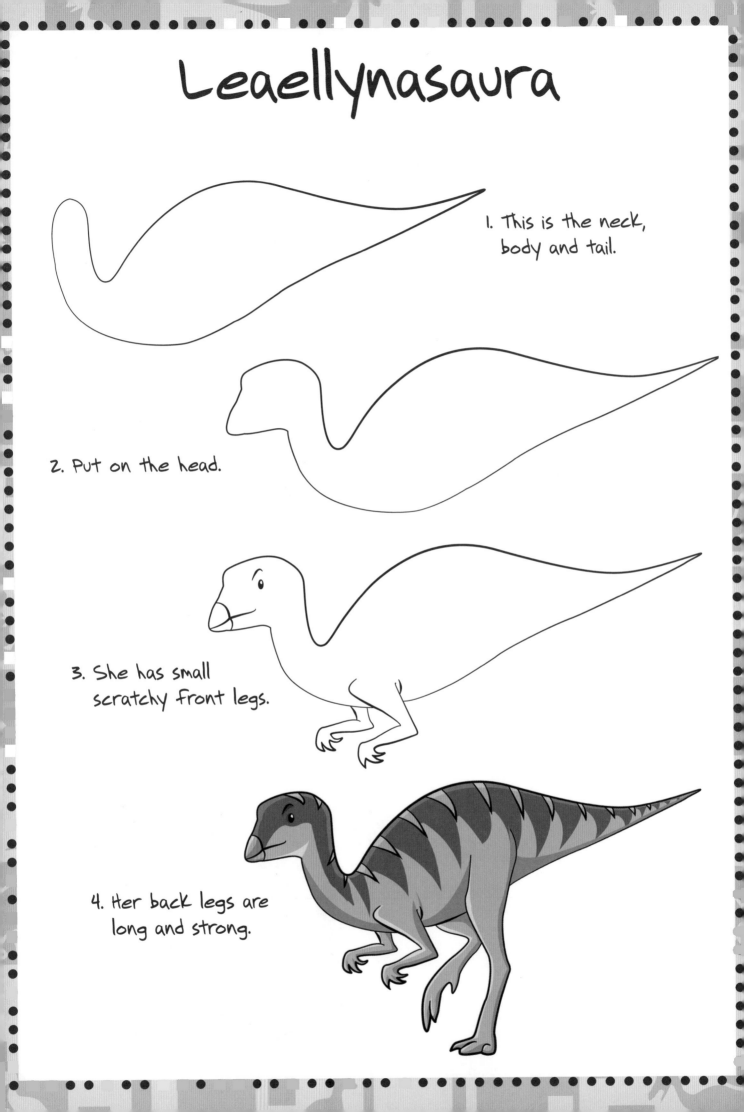

1. This is the neck, body and tail.

2. Put on the head.

3. She has small scratchy front legs.

4. Her back legs are long and strong.

Stegosaurus

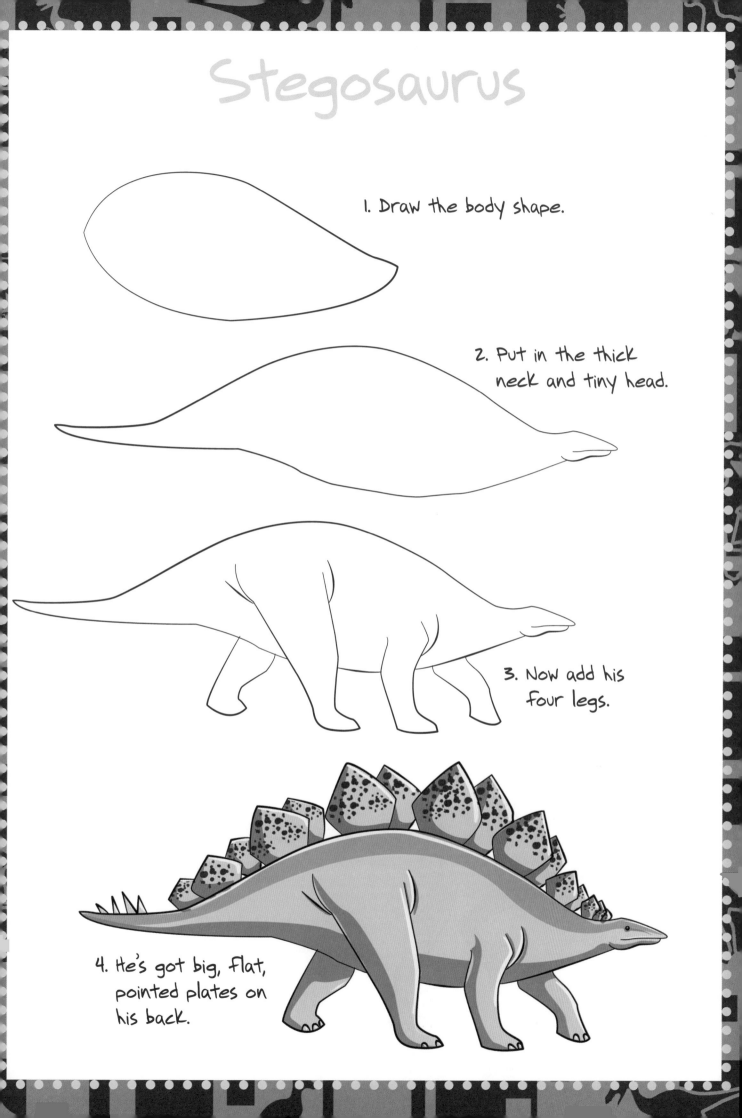

1. Draw the body shape.

2. Put in the thick neck and tiny head.

3. Now add his four legs.

4. He's got big, flat, pointed plates on his back.

Deinonychus

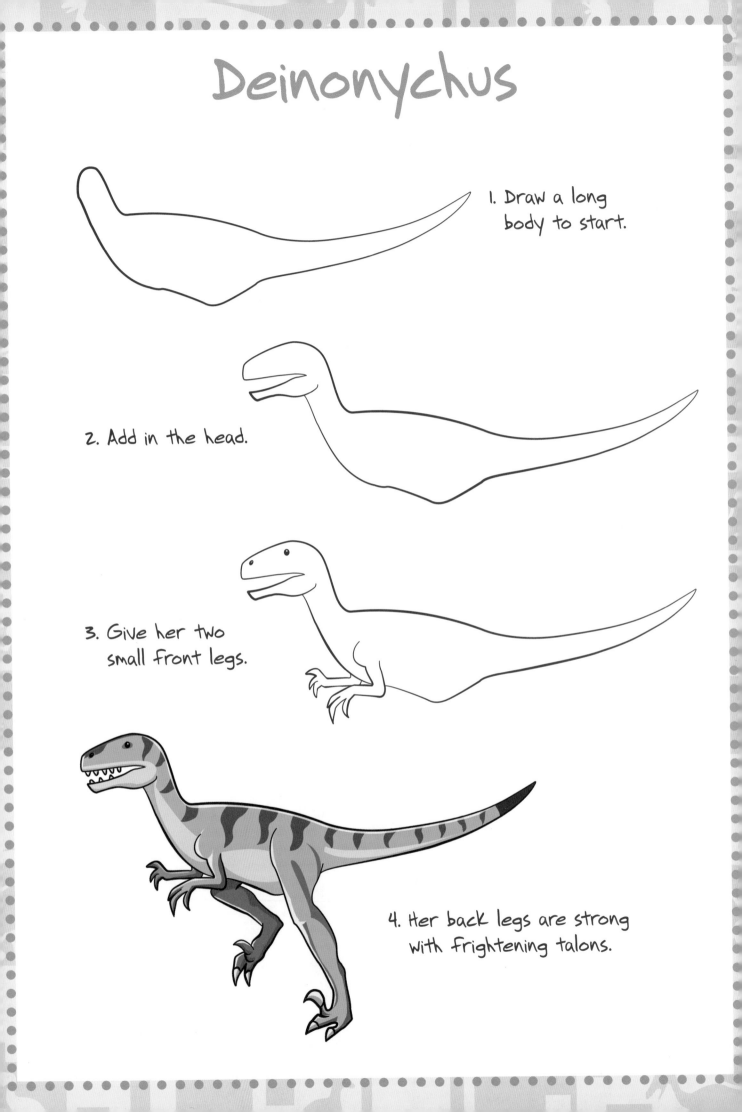

1. Draw a long body to start.

2. Add in the head.

3. Give her two small front legs.

4. Her back legs are strong with frightening talons.

Giganotosaurus

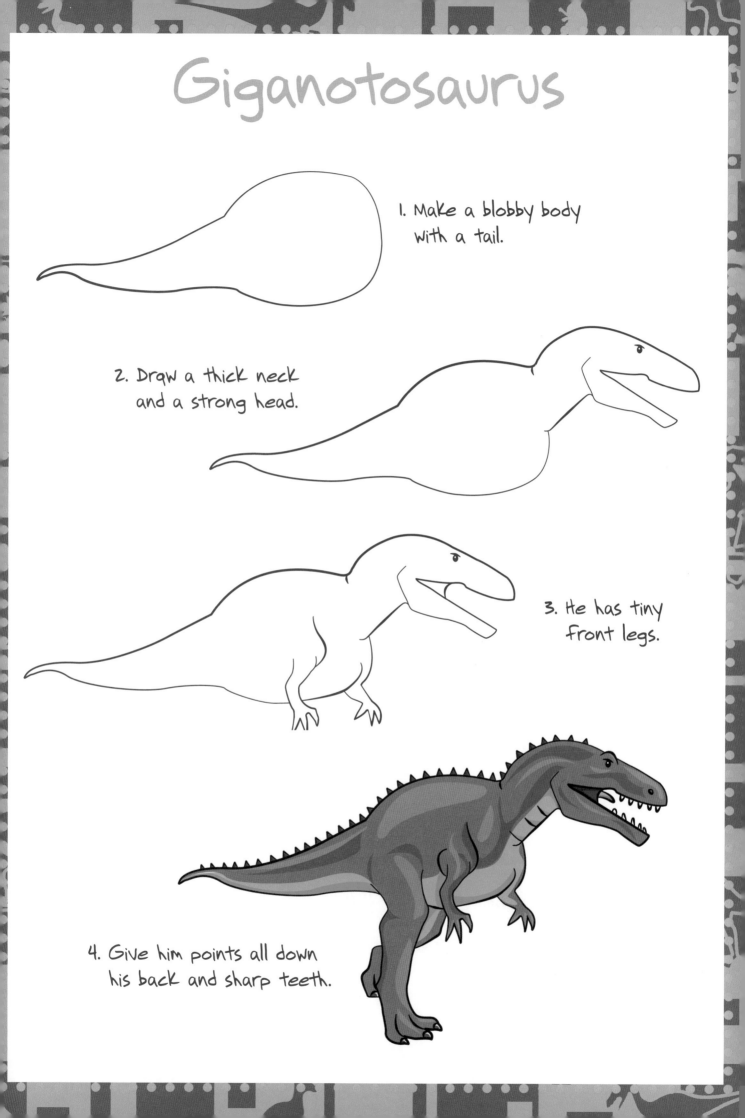

1. Make a blobby body with a tail.

2. Draw a thick neck and a strong head.

3. He has tiny front legs.

4. Give him points all down his back and sharp teeth.

Coelophysis

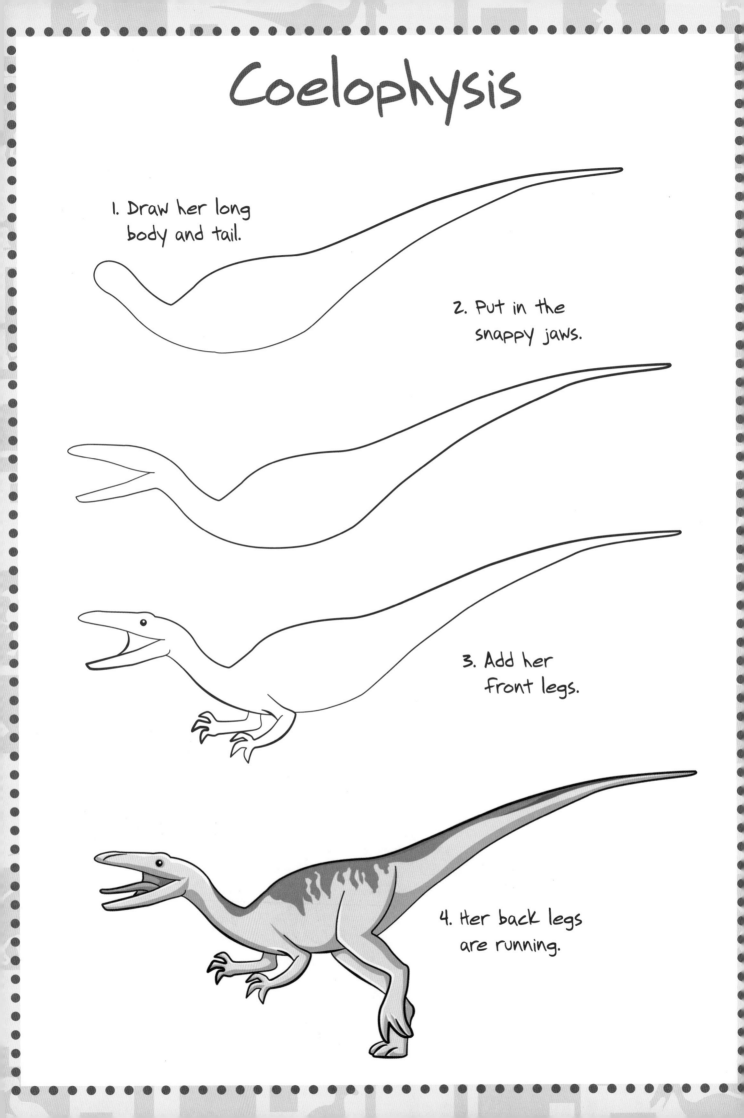

1. Draw her long body and tail.

2. Put in the snappy jaws.

3. Add her front legs.

4. Her back legs are running.

Parasaurolophus

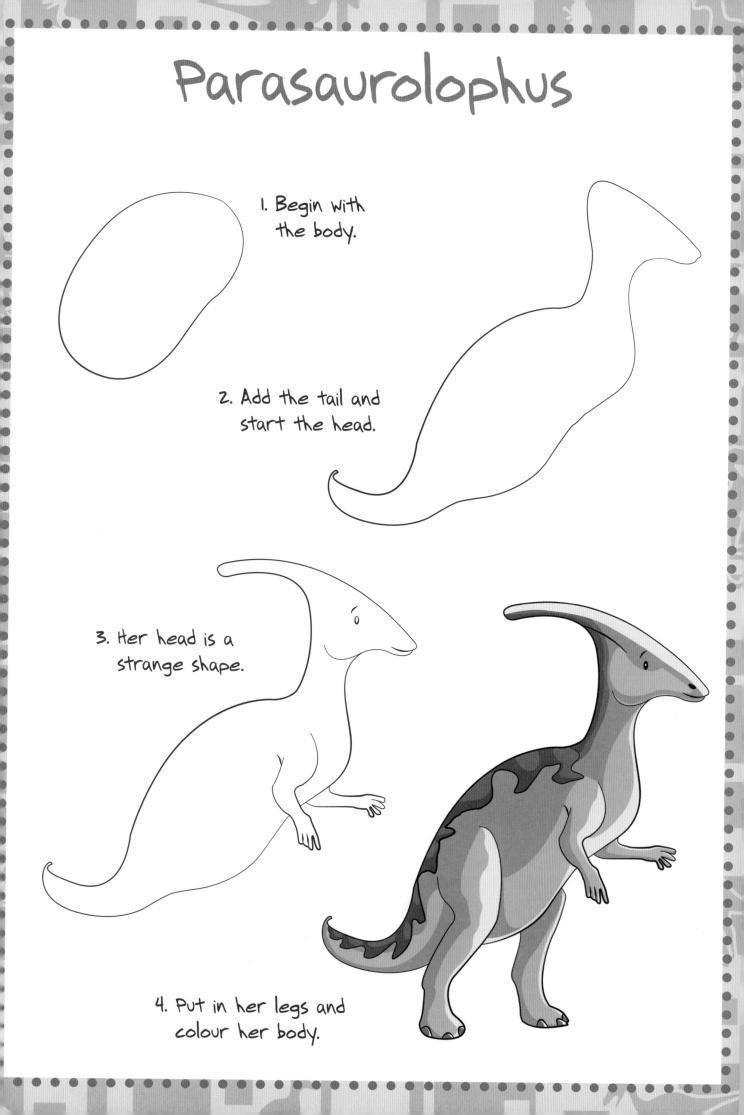

1. Begin with the body.

2. Add the tail and start the head.

3. Her head is a strange shape.

4. Put in her legs and colour her body.

Syntarsus

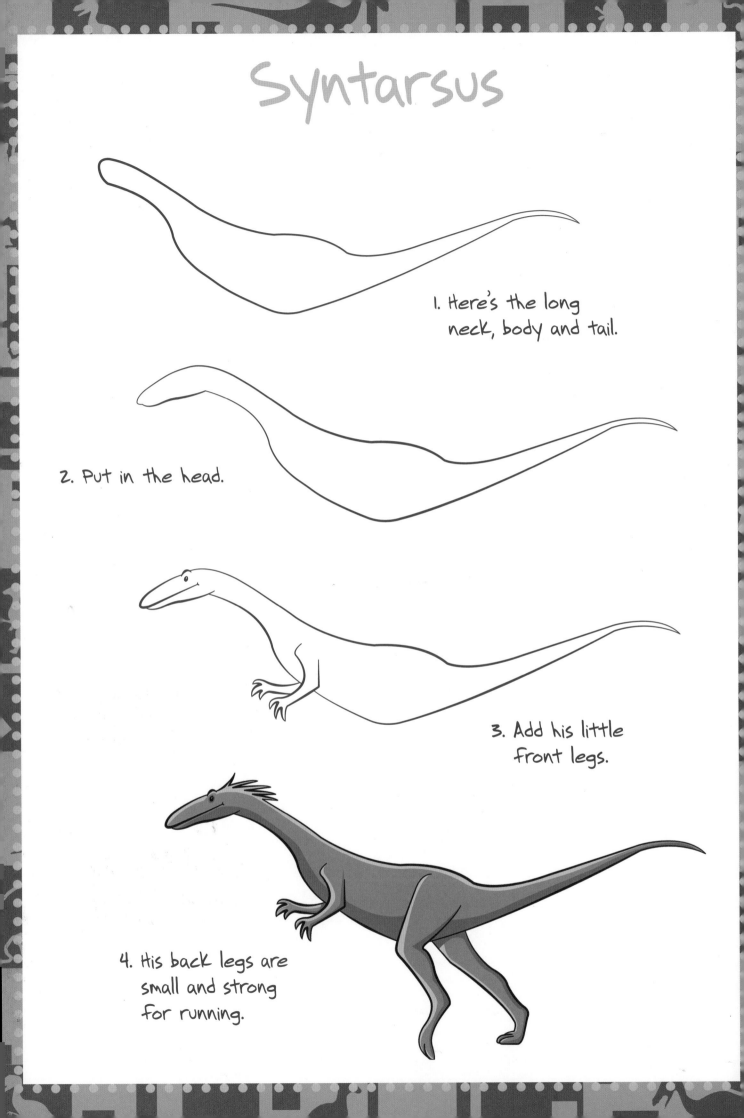

1. Here's the long neck, body and tail.

2. Put in the head.

3. Add his little front legs.

4. His back legs are small and strong for running.

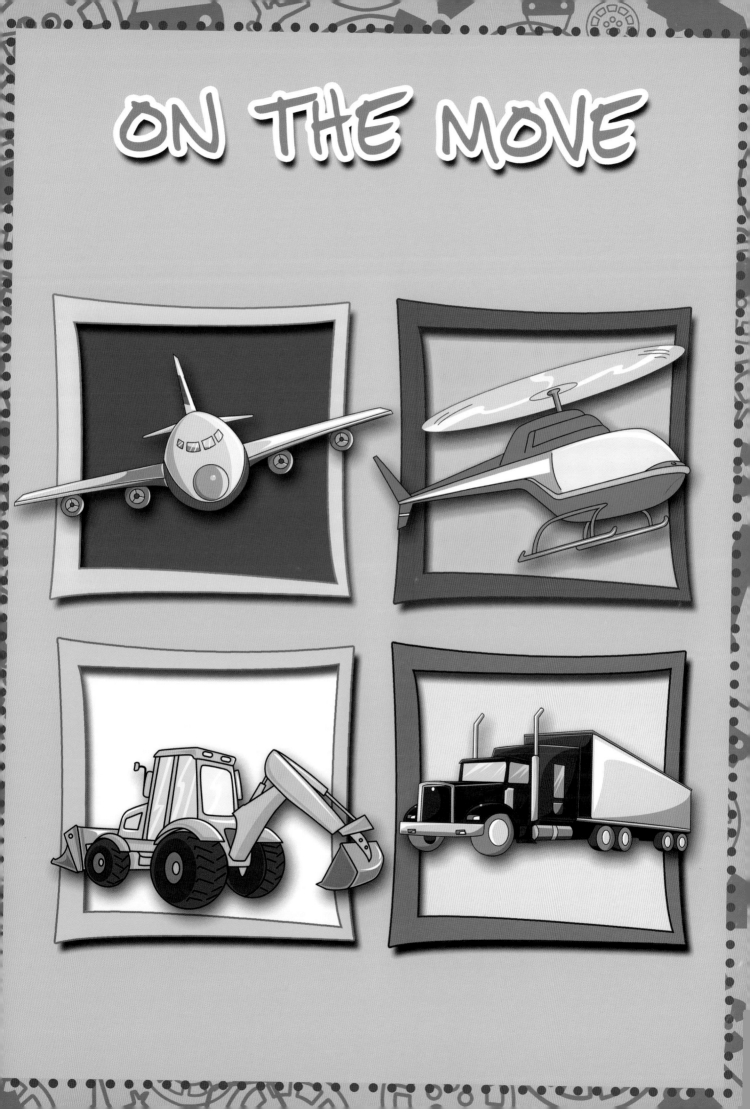

ON THE MOVE

Fire Engine

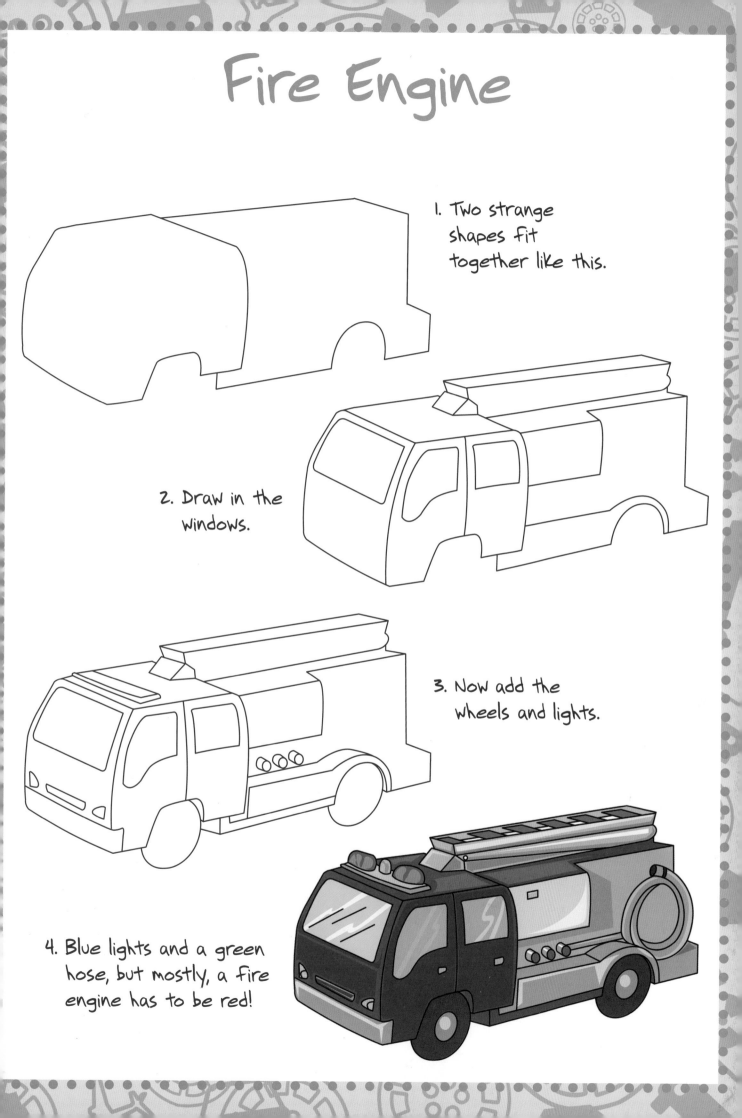

1. Two strange shapes fit together like this.

2. Draw in the windows.

3. Now add the wheels and lights.

4. Blue lights and a green hose, but mostly, a fire engine has to be red!

Viking Ship

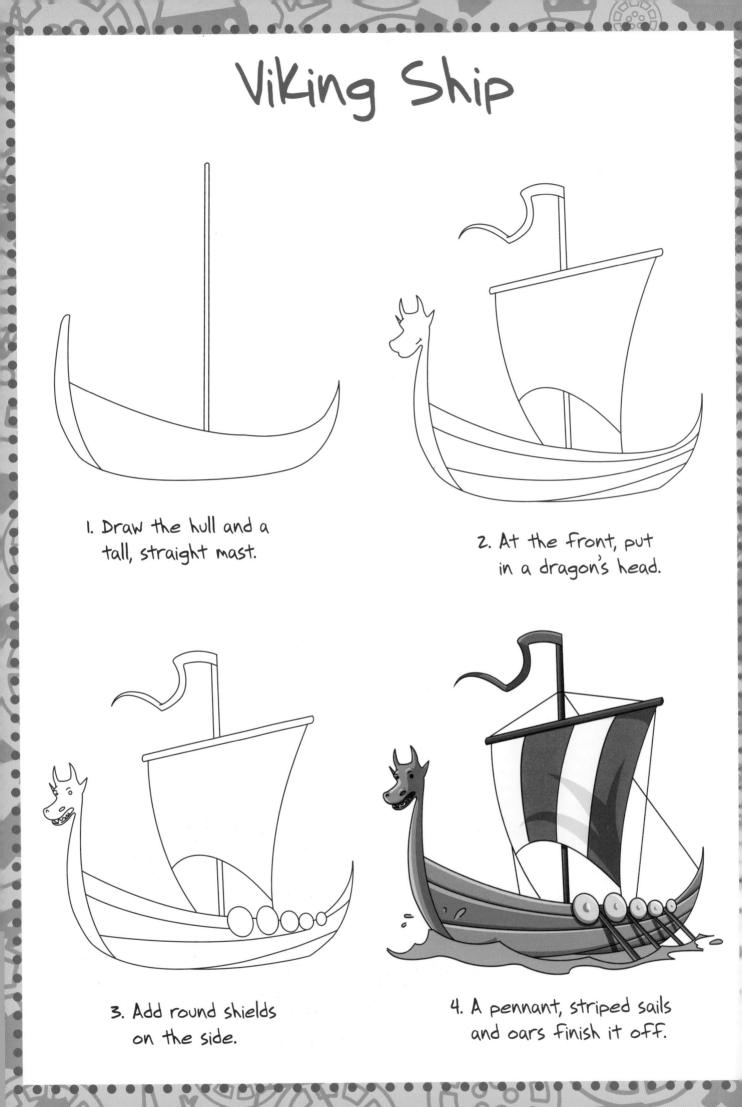

1. Draw the hull and a tall, straight mast.

2. At the front, put in a dragon's head.

3. Add round shields on the side.

4. A pennant, striped sails and oars finish it off.

Jumbo Jet

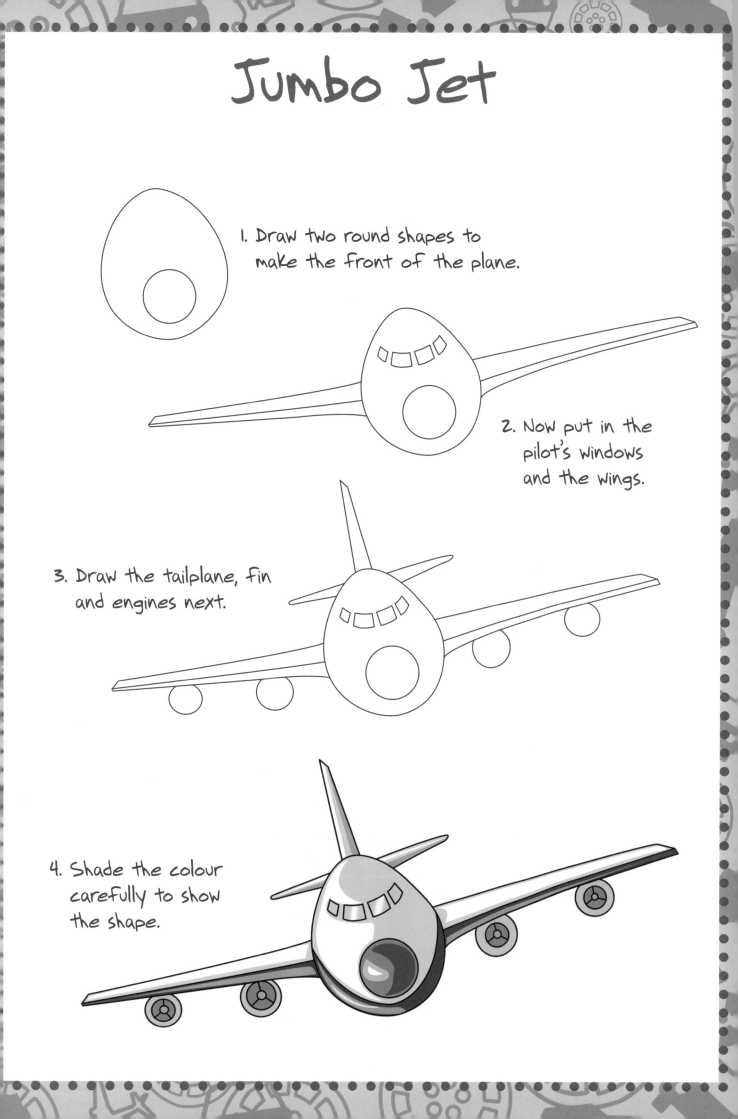

1. Draw two round shapes to make the front of the plane.

2. Now put in the pilot's windows and the wings.

3. Draw the tailplane, fin and engines next.

4. Shade the colour carefully to show the shape.

Train

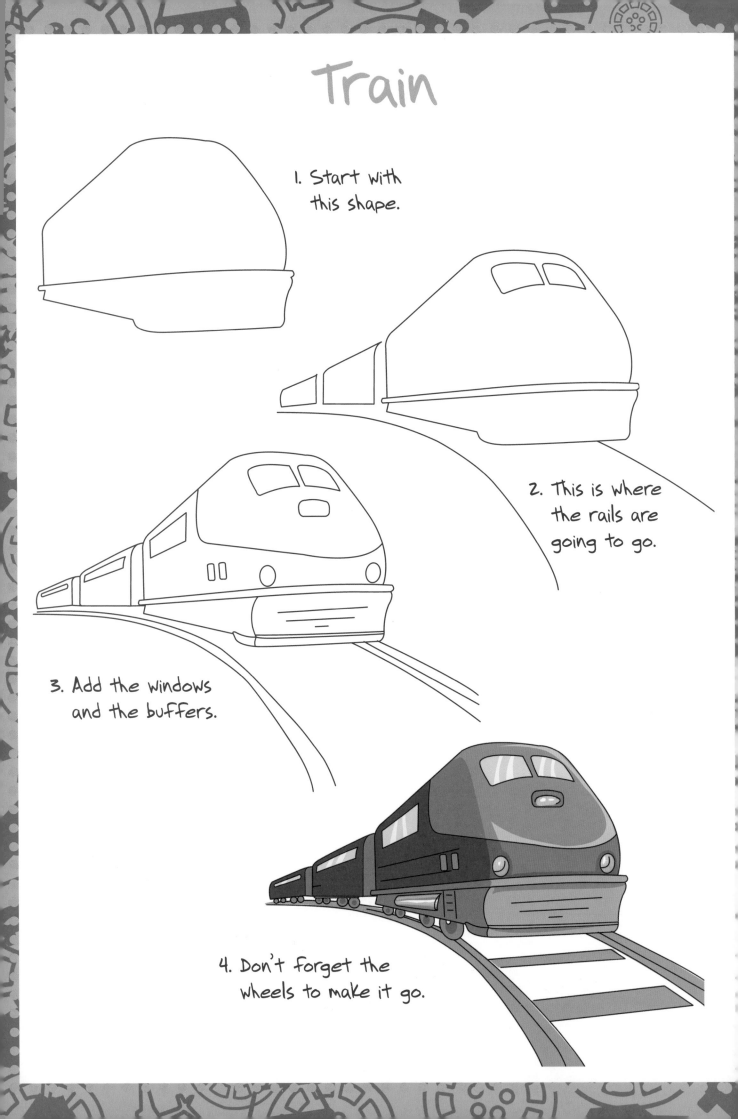

1. Start with this shape.

2. This is where the rails are going to go.

3. Add the windows and the buffers.

4. Don't forget the wheels to make it go.

Bus

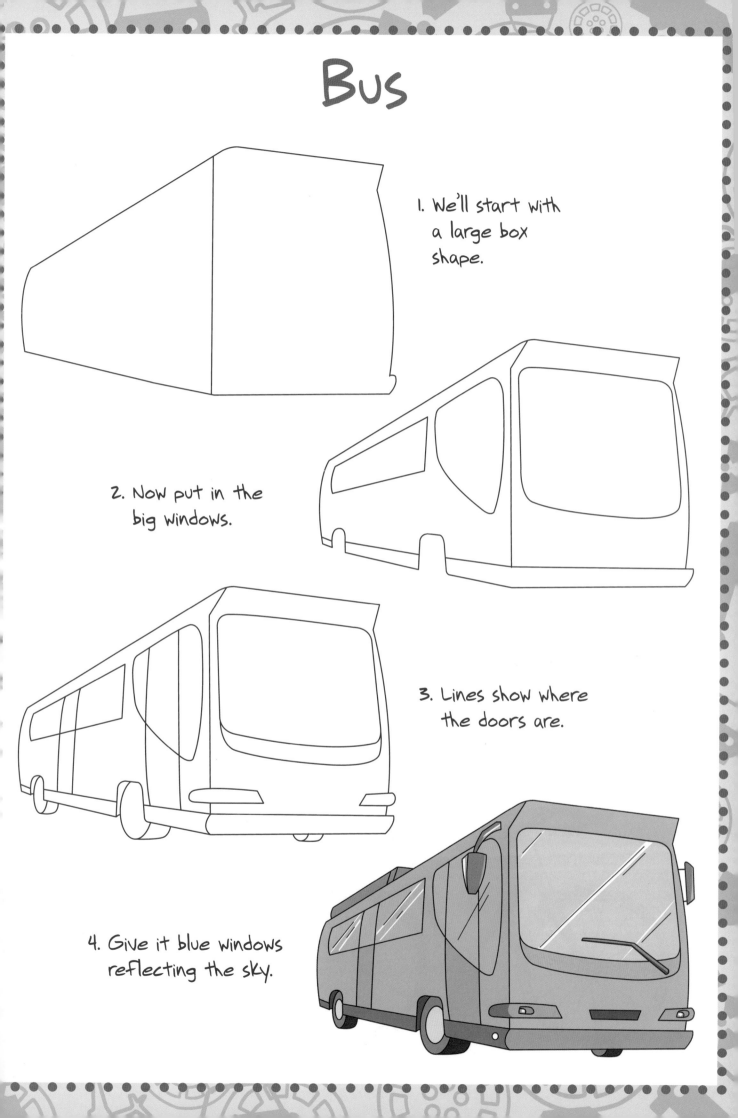

1. We'll start with a large box shape.

2. Now put in the big windows.

3. Lines show where the doors are.

4. Give it blue windows reflecting the sky.

Bicycle

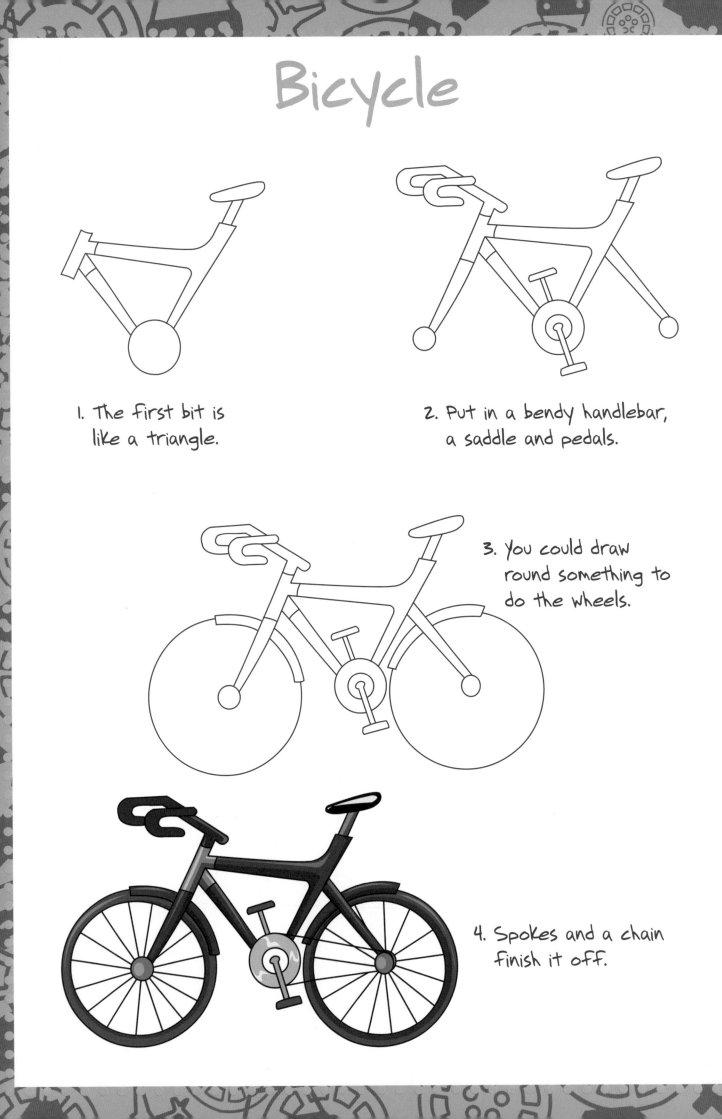

1. The first bit is like a triangle.

2. Put in a bendy handlebar, a saddle and pedals.

3. You could draw round something to do the wheels.

4. Spokes and a chain finish it off.

Helicopter

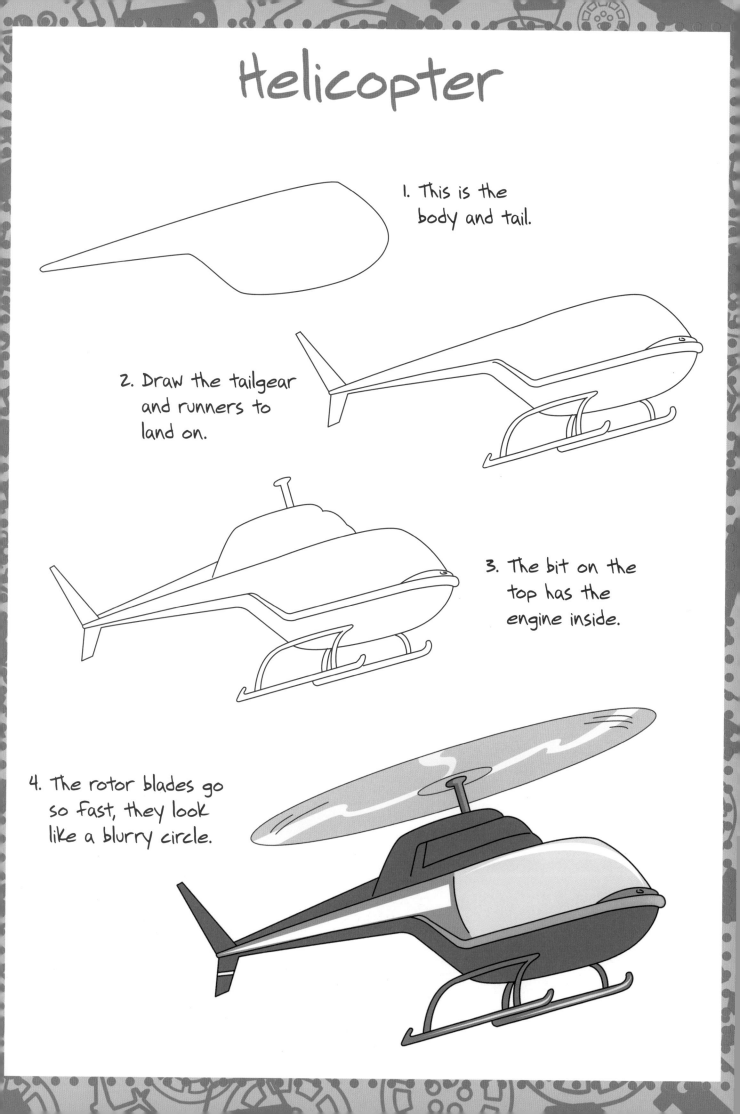

1. This is the body and tail.

2. Draw the tailgear and runners to land on.

3. The bit on the top has the engine inside.

4. The rotor blades go so fast, they look like a blurry circle.

Steamroller

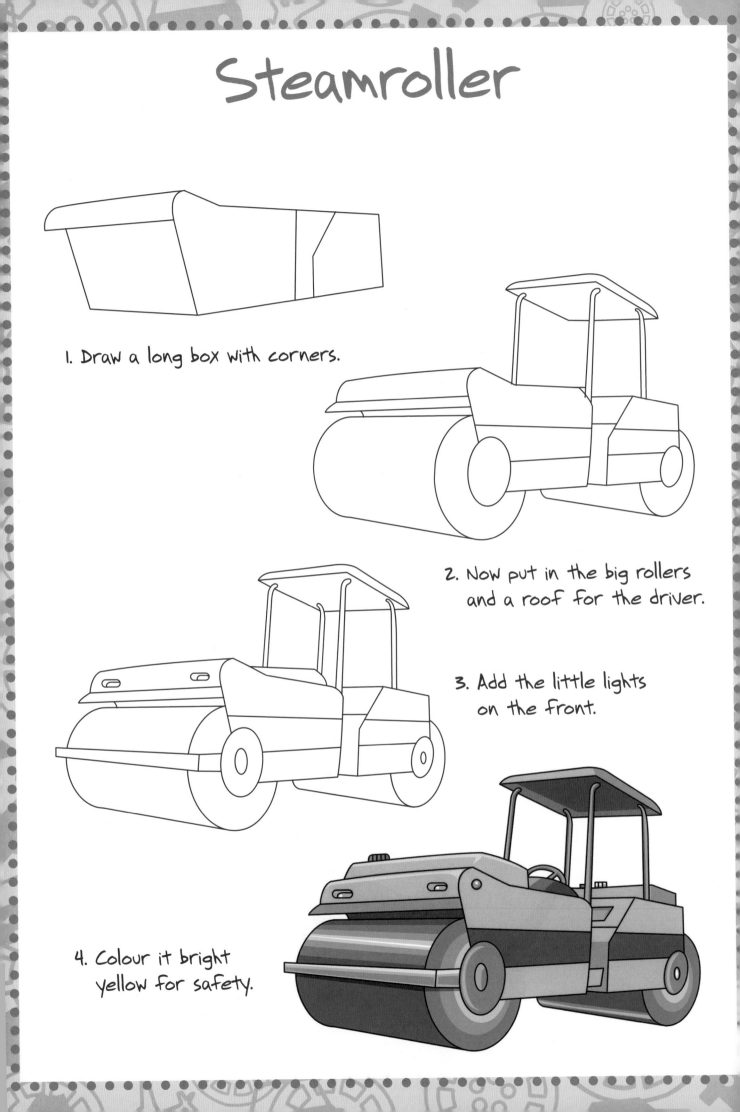

1. Draw a long box with corners.

2. Now put in the big rollers and a roof for the driver.

3. Add the little lights on the front.

4. Colour it bright yellow for safety.

Car

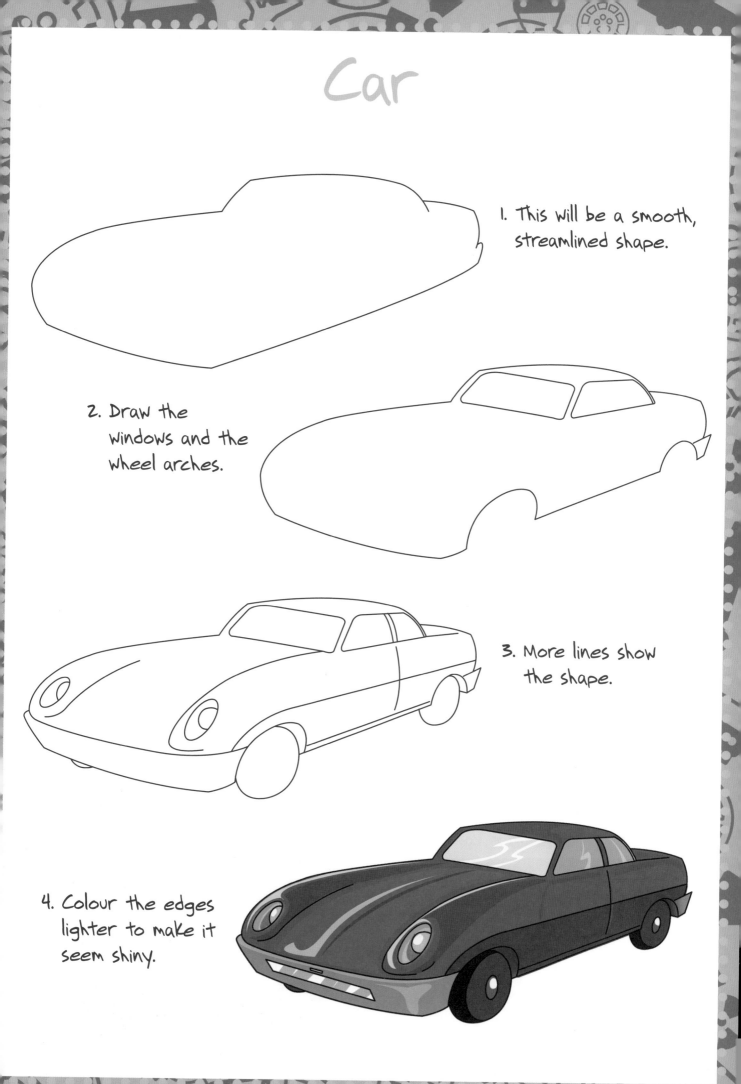

1. This will be a smooth, streamlined shape.

2. Draw the windows and the wheel arches.

3. More lines show the shape.

4. Colour the edges lighter to make it seem shiny.

Pirate Ship

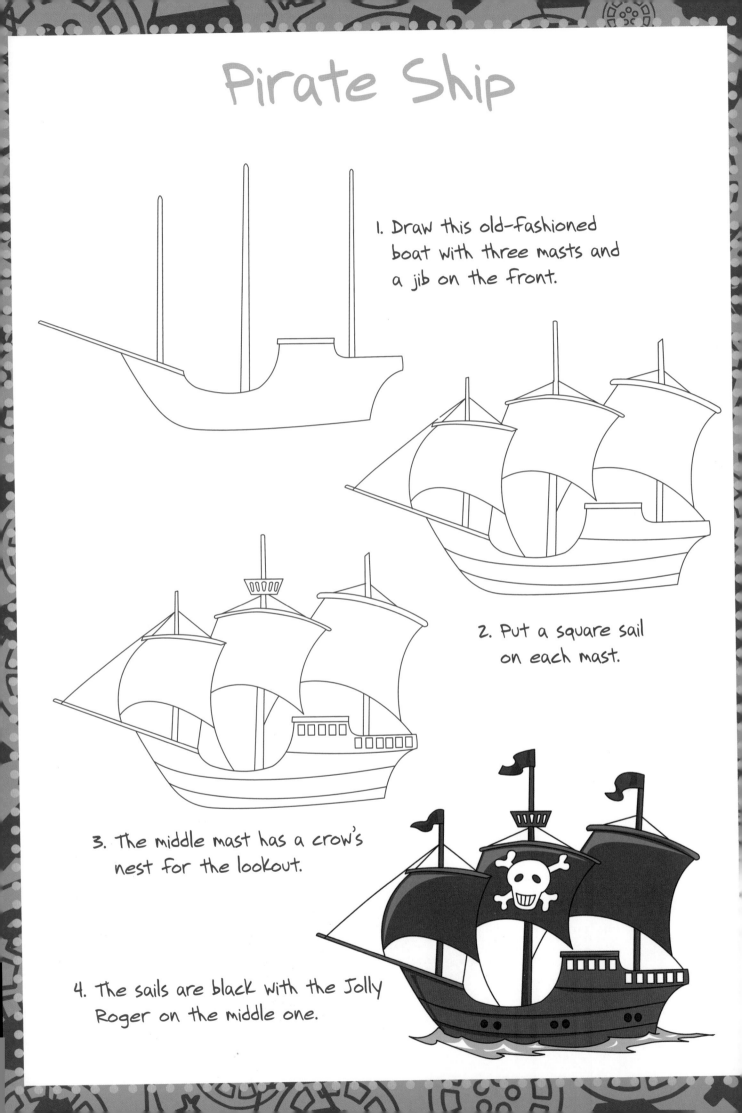

1. Draw this old-fashioned boat with three masts and a jib on the front.

2. Put a square sail on each mast.

3. The middle mast has a crow's nest for the lookout.

4. The sails are black with the Jolly Roger on the middle one.

Digger

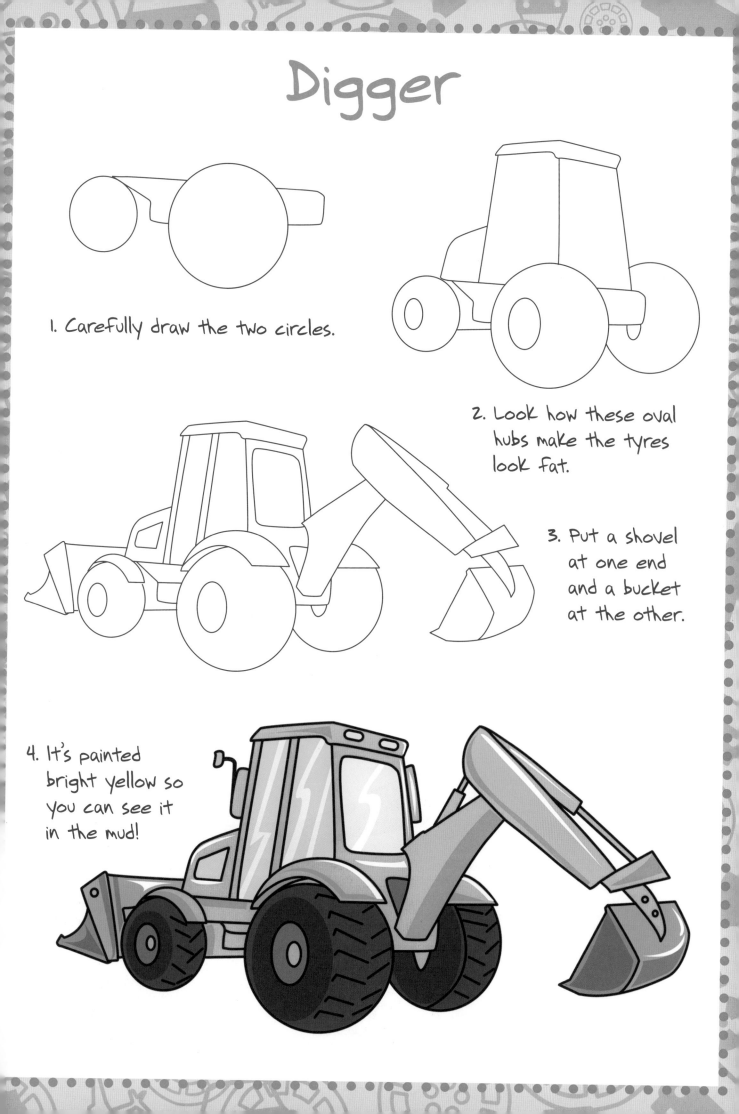

1. Carefully draw the two circles.

2. Look how these oval hubs make the tyres look fat.

3. Put a shovel at one end and a bucket at the other.

4. It's painted bright yellow so you can see it in the mud!

Tank

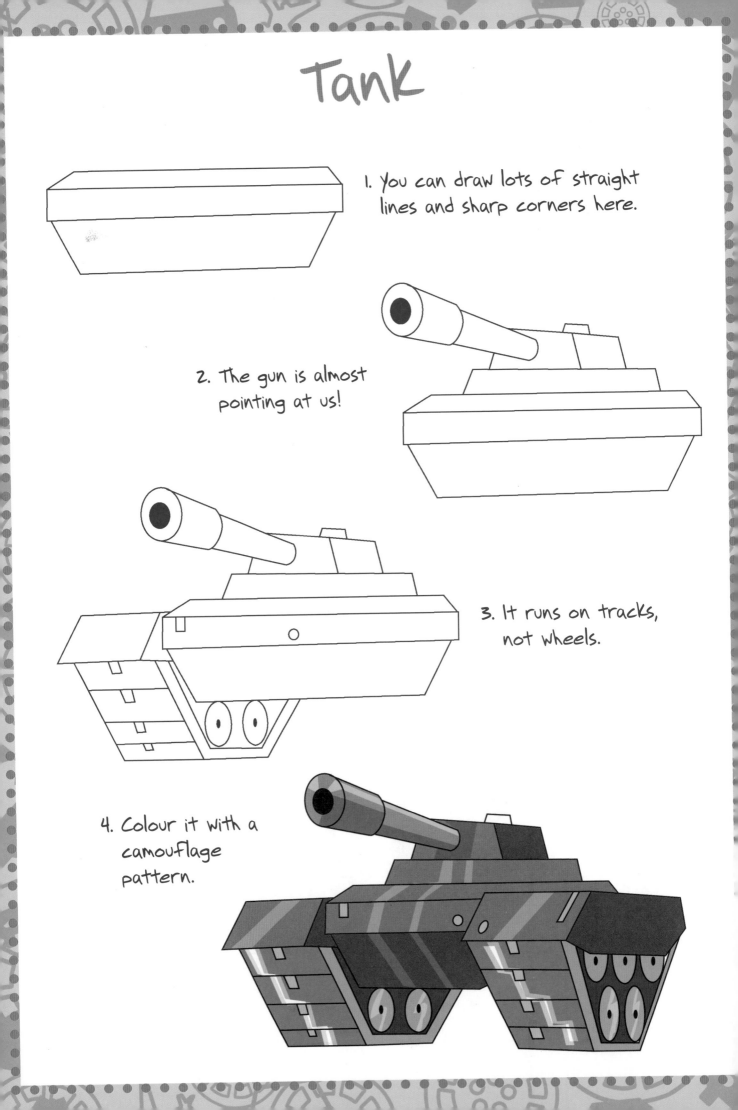

1. You can draw lots of straight lines and sharp corners here.

2. The gun is almost pointing at us!

3. It runs on tracks, not wheels.

4. Colour it with a camouflage pattern.

Tractor

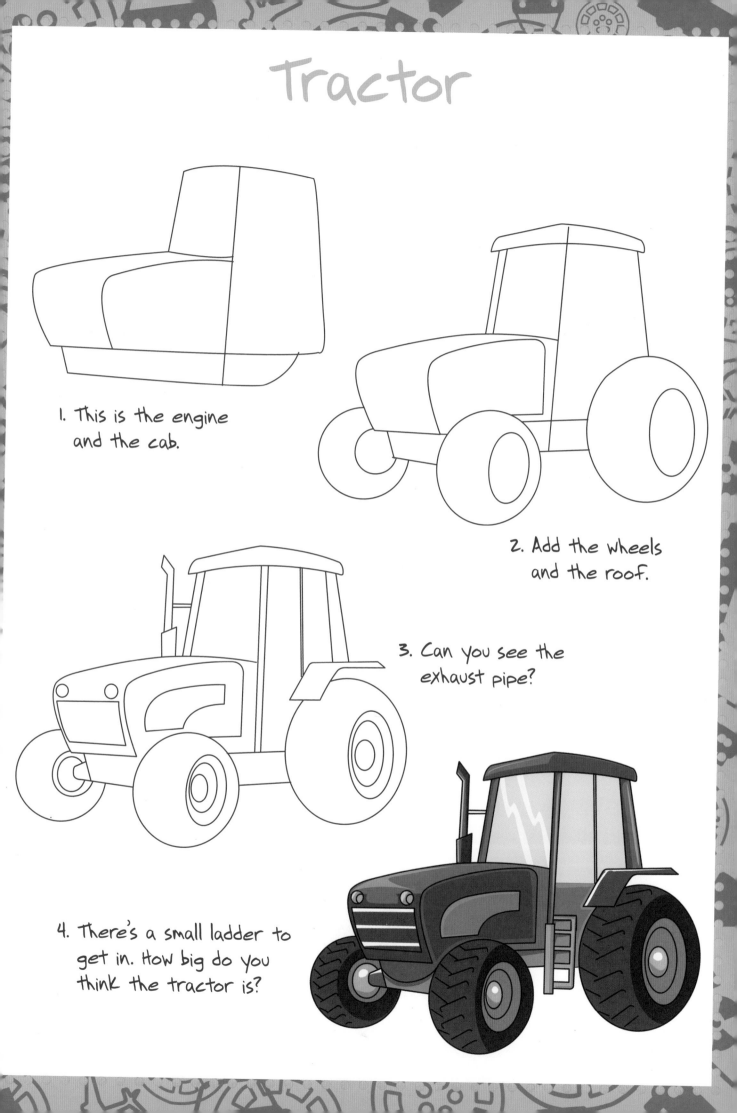

1. This is the engine and the cab.

2. Add the wheels and the roof.

3. Can you see the exhaust pipe?

4. There's a small ladder to get in. How big do you think the tractor is?

Cruise Ship

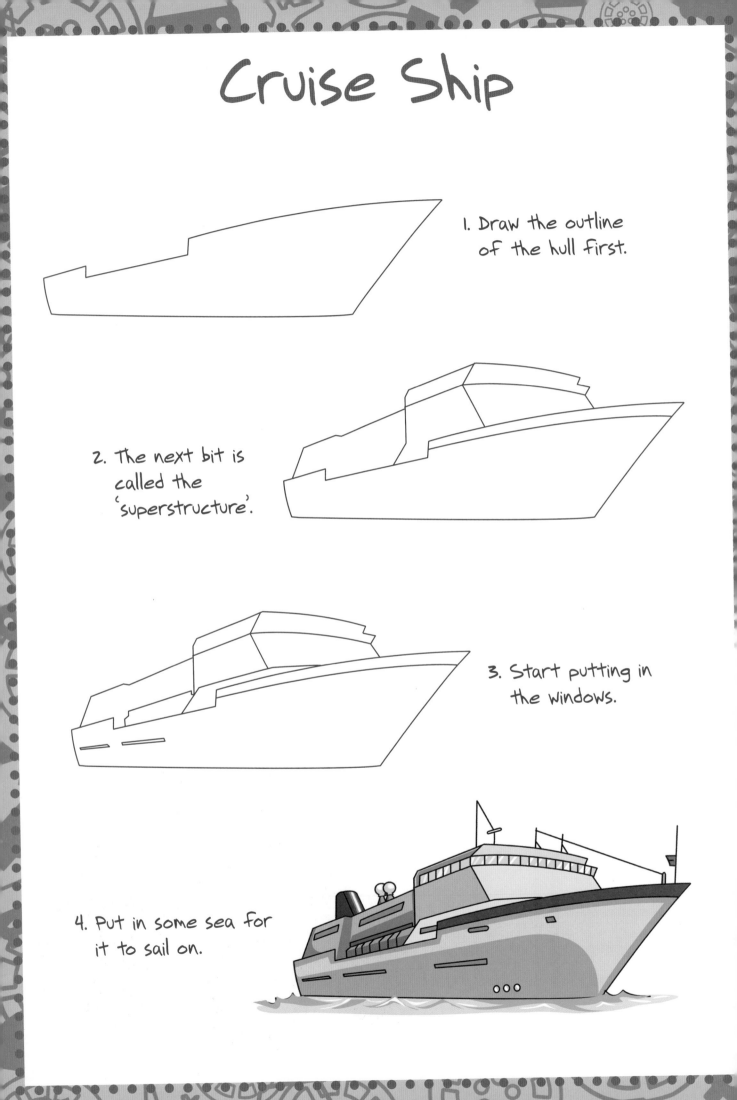

1. Draw the outline of the hull first.

2. The next bit is called the 'superstructure'.

3. Start putting in the windows.

4. Put in some sea for it to sail on.

Truck

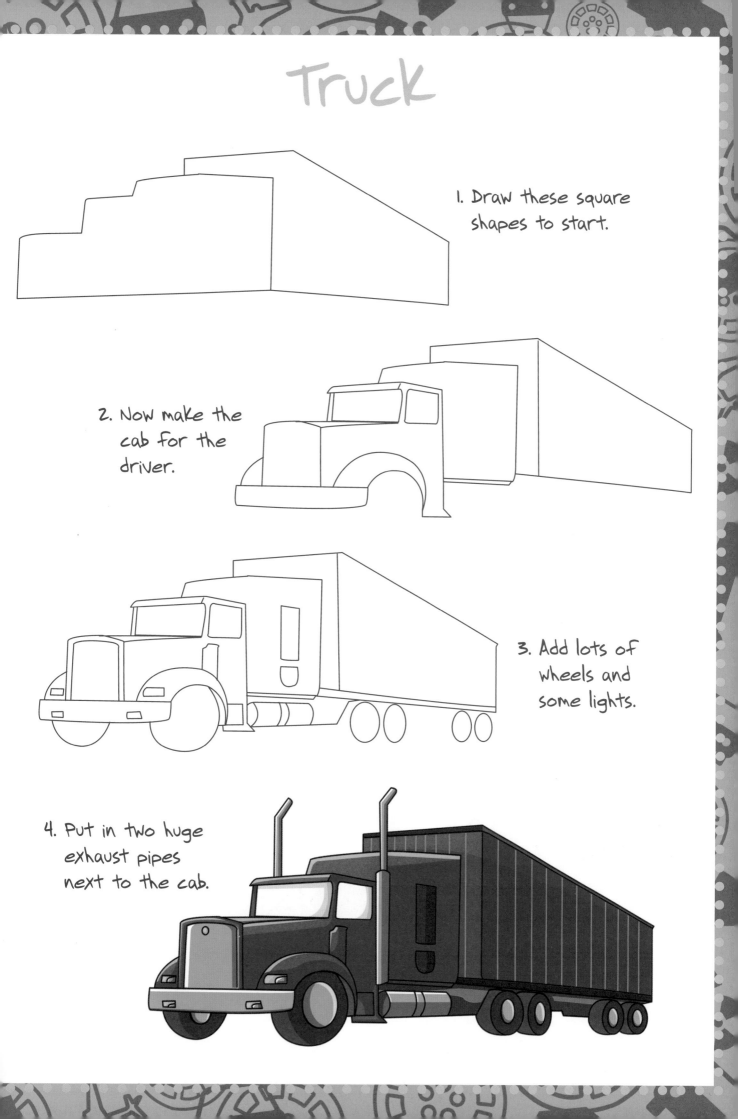

1. Draw these square shapes to start.

2. Now make the cab for the driver.

3. Add lots of wheels and some lights.

4. Put in two huge exhaust pipes next to the cab.

Submarine

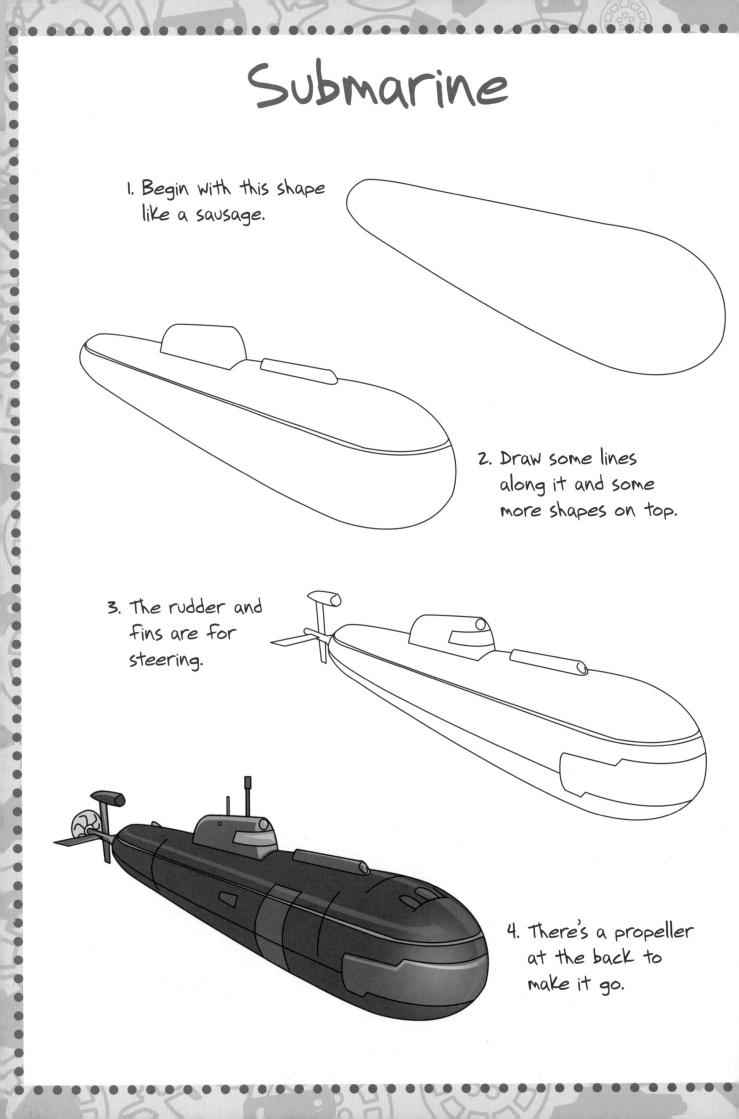

1. Begin with this shape like a sausage.

2. Draw some lines along it and some more shapes on top.

3. The rudder and fins are for steering.

4. There's a propeller at the back to make it go.

ANIMALS

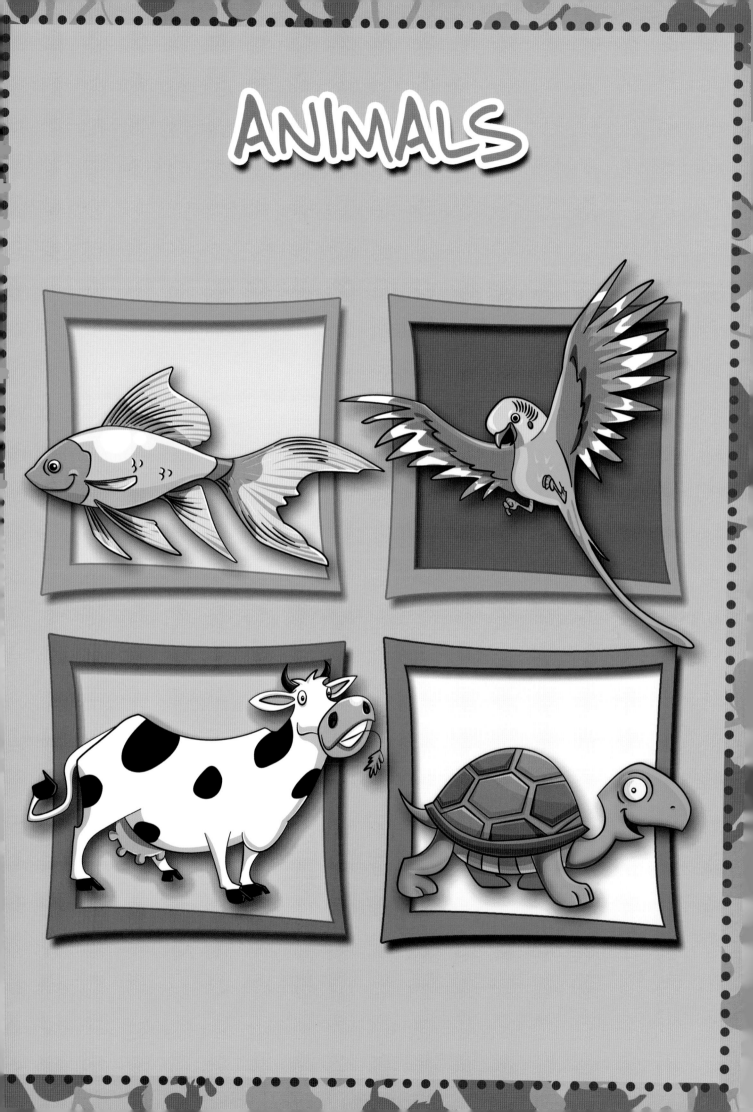

Donkey

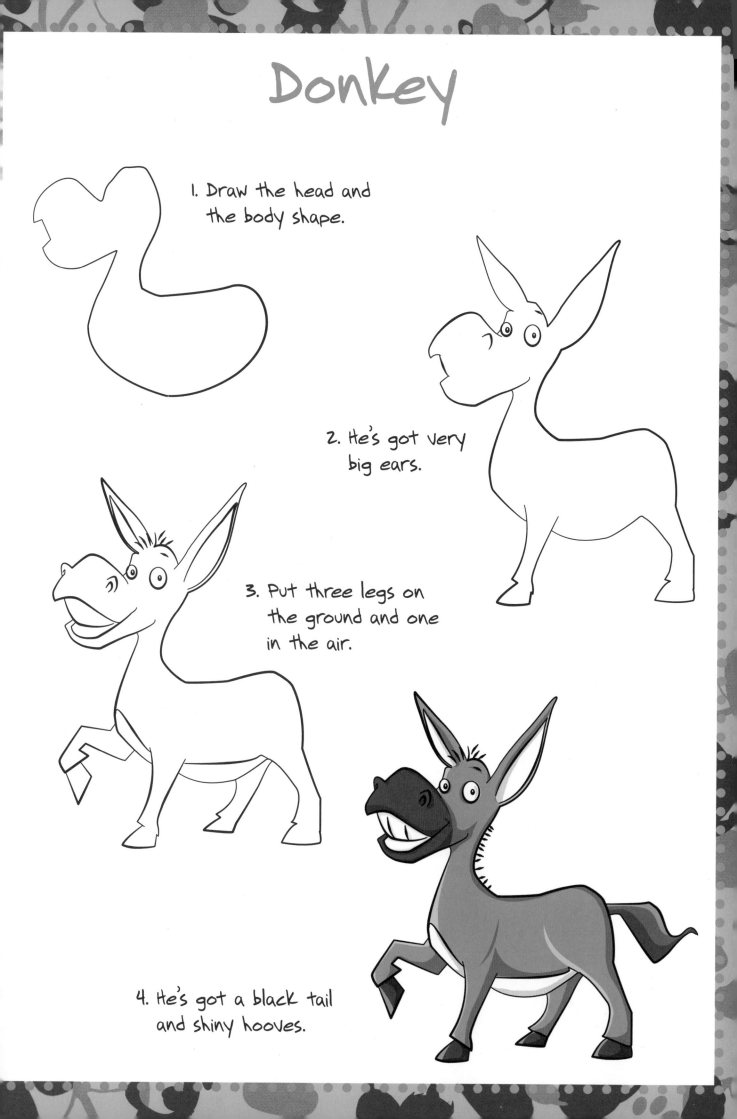

1. Draw the head and the body shape.

2. He's got very big ears.

3. Put three legs on the ground and one in the air.

4. He's got a black tail and shiny hooves.

Dog

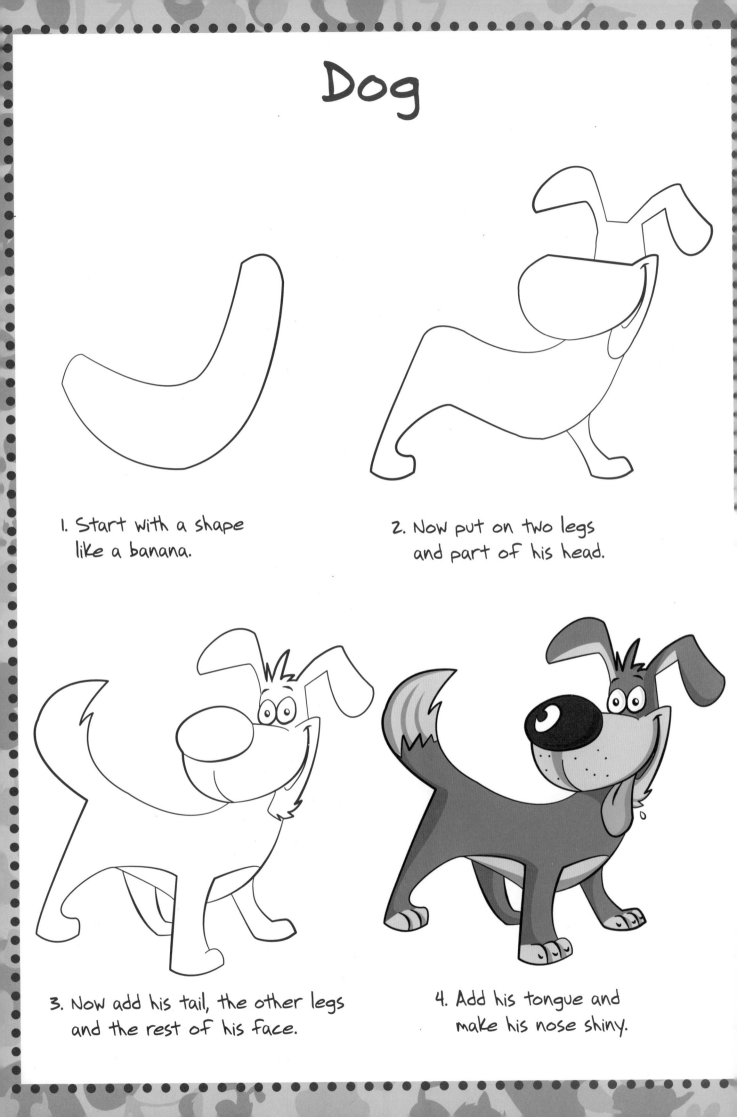

1. Start with a shape like a banana.

2. Now put on two legs and part of his head.

3. Now add his tail, the other legs and the rest of his face.

4. Add his tongue and make his nose shiny.

Goldfish

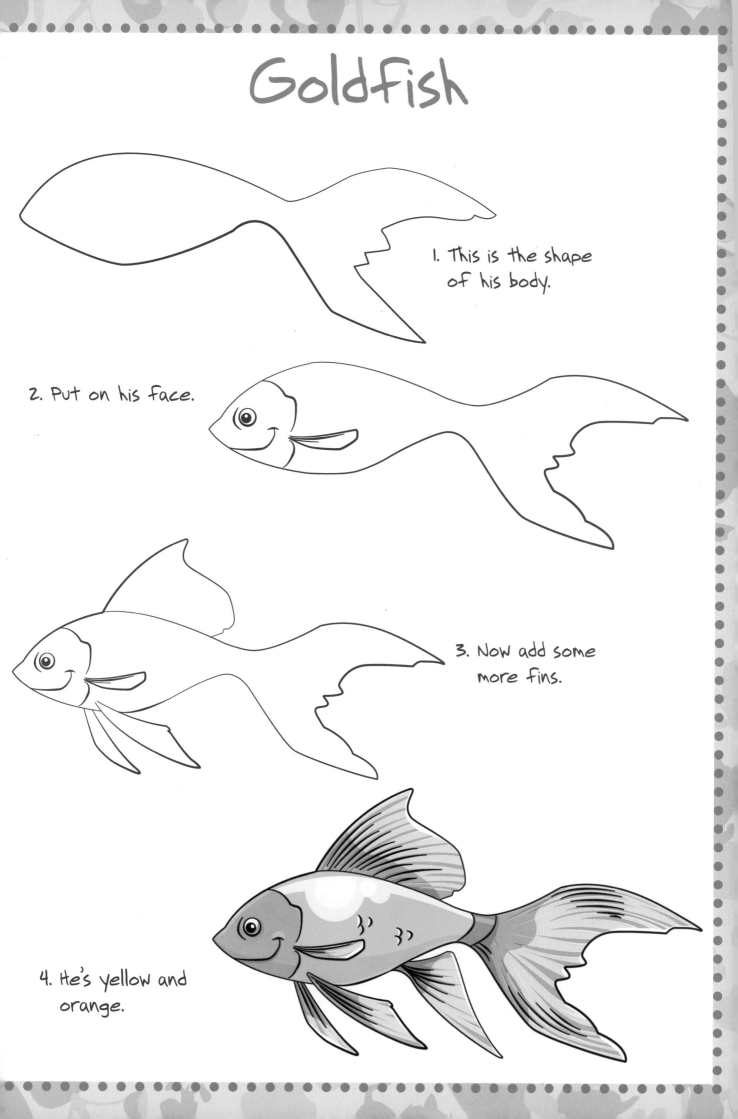

1. This is the shape of his body.

2. Put on his face.

3. Now add some more fins.

4. He's yellow and orange.

Hamster

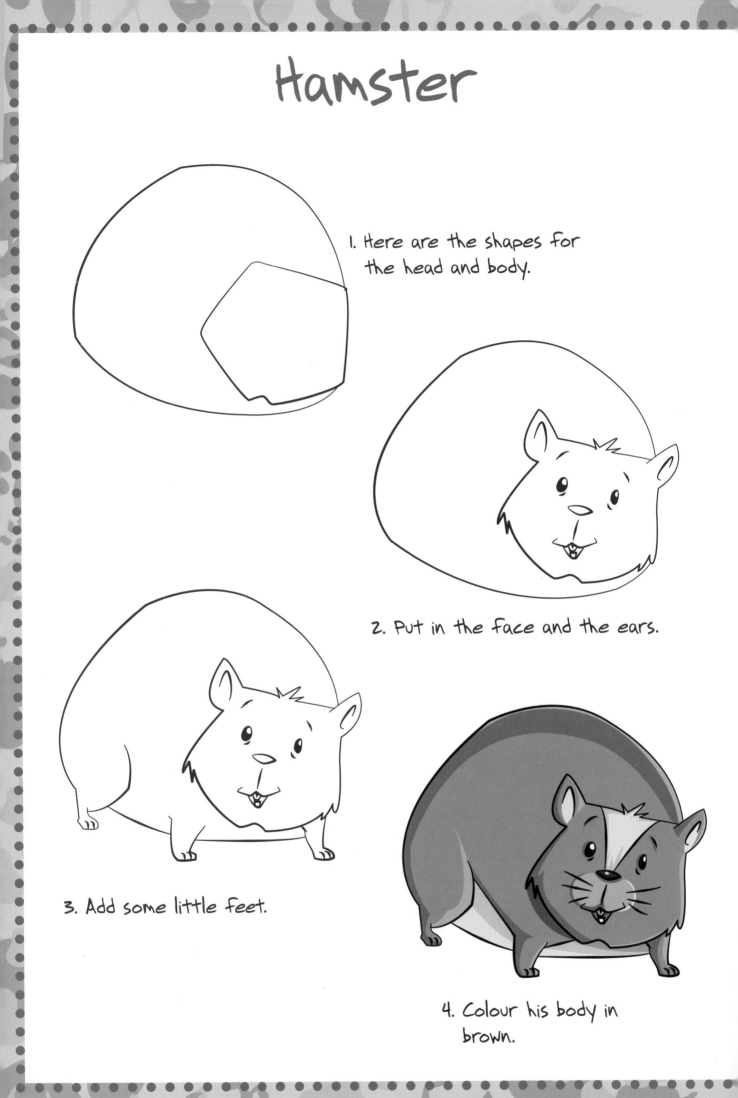

1. Here are the shapes for the head and body.

2. Put in the face and the ears.

3. Add some little feet.

4. Colour his body in brown.

Cat

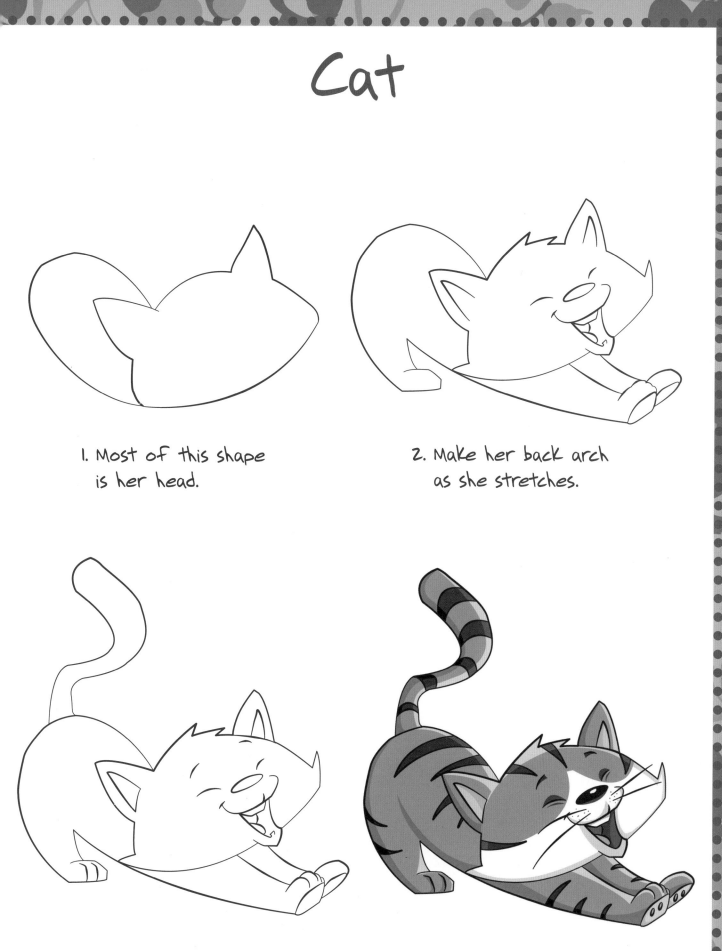

1. Most of this shape is her head.

2. Make her back arch as she stretches.

3. Her tail is a bit like a question mark.

4. She's stripy like her cousin, the tiger.

Rabbit

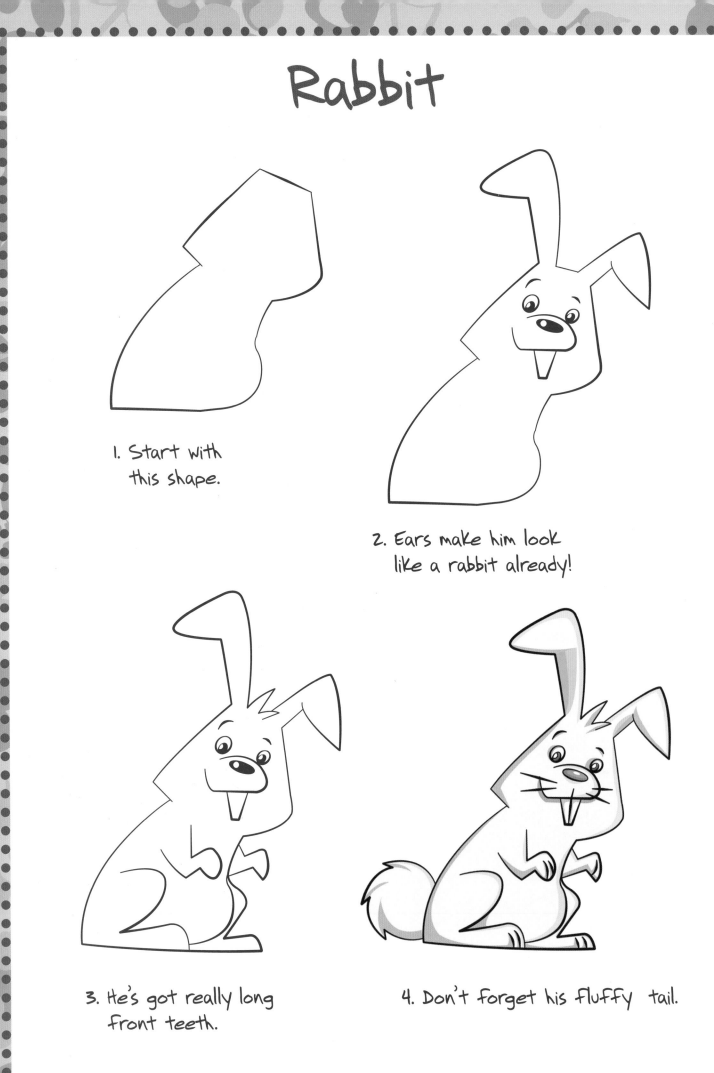

1. Start with this shape.

2. Ears make him look like a rabbit already!

3. He's got really long front teeth.

4. Don't forget his fluffy tail.

Budgerigar

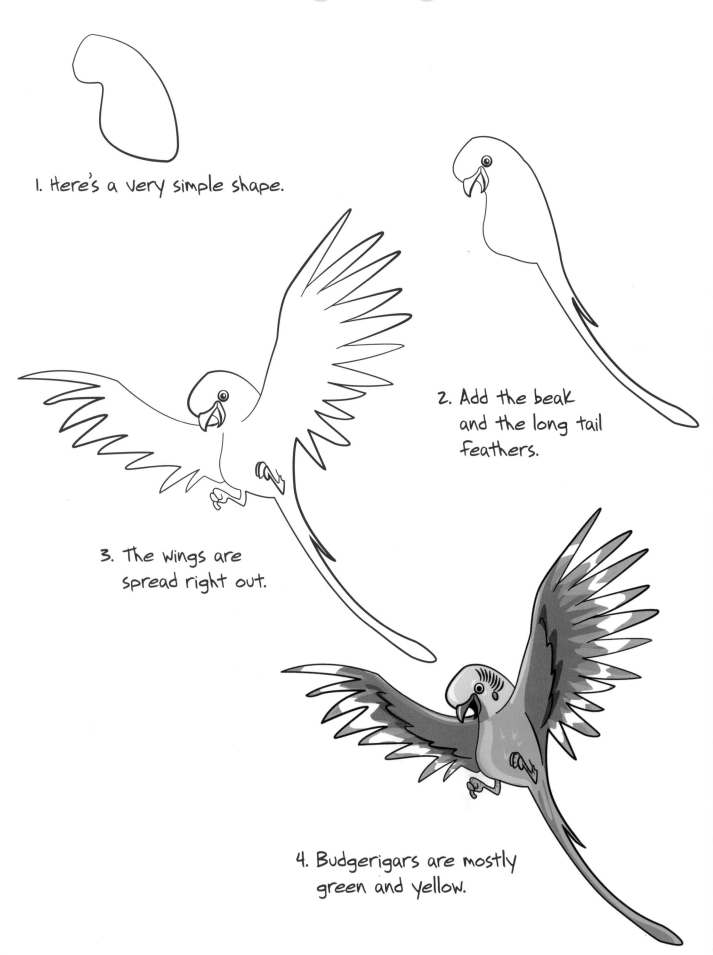

1. Here's a very simple shape.

2. Add the beak and the long tail feathers.

3. The wings are spread right out.

4. Budgerigars are mostly green and yellow.

Horse

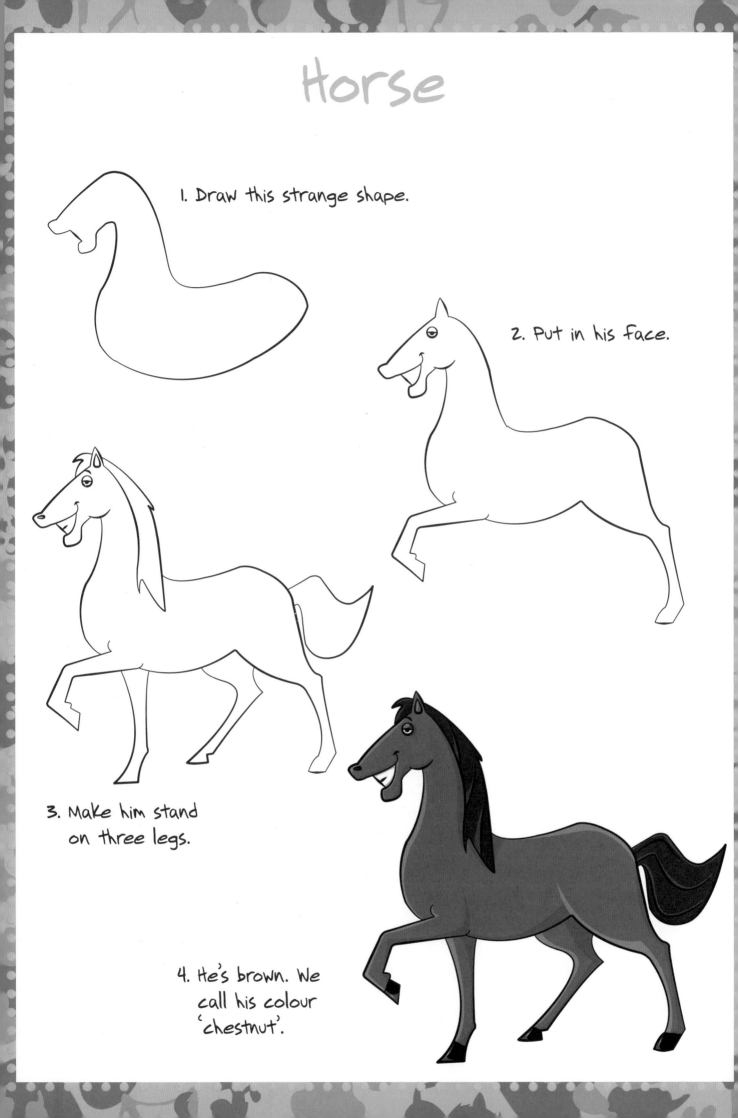

1. Draw this strange shape.

2. Put in his face.

3. Make him stand on three legs.

4. He's brown. We call his colour 'chestnut'.

Pig

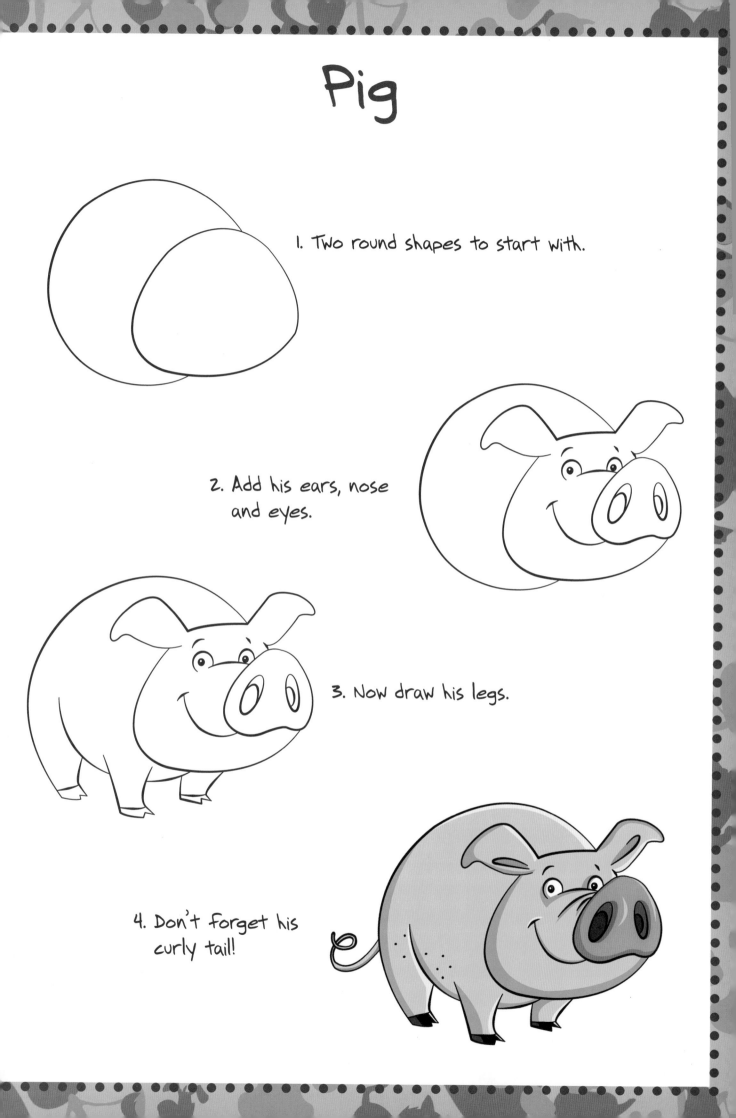

1. Two round shapes to start with.

2. Add his ears, nose and eyes.

3. Now draw his legs.

4. Don't forget his curly tail!

Rat

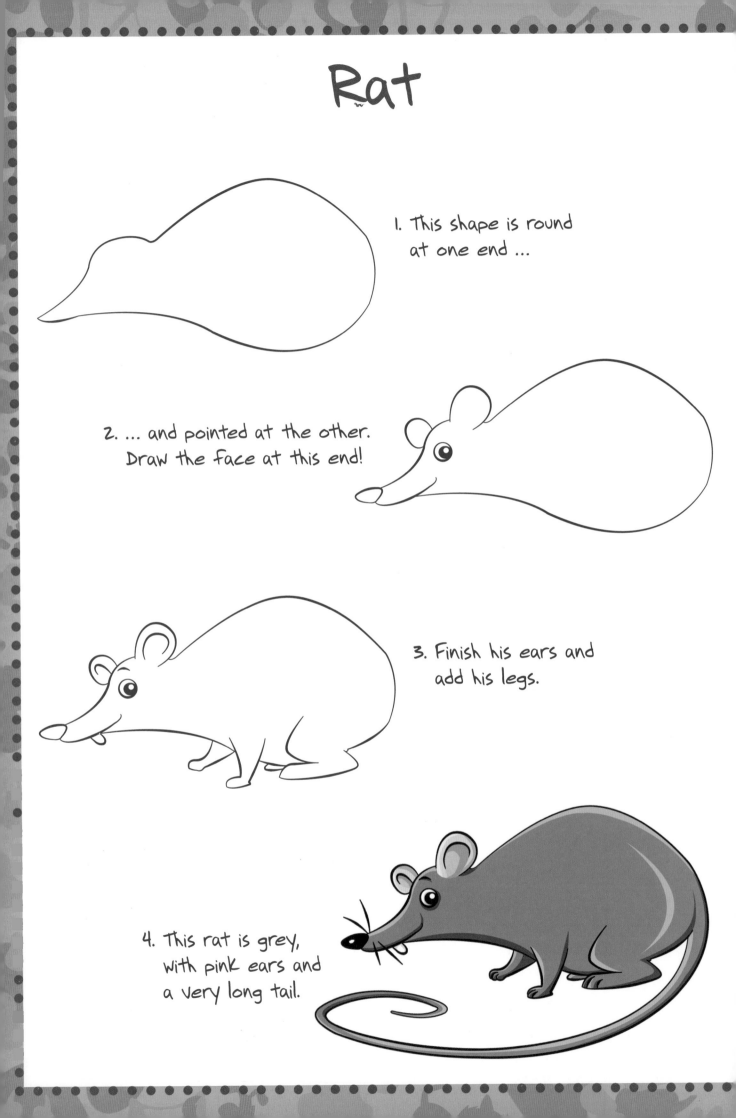

1. This shape is round at one end ...

2. ... and pointed at the other. Draw the face at this end!

3. Finish his ears and add his legs.

4. This rat is grey, with pink ears and a very long tail.

Cow

1. Her body has some corners.

2. Now fit on the legs and the head.

3. She's got a big mouth for eating lots of grass.

4. Underneath are her udders where her milk comes from.

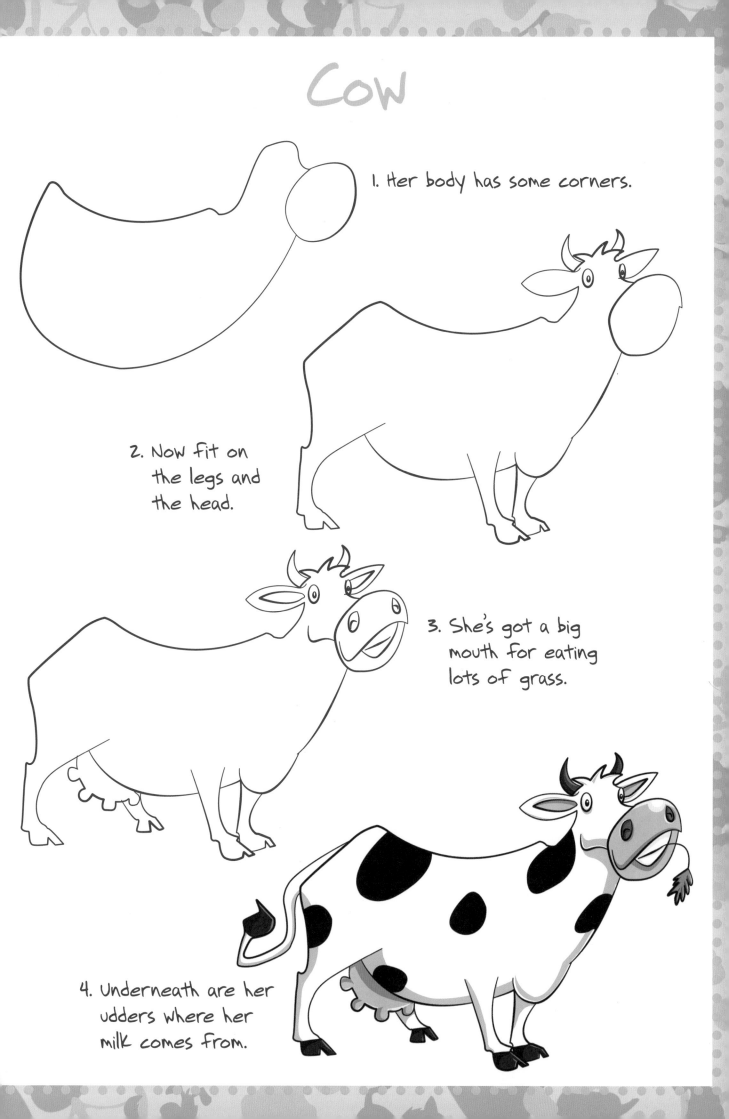

Sheep

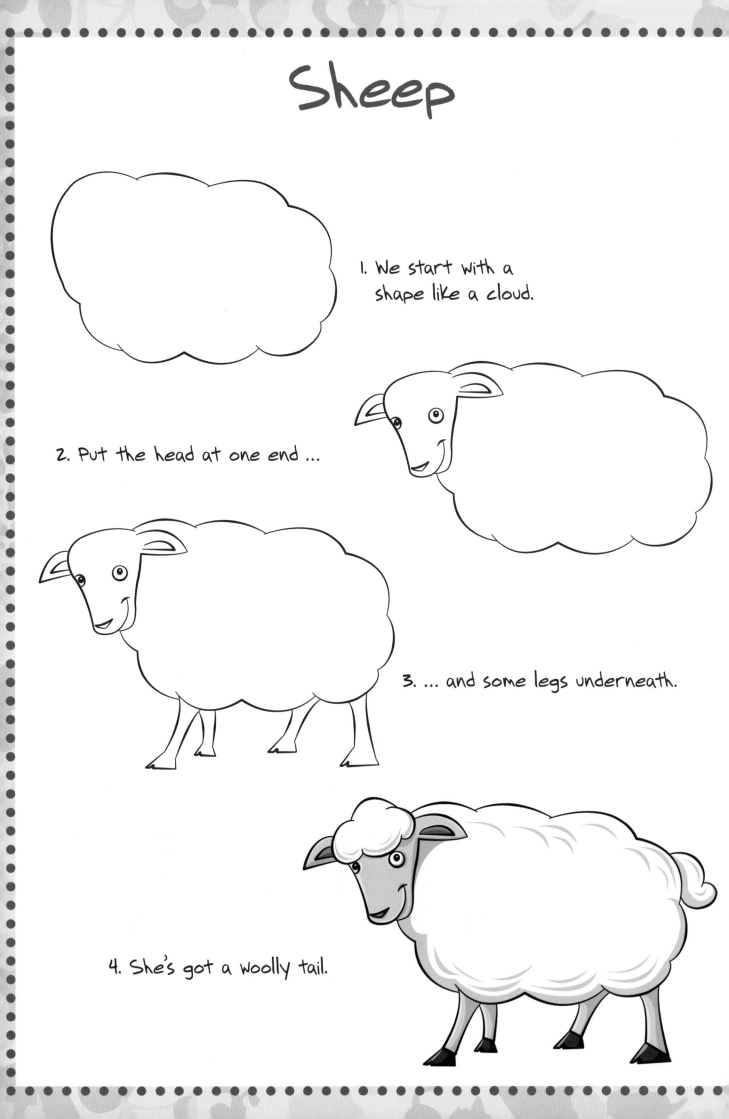

1. We start with a shape like a cloud.

2. Put the head at one end ...

3. ... and some legs underneath.

4. She's got a woolly tail.

Tortoise

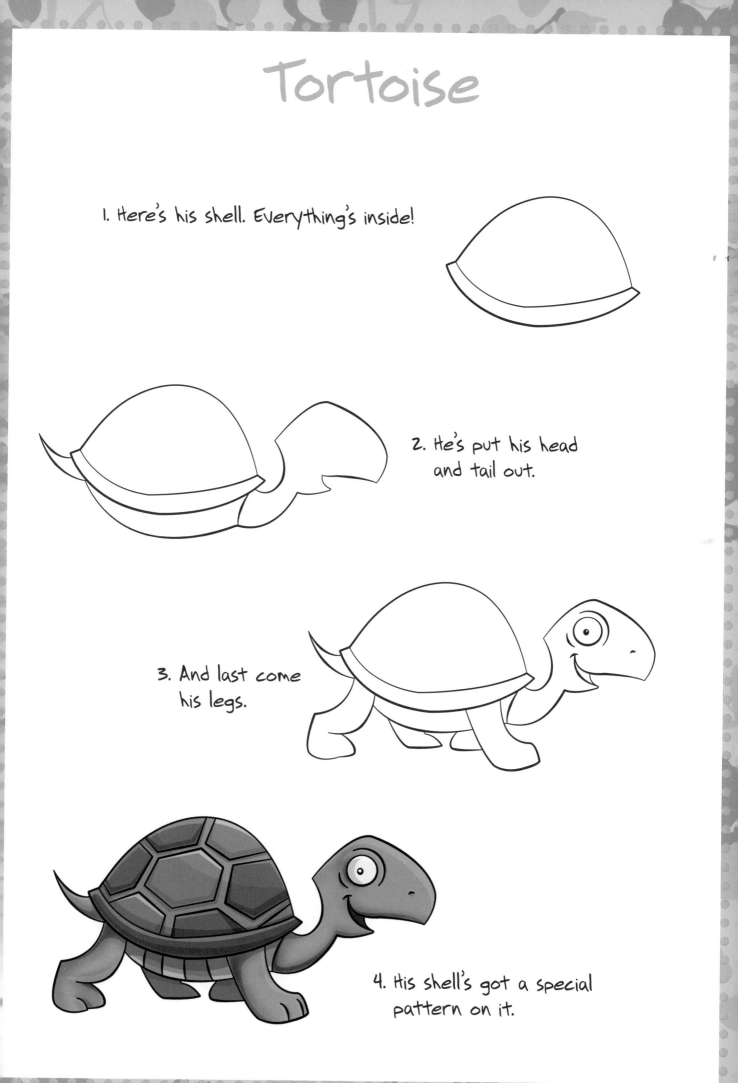

1. Here's his shell. Everything's inside!

2. He's put his head and tail out.

3. And last come his legs.

4. His shell's got a special pattern on it.

Chicken

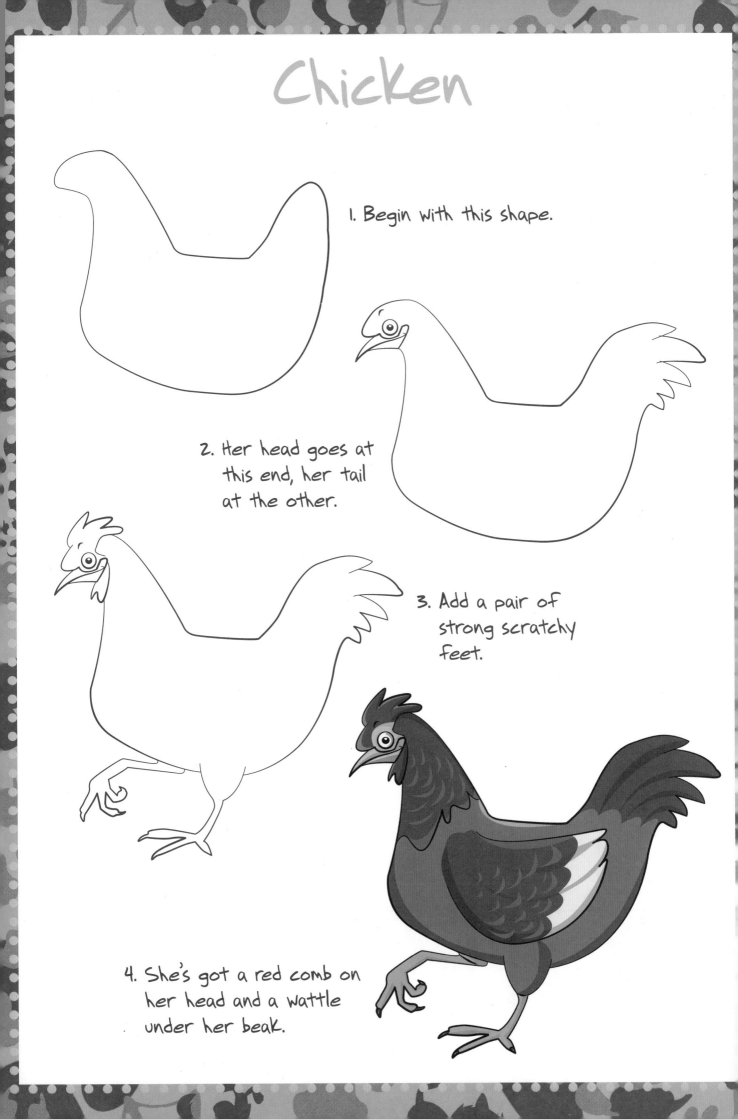

1. Begin with this shape.

2. Her head goes at this end, her tail at the other.

3. Add a pair of strong scratchy feet.

4. She's got a red comb on her head and a wattle under her beak.

Duck

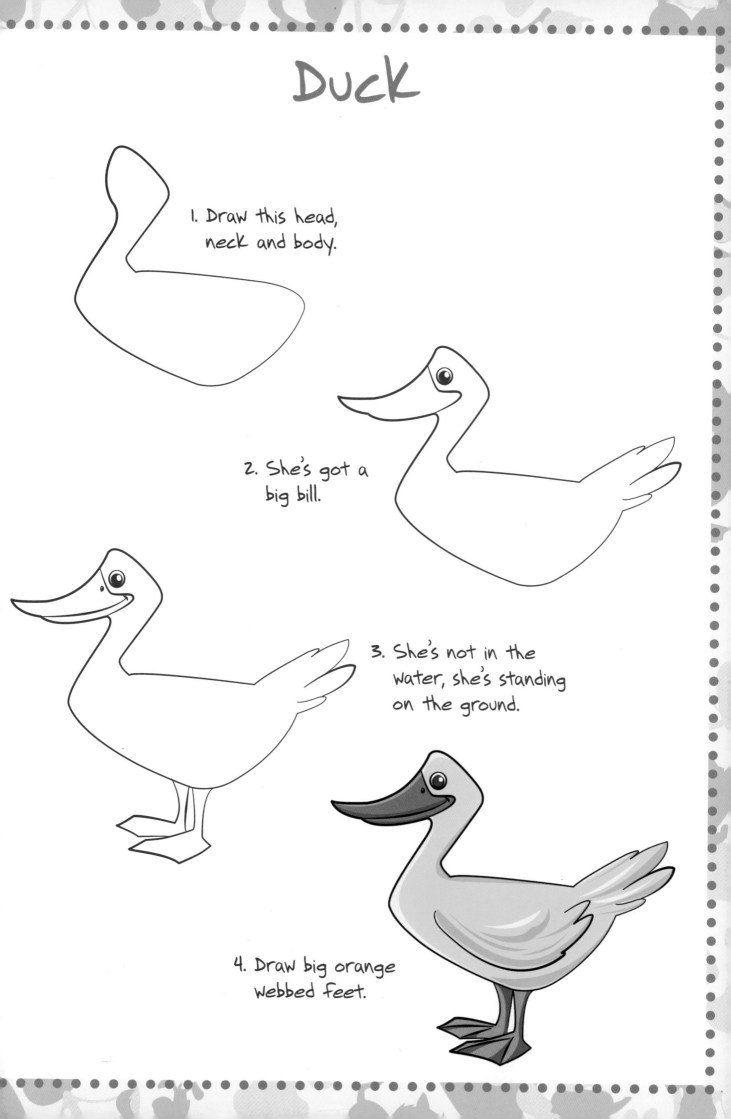

1. Draw this head, neck and body.

2. She's got a big bill.

3. She's not in the water, she's standing on the ground.

4. Draw big orange webbed feet.

Camel

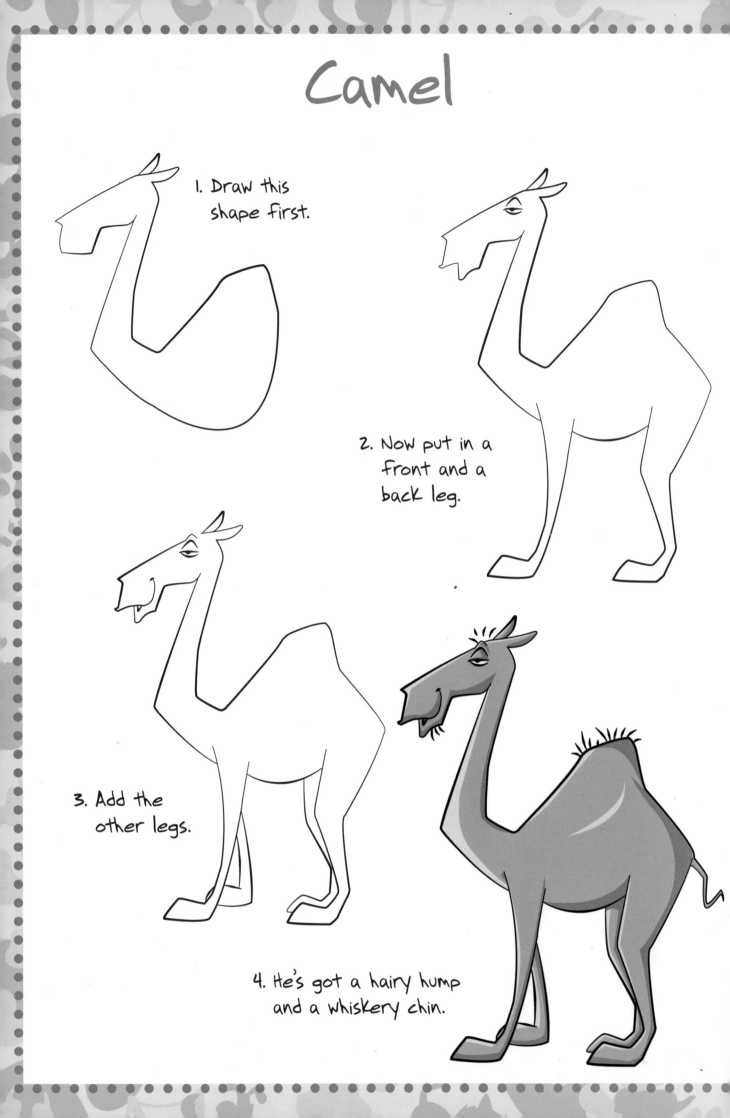

1. Draw this shape first.

2. Now put in a front and a back leg.

3. Add the other legs.

4. He's got a hairy hump and a whiskery chin.